Edvard
MUNCH
SOHLBERG
Harald

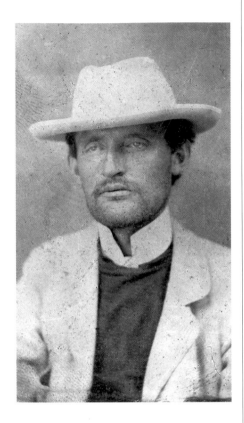

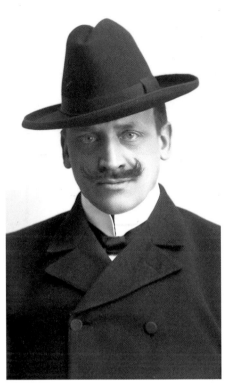

Edvard Munch, ca. 1902

Harald Sohlberg, 1904

ØIVIND STORM BJERKE

Edvard
MUNCH

SOHLBERG
Harald

Landscapes of the Mind

National Academy of Design
New York
1995

This book was published to accompany the exhibition *Edvard Munch and Harald Sohlberg:*
Landscapes of the Mind, presented at the National Academy of Design
October 12, 1995 through January 14, 1996.

The exhibition has been organized by the National Academy of Design in cooperation
with the Royal Norwegian Ministry of Foreign Affairs.

The exhibition is sponsored by Kraft Freia Marabou, a subsidiary of Philip Morris Companies Inc.
Additional support for the exhibition has been provided by the F. Donald Kenney Foundation.
Educational programs have been funded, in part, by The American-Scandinavian Foundation.

Transportation services have been provided by SAS.

SCANDINAVIAN AIRLINES

Catalogue translated by Francesca M. Nichols and Pat Shaw
Design and Production by Øivind Pedersen, Labyrinth Press, Oslo

FRONT COVER:
Edvard Munch, *Separation,* 1896 (no. 13)
Harald Sohlberg, *Flower Meadow in the North,* 1905 (no. 100)

LIBRARY OF CONGRESS CATALOGING-IN-PUBLICATION DATA

Bjerke, Øivind Storm, 1953-
Edvard Munch and Harald Sohlberg: landscapes of the mind/Øivind Storm Bjerke.
p. cm.
Catalog of an exhibition held at the National Academy of Design, Oct. 12, 1995–Jan. 14, 1996.
Includes bibliographical references and index.
ISBN 1-887149-01-5 (hardcover)
1. Munch, Edvard, 1863-1944 – Exhibitions. 2. Sohlberg, Harald, 1869-1935 – Exhibitions.
3. Nature (Aesthetics) – Exhibitions. 4. Symbolism (Art movement) – Norway – Exhibitions.
I. Munch, Edvard, 1863-1944. II. Sohlberg, Harald, 1869-1935.
III. National Academy of Design (U.S.) IV. Title.
N7053.M85A4 1995

760'.092--dc20 95-37128
 CIP

Distributed by University Press of New England
Hanover and London

CONTENTS

PREFACE . 9

ACKNOWLEDGMENTS 11

INTRODUCTION . 15

EDVARD MUNCH . 19

HARALD SOHLBERG 51

EDVARD MUNCH AND HARALD SOHLBERG
Two Artists and Their Relationship to
the Local Norwegian Art World 81

CHRONOLOGY Edvard Munch 99

CHRONOLOGY Harald Sohlberg 107

EXHIBITION CHECKLIST 111

PLATES Edvard Munch 123

PLATES Harald Sohlberg 187

BIBLIOGRAPHY . 251

The last decades of the nineteenth century were the "Golden Age" for Norwegian culture. As one of the poorest countries in Europe, situated on the periphery of the Continent, Norway produced a remarkable number of outstanding writers, painters, composers, explorers, and scientists who gained international recognition and acclaim both in Europe and the United States. Some are still internationally celebrated today, such as the playwright Henrik Ibsen, the composer Edvard Grieg, the novelist Knut Hamsun, the explorer, scientist, and humanist Fridtjof Nansen, and the painter Edvard Munch.

In Scandinavian art, Edvard Munch is the foremost example of an artist who shifted from long-established art traditions to an avant-garde modernist approach. His younger contemporary, Harald Sohlberg, was also an important figure in this radically new approach to painting.

The Royal Norwegian Ministry of Foreign Affairs is very pleased to have the opportunity to show two of our masters at the prestigious National Academy of Design during the "NORWEGIAN: Visions" cultural program in the United States. I would like to express our gratitude to the staff of the Academy, especially Director Edward Gallagher and Curator Dita Amory for their wholehearted cooperation and dedication to making this exhibition possible.

I would also like to thank Øivind Storm Bjerke, Chief Curator of the Henie-Onstad Art Center, for his work both as curator of the show and author of this catalogue.

Geir Grung
Director General
Royal Ministry of Foreign Affairs

Edvard Munch and Harald Sohlberg took distinctive and original approaches to their art. Yet seen together, their very different techniques and works yield a rich and full portrayal of the Norwegian spirit, in the language of Scandinavian modernism at the turn of the century. Serving as the centerpiece of the "Norwegian Visions" cultural exchange program, Edvard Munch and Harald Sohlberg: Landscapes of the Mind brings together two of Norway's most beloved cultural geniuses in an international exhibition for the first time.

Philip Morris, Freia and Marabou have long been recognized as pioneering supporters of the arts. In 1922, A/S Freia commissioned Edvard Munch to decorate the company's dining halls with twelve paintings. When Harald Sohlberg, a friend of Freia's founder, Johan Throne Holst, saw the newly painted frieze, he recommended changes in the dining room's architecture to enhance the viewing of the paintings. A few years later, the present Freia Hall was built. The Hall serves as a custom–made "frame" for the frieze, incorporating Sohlberg's suggestions, which clearly pleased both Munch and Sohlberg. Today, the delightful Freia frieze is the only privately owned decorative frieze by Munch that is still complete. It enhances the workday of the employees and attracts widespread attention from the public.

This is our first joint sponsorship since Freia and Marabou joined the Philip Morris family of companies in 1993, and we are delighted to help increase understanding and dialogue between our countries. Many Norwegian and American cultural and government institutions cooperated to bring the luminous works of Munch and Sohlberg together, and we thank all those, especially the National Academy of Design, who have made this ambitious exhibition possible.

Geoffrey Bible
Chairman and C.E.O.
Philip Morris Companies Inc.

Torstein Bore
Managing Director, A/S Freia
Kraft Freia Marabou

PREFACE

Edvard Munch and Harald Sohlberg: Landscapes of the Mind illuminates the *work of two of Norway's twentieth–century masters while continuing the National Academy of Design's commitment to the presentation of important European art as a complement to our collection and exhibition of American art.*

The work of Edvard Munch is well–known throughout the world. However, that of Harald Sohlberg has never been exhibited in depth outside of Norway. This catalogue and the accompanying exhibition offer American audiences the opportunity to study a large selection of paintings, drawings, and prints by both artists, while providing new insights into the Symbolist aesthetic.

In undertaking the organization of this exhibition, the National Academy of Design was enormously fortunate to have the wholehearted cooperation and support of the Royal Norwegian Ministry of Foreign Affairs. A number of individuals at the ministry have been closely involved in the development of the exhibition, including Geir Grung, Director General, Eva Bugge, Deputy Director General, and Ellen Høiness, Executive Officer. The current Norwegian ambassador to Japan, John Bjørnebye, played a key role in the initiation and formulation of the project while serving as Norwegian consul general in New York. Jan Flatla, the present consul general, has been an ongoing source of encouragement and support.

Over 150 paintings, drawings, and prints are included in this exhibition, the vast majority borrowed from Norwegian collections and never before exhibited in the United States. We are indebted to the numerous institutions which have lent works, chief among them the Munch–museet, City of Oslo Art Collections, Per Bj. Boym, director; and the Nasjonalgalleriet, Tone Skedsmo, director. We are equally indebted to the many individuals who generously agreed to lend works, most notably Harald Sohlberg's daughter Kari Stavnes and other members of the artist's family. All loans have been greatly facilitated by the government of Norway, which has provided a special indemnification for works in the exhibition.

F. Donald Kenney, council member of the National Academy of Design, has been an enthusiastic patron of this project from its beginning. His support for the exhibition, and that provided by the F. Donald Kenney Foundation, have been invaluable and are warmly appreciated.

The National Academy of Design's presentation of Edvard Munch and Harald Sohlberg: Landscapes of the Mind *has been sponsored by Kraft Freia Marabou, a subsidiary of the Philip Morris Companies Inc., continuing their illustrious tradition of cultural patronage. We extend our sincere thanks to Geoffrey Bible, chairman and C.E.O., Philip Morris Companies Inc., and Torstein Bore, managing director, A/S Freia. Andrew Whist, senior vice president, external affairs, Philip Morris Companies Inc., a committed advocate of this project, also deserves our thanks, as do Stephanie French, Karen Brosius, and Jennifer P. Goodale.*

The National Endowment for the Arts has provided additional support for the exhibition, and the American–Scandinavian Foundation has provided important support for the educational programs. We are deeply grateful to both organizations.

Transportation for the exhibition has been generously provided by SAS.

And finally, an exhibition of this scope could not take place without the efforts of many individuals. Foremost among these is Øivind Storm Bjerke, chief curator of the Henie–Onstad Art Center. As exhibition curator and catalogue author, Mr. Storm Bjerke's work has been distinguished by his energy, imagination, and strong sense of purpose. Dita Amory, curator of the National Academy of Design, has worked closely with Mr. Storm Bjerke on every aspect of the project with great skill and dedication. Both have been assisted by many people. Their names appear in the Acknowledgments that follow. To all of them, we extend our most enthusiastic thanks.

Edward P. Gallagher
Director
National Academy of Design

ACKNOWLEDGMENTS

Øivind Storm Bjerke offers special thanks to Ben Frija and John Bjørnebye who have followed the project from its beginning. Thanks also to Nils Messel, Gerd Woll, Arne Eggum, Walfried Brandt, Ken Friedman, Kari Stavnes, and Ragnhild Sohlberg for their assistance in realizing the project.

The National Academy of Design especially wishes to express its gratitude to the following individuals and institutions for their generous assistance with the organization of *Edvard Munch and Harald Sohlberg: Landscapes of the Mind* and this publication. Chief among these are the many individuals and institutions who lent works for the exhibition. Others include:

Torleiv Aaslestad

Johan H. Andresen

A/S Freia, Oslo
 Torstein Bore, Managing Director

Bergen Billedgalleri – Rasmus Meyers Samlinger
 Frode Haverkamp, Director

Kaare Berntsen A/S
 Kaare Berntsen, Jr. Director

Drammen Kunstforening
 Øystein Loge, Curator

Fjøsangersamlingen, Bergen
 Arnljot Strømme Svendsen

Ken Friedman

Gallerie Bellman, Oslo
 Tor Arne Uppstrøm, Director

Gallerie K, Oslo
 Ben Frija

Henie-Onstad Art Center, Høvikodden
 Per Hovdenakk, Director
 Walfried Brandt, Conservation officer

Kraft Freia Marabou, Oslo
 Arne Jurbrandt, Executive Vice President and Area Director

Kraft Jacobs Suchard, Zurich
 Walter Anderau, Vice President, External Affairs Public Relations

Labyrinth Press, Oslo
 Øivind Pedersen

Lillehammer Kunstmuseum
 Svein Olav Hoff, Executive Director

Kathleen Luhrs

Oslo Kommunes Kunstsamlinger, Munch-museet, Stenersenmuseet
 Per Bj. Boym, Director
 Arne Eggum, Chief Curator
 Gerd Woll, Curator of Prints and Drawings
 Gunnar Sørensen, Curator of Stenersenmuseet
 Iris Müller-Westermann, Assistant Curator

Nasjonalgalleriet, Oslo
 Tone Skedsmo, Director
 Nils Messel, Chief Curator
 Marit Lange, Curator
 Sidsel Helliesen, Curator of Prints and Drawings

Einar Pettersen

Jan Åke Pettersson, Director of the Art Academy of Oslo

Philip Morris Companies Inc.
 Geoffrey Bible, Chairman and C.E.O.
 Andrew Whist, Senior Vice President, External Affairs
 Stephanie French, Vice President, Corporate Contributions
 and Cultural Programs
 Karen Brosius, Manager, Cultural Programs
 Jennifer P. Goodale, Specialist, Cultural Programs
 K. Richmond Temple, Specialist, External Communications
 Karen E. Zani, Coordinator, Cultural Affairs and Special Programs

Resnicow Schroeder Associates, Inc.
 Frederick C. Schroeder, Executive Vice President
 Julie Zander, Account Supervisor
 Sophie Henderson, Account Executive
 Lisa Cohen, Account Executive

Rogaland Kunstmuseum, Stavanger
 Lau Albrektsen, Chief Curator

Royal Norwegian Consulate General, New York
 Honorable Jan Flatla, Consul General of Norway
 Honorable John Bjørnebye, former Consul General of Norway
 Janis Bjørn Kanavin, Director, Norwegian Information Service
 John Petter Opdahl, Vice Consul General of Norway

Royal Norwegian Ministry of Foreign Affairs
 Geir Grung, Director General
 Eva Bugge, Deputy Director General
 Ellen Høiness, Senior Executive Officer
 Eva Finstad, Counsellor

SAS
 Jan Stenberg, C.E.O.

Ragnhild Sohlberg

Kari Stavnes

Bente Tellefsen

Trondhjems Kunstforening
 Svein Thorud, Curator

Einar Tore Ulving

And warm thanks to the staff of the National Academy of Design who have
participated in the organization, presentation, and promotion of the exhibition
and catalogue, most particularly:

 Dita Amory, Curator
 Betsy Arvidson, Director of Special Events
 Maggie Christ, Director of Finance
 Jonah Ellis, Director of Maintenance
 Anne Jamieson, Development and Membership Associate
 Lucie Kinsolving, Conservator
 Lesley Kurtz, Director of Education
 Heather Lemonedes, Curatorial Assistant
 Frank O'Bremski, Chief of Security
 Souhad Rafey, Registrar
 Sandy Repp, Director of Development
 Heidi Rosenau, Director of Communications and Public Programs
 Larry Spain, Bookstore Manager
 Colin Thomson, Exhibitions Director

INTRODUCTION

This publication accompanies an exhibition of the paintings, drawings, and prints of the Norwegian Symbolists Harald Sohlberg and Edvard Munch and specifically examines the landscape aesthetics that they formulated around the turn of the twentieth century. Internationally recognized in his lifetime, Edvard Munch was the most powerful artist of his generation in Norway and the figure by whom fellow artists measured their own achievements. Harald Sohlberg never publicly acknowledged Munch as his idol. In spite of their stylistic individualism, Munch and Sohlberg developed radical approaches to painting the landscape and stand today as two of northern Symbolism's greatest practitioners.

The essays in this book will interpret landscapes in this exhibition that at first appear to be factual representations of concrete motifs but which actually are imbued with symbolic content. As contemporaries, both artists emerged from an artistic tradition that encouraged Naturalism in painting. This entrenched Naturalism favored the literal transcription of the land and sea. For Sohlberg and Munch, however, nature became a metaphor for interior emotions, and the landscape came to symbolize a state of mind. So taken with the sublime, untrammeled majesty of the Rondane mountains, Harald Sohlberg spent countless icy winter days and evenings sketching their peaks. Not content to be an observer, Sohlberg immersed himself in the mountain scenery, eventually imbuing his imagery with an otherworldly, transcendent spirituality. Munch's figural landscapes became metaphors for his emotionally charged subjects: anxiety, despair, melancholy. His boldly expressive brushstrokes projected his own inner turmoil as much upon nature's elements as upon the figures that inhabit his landscapes. A comparison of painting techniques articulates the artists' differences. Munch's sweeping brushstrokes in an often pulsating palette vividly contrast with Sohlberg's tightly rendered, luminous images, built up in delicate, transparent glazes.

Although Edvard Munch spent several years in Paris and Berlin while Sohlberg generally eschewed contact with the Continent, both artists were deeply attracted to the Norwegian landscape, particularly the fjords around Oslo (then Christiania). This exhibition presents paintings by Munch and Sohlberg painted

in or near the now legendary seaside resort Åsgårdstrand, at the entrance to the Oslo Fjord.

Munch and Sohlberg saw the individual as very much alone in a vast universe. To convey the enormity of the natural world, Sohlberg focused his attention on its overlooked details. What he called "the awesome beauty of detail" became his metaphor for sublime nature. Articulating his own isolation, Munch derived a private language of symbolism that grew from life's often bitter experiences. Both Sohlberg and Munch painted nature filtered through highly individual views, and in the landscape they found symbols to reflect their souls.

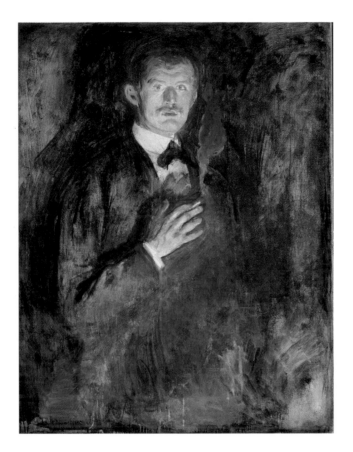

Edvard Munch, *Self-portrait with Cigarette,* 1895. Nasjonalgalleriet, Oslo.

EDVARD MUNCH

The art of Edvard Munch (1863-1944) can be divided into fairly distinct periods. The first period was governed by his association with the Norwegian Naturalists and extended until 1889. The period between 1889 and 1892 marked a shift between Impressionist and Symbolist expression under the influence of French art. The years from 1892 to 1900 form a Symbolist period when he adapted his impressions from a sojourn in Paris and Berlin. The period between 1900 and 1908 was characterized by a pronounced expressive style, powerful use of color, and the breaking down of large shapes and planes. Subsequent to 1908 came a period of work that can broadly be defined as painterly realism. During the 1920s Munch's style became somewhat subdued under the influence of various classicist movements. During the 1930s he worked in a broad and succinct style marked by exposure to the second generation of German Expressionists.

Munch's considerable production can be interpreted from several viewpoints. The literature on him reveals not one Munch but many. His works facilitate categorization. We see a self-centered painter of the soul as well as a proletarian painter.[1] In addition to categories revealing different aspects of the artist, we also find thematic groupings: nudes, landscapes, proletarian subjects, portraits, and studies of models.

As the painter Ludvig Ravensberg noted: "Throughout his life there was something mystifying about Munch. This mystery...had to do with the fact that Munch knew so much without being conscious of knowing it himself and without anyone knowing how he could possibly have acquired this knowledge!"[2] The foundation for this was his background. He later built on this foundation through extensive reading and associating with many of Europe's leading intellectuals. The breadth and magnitude of his work can be seen as the outcome of this cultural heritage.

Munch was born into a family that had achieved intellectual distinction. In addition to one of the most renown Norwegian historians of the nineteenth century, we find priests, poets, and painters among his ancestors. Edvard's father, Christian Munch (1817-1889), was a military physician. He tried, without much success, to develop a private practice alongside his public responsibilities. He

eventually developed a small practice in the poorer neighborhoods of Christiania (Oslo). Edvard's mother, Laura, born Bjølstad (1837-1868), died of tuberculosis after giving birth to five children. Her sister, Karen Bjølstad, took care of the children and became the mainstay of the family. Both of Edvard's parents were deeply religious, but after his wife's death the father's religious ruminations took on a manic-depressive character that at times darkened the atmosphere of the household. Edvard's childhood was marked by the fact that he was often ill. His favorite sister, Sophie, died of tuberculosis in 1877. A younger brother died in 1895. The family followed Edvard's career with great interest and gave him unwavering support. When he eventually was able to earn a good income from the sale of his work, he supported his two sisters and his aunt.

Strongly conscious of his heritage, Munch had a feeling of obligation toward his family. It gave him strength in the face of adversity and compensated for the lack of material wealth. Genteel poverty was a widespread condition for many descendants of the social class of government officials, who lost their position as Norway's ruling class to the bourgeoisie in the course of the nineteenth century. It was the bourgeoisie that Munch opposed from the moment he stepped into the art arena. From an early age he had little respect for the people of this class, and this came to be an asset in his development as an intellectual and an artist.

Munch's talent was evident early on, and it was well nurtured. His first supporter was his admiring Aunt Karen, who made pictures herself out of organic materials which she glued together and sold to supplement the family's modest income. Munch was admitted to the School of Design in Christiania, where he became the star pupil of the drawing teacher and classicist sculptor Julius Middelthun. He was later tutored by Christian Krohg and other contemporary Norwegian artists of the Naturalist school who instantly recognized his talent. Artistically speaking, Munch received solid schooling in Naturalistic painting as it developed in Christiania in the 1880s.

The positive reception Munch received from his older colleagues had its counterpoint in total rejection by the public at large.[3] This did not have a negative effect on the young artist's self-confidence; quite the contrary, Norwegian artists had, to an even greater degree than was the case in the rest of Europe, carved out a role for themselves in which the artist was indisputably the highest authority on the subject of art. All other opinion makers were deemed parasites. The most important critics were one's colleagues. This explains the aloofness with which Munch tolerated negative public criticism. The critics were hardly considered competent to judge a work's artistic value.

Had Munch been obliged to live on the sale of his works to the art buying members of the Christiania bourgeoisie, his development would surely have stagnated quite early. Instead, he received economic assistance from older colleagues who bought his paintings and supported his applications for stipends. In 1884 the painter Frits Thaulow funded his work. The following year Munch received his first government stipend.

In connection with his application for a stipend to study abroad, Munch orga-

nized his first one-man show in 1889. The hullabaloo it caused brought a great wave of visitors, and Munch learned that it was possible to earn an income other than through sales by charging an entrance fee. He later repeated this success with scandalous shows in Christiania in1892 and 1895 and in Berlin in 1892. The Berlin show was followed by a tour to a number of other major German cities. In this way Munch was able to use controversy for economic gain.

When Munch began to turn away from his paternal home during his early twenties, he was drawn into the sphere of influence of the dominating and charismatic political dreamer Hans Jæger (1854-1910). Jæger was the opposite of Munch's father and everything he stood for, personally, politically, and religiously. Edvard's fascination with Jæger caused his father great sorrow. Jæger promulgated an anarchistic message of the right to unrestrained living and the development of the individual's potential with a blind fanaticism that led many weak souls to perdition. Among the words of wisdom he wished to share with young artists was the idea that, aside from "writing their own life," they should abandon family roots in order to "take control of their lives" and finally kill themselves.[3] Jæger became a mentor to the young Munch. Naturalism was the artistic ideal for both literary and artistic expression in the circles surrounding Jæger, but it was a naturalism that did not strive toward an objective rendition of nature. This naturalism meant portraying human reality by adapting personal experience. Private life thus was the raw material for artistic interpretation in Jæger's novels, and Munch's own attempts at literary expression were deeply influenced by the confessional literature that Jæger advocated. Interest was reflected away from the social sphere to the individual's life experience. In the rough draft of a letter from 1926 Munch himself writes that it is a mistake to consider his mature ideas as the fruition of his stay in Berlin from 1892 to 1894 and his exposure to the Continental Symbolist milieu: "My ideas had already matured, and I had been painting 'Life paintings' for many years."[4]

Munch's association with Hans Jæger during the 1880s had drawn him away from his father and his father's Christian faith, but the "mystery" in Munch's art points to his basic reliance on faith: "during all of the formative years of his youth, he lived between these two poles: Christianity of home and the paganism of bohemia. Eventually he grew to become an astute observer of both sides."[5] Munch's work was illuminated by the conviction that there existed a higher order that appeared in different guises thoughout the course of one's life; threatening and oppressive in youth, good fortune and blessings in manhood, mediation between light and dark in old age.[6]

It is doubtful that Munch was ever a convinced atheist. One could say that he was of two minds, drawn between the diverging sets of ideas that flourished at the time. He worked toward a form of syncretism with the idea of God's existence in all things as a fundamental element.[7] Munch formulated his pantheism in such expressions as: "Everything is movement and light: God is in us and we are in God. God is in everything. Everything is in us. In us are whole worlds." [8] The therapeutic aspect of faith is treated in a letter dated about 1937: "Prayer and

21

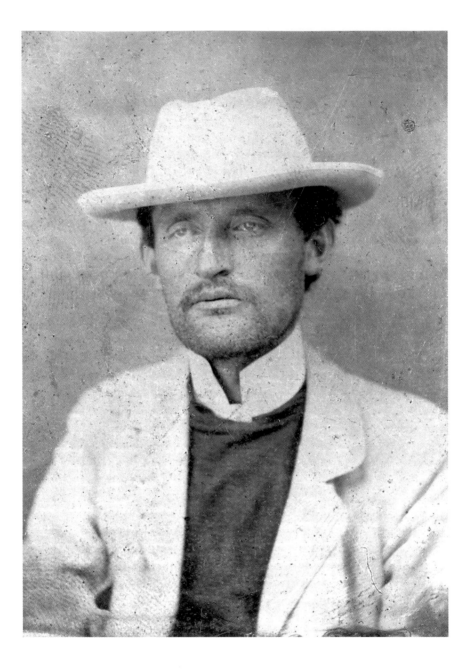

Edvard Munch, ca. 1902.

religious thought – the idea of God, of eternity – take us out of ourselves; unite us with the universe, with the origins of light, with the origins of life, with the world. It soothes, thus does faith make us strong. It allows us to distance ourselves from the body."[9] Munch's renewed interest in mysticism and religion at the close of the 1880s is in line with the general wave of conversions that were taking place at the time.

The role of the artist that Munch adopted has its historical roots in the idea of the artist as a modern Christ: the artist as chosen one, as a healer. This separation from "the others" simultaneously caused him to take on the role of victim. He often called attention to the "wounds" which afflicted him during his life, "wounds" that condemned him to a life filled with anxiety and loneliness.[10] Negatively seen, one could call this a form of narcissism. But this can also be viewed in a positive light in which the artist's exposure of his sorrows and his joys is exemplary, and he treats himself as a research object.

By placing individual experience at the forefront, the work of art and the artist's life early on came to be considered mirror images of each other. Christian Krohg sees it this way when he writes about Munch: "He is an interesting and remarkable person, and has, for that reason, created remarkable and interesting paintings."[11] Since Munch's death, access to personal archives, written reflections, and letters has opened the way for excessive connections to be made in the literature between the artist's comments and his work. The result has been that his own words are perceived as "statements of intention."[12] Quite contrary to the view of Munch as a Symbolist who expresses generally understood ideas, Munch has come to be considered an artist who formulates a symbolism based on his own private experiences. Therefore the issue that arises here is: Does Munch make use of a private, esoteric language, or, quite the opposite, does he speak a generally understood language rooted in archetypal ideas and common existential experience? By leaving his work in the care of an exclusive museum dedicated solely to his own work, Munch cemented the very idea that a person's importance determined the significance of a work. The smallest exhibition in this museum has become a part of the greater whole, which presumably can cast an enlightening sheen over his lifework. The gathering together of his works enhances what has been called the serial quality of Munch's work. The idea thus arose that Munch's work takes on its full meaning when seen in its entirety and proper sequence. It is said that the individual painting has little significance when seen outside the context of his entire production. Each work is a link in a developmental chain and, as such, has value and significance beyond itself. In this context, even an individual piece that appears insignificant on its own becomes important. All of this is ironic when one considers that Munch, to a very large degree, is known more for individual motifs than an oeuvre.

Munch was criticized early in his career for exhibiting pictures that were merely unfinished sketches. His famous *The Sick Child* was characterized as a miscarriage the first time it was exhibited.[13] Later on, he cultivated the expressive use of the fragment in paintings that approach the pictograph in appear-

ance. He felt so strongly about the unfinished and indefinite aspect of his works that he always had to have them around him. They acted as inspiration for new works, and when he sold a motif, he often made a copy of it for later use. Munch substantiates the idea that individual works should be seen in light of one another, among other things by creating the *Frieze of Life*. The paintings were exhibited for the first time in 1902 under the title *Portrayal of a Number of Paintings of Life*. This compilation portrayed in part the fundamental instincts of humans and in part life in its different stages. A landscape background with a marked horizontal orientation was the binding element. What makes up the *Frieze of Life* has become somewhat flexible in Munch research. With time, interest in the frieze concept grew to such an extent that the limits delineating which paintings could be related to it became more and more unclear. This uncertainty with respect to the frieze reflects the artist's predilection for treating details as fragments that point toward the larger whole and are thus totally in keeping with the basic theme of the interplay between the fragment and the whole in his lifework. Munch also completed three decorative friezes using the same themes.[14]

Krohg objected to the aspect of the fragment in Munch's paintings when he wrote that:

> *They are never quite finished; not finished by his hand. They are as he is; when he has achieved something that he has sought after, he is so afraid of losing the very least bit of this precious thing that he doesn't dare go on for fear of destroying what he has attained. He harbors an almost abnormal reverence for his talent and a mother's affection for the seeds of his spirit, so that he doesn't dare expose them to the least germs.[15]*

The Naturalist Krohg had no patience for the implications of the Romantic tradition of representing the whole through fragments; the infinite symbolized by the finite. In Munch this concept is stretched so far that it also embraces painting as a technical process: the line separating the sketch from the finished work is unclear. With the introduction of the concept of the frieze with respect to the *Frieze of Life*, he also ties the individual work to the theme of a group of works in which the boundaries between individual works are erased. A picture that was started had no definite end, and he often made additions to his works after intervals of many years. Such reworking is a natural part of the continuous interpreting and reinterpreting of a work that takes place in the mind of the artist. In accordance with his openminded aesthetics, he was fascinated by the accidental element of the creative process. When he left his paintings outdoors, considering what happened to them as a part of the work, it was an expression of a process-oriented way of thinking. Munch may have borrowed the idea about the role that coincidence played in art from August Strindberg (1849-1912) with

whom he had close contact in Berlin in 1892 and 1893, and later in Paris during the spring of 1896. In 1894 Strindberg published an article on "The Role of Coincidence in Artistic Creation."[16]

During the spring of 1889, Munch wrote reflections on his life and his art that have since been used in the literature about him as though they were manifesto-like writings. The notes have been interpreted as representing a break with the Naturalist aesthetic and as a transition leading to Symbolism. These reflections appear in different forms, but they could have been intended as fragments of a literary work where Munch, in the bohemian spirit, "writes his life." In the best known of these – often called "Munch's manifesto" – the artist visits a public hall that advertises Spanish dancers as entertainment:

> *The music and the colors captured my thoughts. They follow the graceful clouds and are carried by the soft notes into a world of joyful, light dreaming.*
> *I had to do something – it felt as though it would be so easy – it would take shape under my hands as though by magic.*
> *Then they would see.*
> *A strong naked arm – a swarthy, broad neck – up against the raised chest a young woman lays her head.*
> *She closes her eyes and listens with an open, vibrant mouth, to the words that he whispers into her long, flowing hair.*
> *I would create it just as I saw it now in the blue haze.*
> *These two in the exact moment that they are no longer themselves but merely one of the thousands of links of kinship that connect generation to generation.*
> *People must understand the sanctity and the might of it, and they should take off their hats to it, as they do in church.*
> *I would paint a whole series of such pictures.*
> *One should no longer paint interiors, with people reading or women knitting.*
> *One should paint people that were alive; that breathed and had emotions, that suffered and loved.*
> *I felt that I could do this – that it would be so easy. The flesh would take shape and the colors come alive.[17]*

The music stops and the artist is left sadly alone. He goes out onto the boulevard "with a thousand faces of strangers who look so ghostlike in the electric light."

These words can probably be taken literally. The artist exclaims that there will be no more pictures such as those showing women knitting – motifs that have hitherto been prominent in his art and the art of his friends. The notes contain nothing more than a desire to move on to a new iconography, an iconography of ideas that eventually would come together in what he called the *Frieze of Life*. Nothing fundamentally new emerges here with respect to shaping the

motif. In the following years Munch shifted between Naturalism and Synthetism as his preferred style.

The Norwegian Symbolist poet Sigbjørn Obstfelder (1866-1900) was of the opinion that Munch "does not have that type of imagination that, out of itself, creates new worlds, new combinations or epics. He possesses a reproductive imagination. He is receptive. His merit lies in that he is able to feel intense passion under the impact of life. He does not recreate it."[18] Judging from this observation by one of Norway's foremost Symbolist poets, Munch realized the program that Jæger and Krohg had laid down for naturalistic art.

The art historian Jens Thiis, Munch's close friend and supporter, drew a picture of the dialectical relationship between Naturalism and Symbolism in Munch's art. He claimed that while Munch's art sprang from Naturalism, its essence was rather "the secret enemy of naturalism." According to Thiis, Munch's work approached the edge of mysticism. Not until 1907 was Munch once again occupied with "the study of reality."[19] Thiis grouped Munch's paintings into three main themes: "Illness, desire, night. Behind them all lurks the scream of angst."[20]

While criticism of Munch's early work mainly concerned form, the ideational content became a barrier to the acknowledgment of his older colleagues during the 1890s. He became instead the comfort and hope of the younger generation. This partially explains why Munch's breakthrough in Norway did not occur until 1909, when the generation that had grown up with him began to achieve powerful positions in society and cultural life.

Some have claimed that Munch's symbolism does not encompass the nationalist overtones that marked the work of his contemporary Nordic colleagues. Rather, they assert that his art is marked to a stronger degree by an international Symbolism which gave him his pictorial repertoire. It is nevertheless impossible to overlook the characteristic overtones that – if not national or Norwegian – are related to the concept of a Nordic cultural sphere (and that includes everything located north of the Alps). These overtones reveal Munch's attachment to Christiania and his strong bonds to diverse Scandinavian artistic and intellectual circles. A wave of "Nordic enthusiasm" swept across Europe during those years with authors like Henrik Ibsen, Bjørnstjerne Bjørnson, and August Strindberg as the best known personalities carrying a number of lesser known names in their wake.

Research on Munch has pinpointed a number of possible influences from specific paintings of French, Belgian, and German Symbolism. If we add this to influences that Munch absorbed from his extensive reading from the classics to contemporary works, then this suggests an almost infinite number of possible influences on his work.[21] All of these essentially apply to iconography. They also involve to a minor degree Munch's stylistic development. Even so, it is possible to trace different influences on aspects of his art in any number of connections. References in his art to the total contemporary situation are so numerous that they could almost in themselves constitute a catalogue of the most impor-

tant artistic trends of the 1880s and 1890s in French as well as German and Scandinavian cultural domains.

The interpretation of Munch's work does not end with categorizing subjects (in the light of references from art history or personal history), transposing them into generally accepted symbols. Interpretation encompasses the work as an object. Munch treated both the pictorial field and the picture plane with a critical eye. This led him to a series of paintings in his first period in which he chose eccentric formats.[22] Giving a subject a format that intensified the impact of the painting would later become an essential component of his repertoire, and this was the case with his many large, full-figure portraits as well as the more closely cropped formats he used for intimate scenes.

Munch developed various compositional formulas that are found throughout his oeuvre. These include typologies, such as the woman who leans forward with her hands behind her back as a symbol of the feminine; the pyramidal groups of women in white in contrast to rows of men in black; the contrast between frontal and profile perspectives as well as standing figures in contrast to lying figures.[23] There is disagreement about whether Munch developed these formulas through analytical deduction or whether he made use of them intuitively. Regardless, the goal was to have a formula at hand which functioned as a peg on which to hang spontaneous impulses. These formulas all convey meaning. The most obvious in this sense is his use of frontal perspective, which can be seen as a signal that conveys solemnity or a hallowed atmosphere. In Munch's case, it has also been interpreted as an expression of the artist's personality traits and his desire to face the world head on. The frontal perspective is thus an outcome of his penetrating view of reality and of a fundamental honesty when standing face to face with the world.[24] Frontal perspective in this particular sense stems from the aesthetic demand for integrity found in Naturalism. We see this trait most clearly in a number of portraits and also when Munch inserts figures in the foreground of a landscape or a room. Arne Eggum, the leading Norwegian Munch scholar, draws a parallel with the theater in which contact between stage and theater hall is made by creating a psychological space in the physical space between the actor and the audience. In Munch's paintings this is the space between the viewer and the picture plane. What the central subject sees in his mind's eye is projected onto the picture plane – in the background.[25]

In Munch's works, the figure and its surroundings are treated as one. Meyer Schapiro notes that: "It is clear that the picture field has local properties that affect our sense of the signs. These are most obvious in the difference of expressive quality between broad and narrow, upper and lower, left and right, central and peripheral, the corners and the rest of the space." Schapiro makes use of the example of how "the isolated figure is characterized in part by its place in the field. When stationed in the middle it has another quality for us than when set at the side, even if balanced then by a small detail that adds weight to the larger void. A visual tension remains, and the figure appears anomalous, displaced, even spiritually strained; yet this appearance may be a deliberately sought

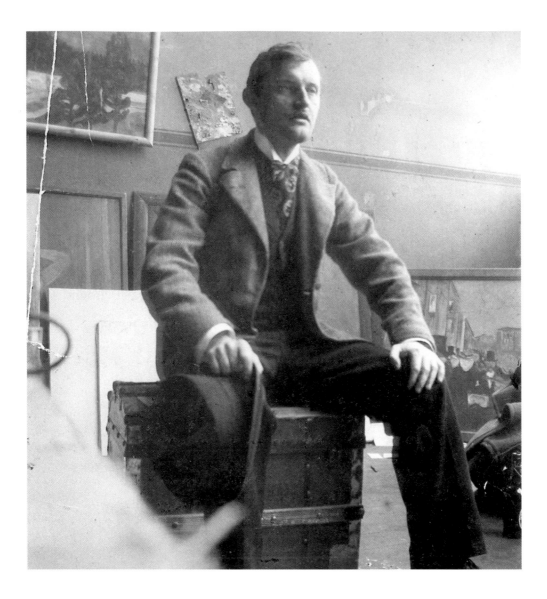

Edvard Munch in Berlin, 1902.

expression as in a portrait by Munch in which the introverted subject stands a little to the side in an empty space."[26]

Munch's treatment of color invites interpretation as well. He allowed color to flow; he scraped it and left whole areas of a picture unpainted; he diluted color and sprayed it all over the canvas with a fixative sprayer. Sigbjørn Obstfelder described Munch's intuitive treatment of color as a stylistic device in 1896 when he wrote that Munch had his own way of letting color "take its own direction."[27]

Munch started experimenting with technique early in his career. He placed Hans Heyerdahl before Krohg as his teacher. Heyerdahl was the leading technical experimenter in Norwegian art, and Munch learned many of his painting techniques from him. Aside from Heyerdahl, Munch pointed to a study by Ferdinand Cormon from the National Gallery of Oslo as the point of departure for his way of painting. There is a striking likeness between Cormon's use of paint and Munch's technique in *The Sick Child*. When Munch encountered international contemporary art, he was quite ready to direct his development to its experimental aspects. His great interest in Jean François Rafaëlli around 1889 can also be explained by this artist's enthusiastic experimentation on the boundry between painting and drawing. This is something that Munch also recognized in Toulouse-Lautrec's work. It is a form of technical experimentation that culminates in Munch's mixed-media pieces in oil and pastel. This interest in experimenting with painting techniques and diverse supports continued throughout his career.

Evening, 1888, is one of the first paintings in which Munch manifests the transition within the Naturalist school from painting motifs bathed in daylight to treating evening and night scenes. The woman in the painting is Munch's aunt, Karen Bjølstad. Painted during the family's summer vacation at Tjøme, she is seen at rest by the roadside. In a letter, Munch's brother refers to the painting under the title *Loneliness*.[28] This title undeniably adds a different dimension to the painting than the prosaic *Evening* and places it instantly within the debate surrounding the transition from Naturalistic mood-landscapes to Symbolism. The title focuses on the woman and her psyche. The position of the figure gives one the immediate association of Romantic landscape painting with a lone figure contemplating nature's magnificence and beauty.

The Munch family rented a cottage in Åsgårdstrand in the summer of 1889. *Evening* (Munch's title), or *Inger at the Seashore*, 1889, shows the view from the beach. The model for the figure was Munch's youngest sister, Inger. *Evening* was shown at the annual state exhibition in Christiania in 1889. The debate it created caused Munch's father to stop his subscription to the conservative newspaper *Aftenposten*, whose critic labeled the painting "the epitome of madness" and accused Munch of being a dilettante given to immature work. The jury made it clear that it had quite a different opinion by giving the painting a prominent place in the exhibition. The painting's most important source of inspiration appears to have been Eilif Peterssen's *Summer Night*, 1886. Peterssen was among the first of the Naturalists who turned into a kind of naturalistic mood-

painter. Munch's paintings have also been shown to have been influenced by Whistler, cloisonnism, and Japonism.[29] Arne Eggum has suggested the British landscape photographer P. H. Emerson as a possible source of inspiration for Eilif Peterssen's painting.[30] What Munch borrowed from Peterssen was the composition, using the raised horizon and large shapes in the foreground to create a powerful repoussoir effect. The moon reflected in the water in the background is not only found in Peterssen during this period. For Munch it became an almost standard element in his landscapes from Åsgårdstrand.

Night in St. Cloud has been viewed in connection with Munch's grief over the death of his father in December of 1889. Munch stayed at the time in Paris, and the loss of his father elicited an acute feeling of isolation. Together with his father, the father image – reincarnated in Jæger and Krohg – also died, marking the beginning of a liberation from "his biological, intellectual, religious and artistic past."[31]

Munch was obviously capable of maintaining a facade of calm and control while remaining open to immediate and violent emotions. After his father's death, he writes letters home that are filled with concern for the family and reassurances that all is well with him. At the same time he writes diary entries and makes drawings that show he is overwhelmed by the thought of death. For example, the lamp he lights casts an enormous shadow on the wall, and in the mirror over the fireplace he sees "the face of my own ghost." In preparatory sketches for *Night in St. Cloud*, we see a figure sitting slumped on a couch from which an enormous shadow emanates: the dark side of the soul. The balance between light and dark is more than a formal element of the picture. It has symbolic significance.[32] In this double quality of his nature, Munch evinces a formidable talent for visualization that perhaps also functioned as a means of bringing him out of his despair. In considering his work from this period as a whole, one finds only a few pieces that express anything other than a light and relatively satisfied mental state.

The first one to write about this painting was the standardbearer of Symbolism in Norway, the poet Vilhelm Krag (1871-1933). Krag published a lengthy Symbolist poem, written in the first person, about a man who sits in silent contemplation waiting for night to descend. He compares the night to a mighty Satan who tries to seduce him with his song. Satan tempts him with the golden treasures of the world and seductive women but not the woman he desires. He then kills Satan and greets the new day rejoicing. Night returns once more, and the woman he longs for marries another. The light over the river is the blood of Satan, and up out of the dark, up from the sea, Satan rises to renewed life. High above it all is a single star which looks down upon the man: it is "my mother's eye./ And she is with God. / And by my side – Satan sits – ..."[33]

The story that is told here is actually about Munch himself. It describes the split he experienced between his religious upbringing and the ideas of his atheist bohemian friends, as well as his disappointment in love. As a twenty-year-old, Munch had had a love affair with a married woman who eventually left him

for another lover. His paintings treating the themes of *The Voice, Separation,* and *The Kiss* are all related to this unhappy affair.

In contrast to Krag's Symbolist interpretation, Jens Thiis gives a sober description of *Night in St. Cloud*: "A hapless dreamer and melancholic, who, glancing dejectedly at the flowing stream, follows a little 'hirondelle' lantern that glides by. One thought that Hans Jæger was the model... but the face was not right. It was the young Danish-Jewish poet Emanuel Goldstein..."[34]

It has been said that his association with the Danish poet Emanuel Goldstein was decisive for Munch's development toward Symbolism. Goldstein wrote Symbolist poems with strong erotic undertones. These poems were inspired by an unhappy relationship and dealt in depth with the theoretical side of Symbolism which Goldstein conveyed to Munch: "...an artistic tendency in which the artist imposes his dominion onto reality, so that it is his servant, not vice versa. Symbolism is the art that values moods and thoughts over all else, and uses reality only as a symbol... No longer should a visual presentation of conventional reality be given, but rather a visual presentation of what lives in the mind... The reality thus depicted will be solely symbols of thoughts and feelings."[35] Munch formulated it in his own way: "Nature is formed in the image of one's mood."[36] His remark can be conceived as an interpretation of the ideas of the Danish art historian Julius Lange about "the art of reminiscing," and *Night in St. Cloud* can be thought of as a demonstration of what lies in that formulation.[37] The interior, the figure, and the landscape outside the window reflect and are shaped by the artist's mood. They have no place on the picture plane as representatives of anything outside of the artist, who rests in himself. The man who sits in contemplation is thus a symbol of Munch himself (as Krag clearly saw him), and the painting is viewed in the light of the shock that Munch experienced when told of his father's death. It is also about this time that Munch began to write drafts of an artistic credo that has been interpreted as his Symbolist manifesto.

Portrait painting became a cornerstone of Munch's art. It was closely tied to his general interest in the human being, both in physiognomy and psyche. He himself referred to his portraits of standing figures as "the bodyguards of my art" and always included one or more of them in his exhibitions. Munch established the genre as one of the main themes of his work during the mid-1880s. The genre had deep roots in European art and was given new life by Manet during the 1800s. The large format was favored by John Singer Sargent and Giovanni Boldini in their full-figure portrayals of European and American aristocrats. We also find it used by Léon Bonnat, who was Munch's teacher in the fall of 1889. In Norwegian art, the tradition was carried on by Christian Krohg, who attracted attention at the state exhibition of 1883 with a full-figure, life-size portrait of the country's radical prime minister Johan Sverdrup. The artist placed a stool with a glass of water on it in front of the painting in order to emphasize its Naturalist expression. In Norwegian painting of the 1880s, artists competed by experimenting with picture format. Together with his friend Kalle Løchen, Munch made the genre his specialty, and it appears that the two artists vied in portray-

ing members of their bohemian circle in full-figure portraits. Munch soon exchanged the bohemians for a wealthier class of industrial magnates and capitalists.

The 1892 portrait of the attorney Ludvig Meyer (1861-1938) was perceived as both a caricature and a striking likeness. Meyer was known as a political radical and as a prominent speculator in real estate. Munch himself claimed that he took the initiative to paint Meyer because he was interested in him as a personality. "I thus painted the attorney to my own satisfaction, but to Mr. Meyer's great dissatisfaction – even sadness. The portrait had unfortunately captured an expression that caused him great pain."[38] If one interprets the picture as a caricature, then the portrait discloses him as a pompous decadent who is incapable of living up to the role he created for himself as an authoritative spokesman and revolutionary. Henrik Ibsen is said to have been amused by the fact that Munch portrayed Meyer in caricature against a red background. He is portrayed standing with his feet apart and his arms hanging limp by his sides. In his left hand he is holding a whip and in his right a top hat that gives the impression of being several sizes too large. The figure is standing full-face, which would normally give an impression of strength, but the effect is negated because the head leans toward one shoulder giving the impression of total powerlessness. Seen from above, Meyer stands as though lost in the great open space surrounding him. The portrait demonstrates Munch's consummate treatment of perspective, with the figure placed in relationship to the format in order to emphasize a psychological aspect of the subject.

After the turn of the century, landscape became an increasingly independent element in Munch's portraits. The figures are often worked into a decorative whole with a flexible transition between the figure and its surroundings. This applies not least to a number of portraits of men and one of a woman, Ida Dorothea Roede, painted in Kragerø in 1909-1910. At this time he also worked on the first sketches of what would become the wall decoration for the University auditorium in Christiania.

While contemporary Symbolists supplemented their paintings and exhibitions with programmatic statements, Munch remained silent in public about his art until long after Symbolism had died out as a movement. It is true that he wrote journal-like entries that seem to have been a form of introspection with a therapeutic function, but he did not publish these notes. It was not until much later that he began to put forth a comprehensive body of writings that disclosed the keys to interpreting his paintings. This may be an indication that as a young man Munch did not feel the need to attach his own meaning to his works. He allowed them to remain open to whatever interpretations were forthcoming. Such openness is evident in the fact that he often changed the title of a painting and also adopted titles that others gave to them. The most telling example has to do with his best-known subject, *The Scream*. The theme is found in two paintings, two pastels, and a print.[39] The most significant of the paintings hangs in the National Gallery in Oslo, executed in a combined technique of oil and pastel.

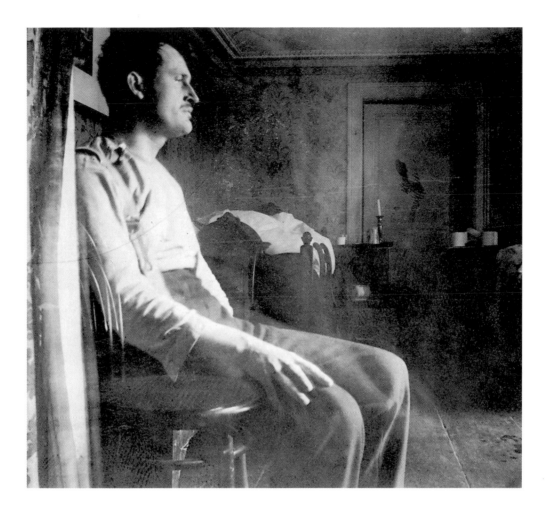

Edvard Munch, photographic self-portrait.

The title *The Scream* has become the main basis for interpreting the painting, but the title alone is a narrow frame of reference. Using this title as the main basis for interpretation raises the risk of transforming the painting from an open, Symbolist work to an emblem symbolizing the act of screaming. In his article on Munch from 1896, Sigbjørn Obstfelder calls the artist a "poet in color"; he sees "grief and screams and brooding and decay in color." Obstfelder criticizes the use of titles for Munch's paintings: "He has paintings that much like symphonies do not need and should not have a title. There should never have been a title for the painting *The Scream*. This term from the world of sound serves only to bungle things."[40]

The picture plane of *The Scream* is divided into three distinct areas: the sky in the background, which is dynamic; the sea of the middle ground, marked by calm; and the bridge in the foreground with its abrupt perspective and its powerful feeling. At the same time we gaze down into an empty, gaping void to the right of the bridge. Two figures at the far left stroll calmly while the figure swaying in the foreground clenches its head. The figure confronting us is the one with whom we are intended to identify. This identification is acheived through the artist's projecting onto the picture plane the figure's experience of the surrounding landscape. We participate in this experience, not by observing the same landscape but rather by having the figure's experience and emotional perception projected onto the picture plane. It is the same technique used in the art of the Middle Ages, and it remains common in Western art right up to Gauguin's *Jacob's Struggle with the Angel*. *The Scream* is a picture of a state of being. It cannot be divided into a dichotomy between the external and the internal; rather it joins the external and internal into a qualitatively new whole – the symbol – which is neither the one nor the other, but the totality of them. Munch's *The Scream* is thus more a deconstruction of the scream than a pictogram that illustrates a person screaming.

We have proof of Munch's reflections about the problem of expressing his intentions with the painting: "For a long time he had wanted to paint the memory of a sunset. Red as blood. No, it was coagulated blood. But not one person would see it the way he had. Everyone would think of clouds. He talked until he became sad about this realization which gripped him with fear. Sad, because the pitiful techniques of painting would never suffice."[41] Munch found out later that the solution lay in "painting the Clouds as Blood,"[42] that is, by deviating from a naturalistic rendition and painting them as they were colored by his own mood. With these reflections, Munch elevates the art of painting to a level of discourse about the reciprocal relationship of art forms. And by means of painting, he enters into the then current debate over synesthesia, the analogy of the senses.[43]

The bloody sky in *The Scream* and other works of the same period are a Symbolist cliché that originated in Baudelaire's "La Fontaine de Sang" from *Les Fleurs du Mal*. Under Baudelaire's influence it spread from poetry to painting. Blood has a metaphysical connotation in *Thus Spoke Zarathustra*, where Nietzsche

discusses writing with blood and in which "blood is spirit." Hans Jæger claimed in 1886 that his novel about the Christiania bohemian scene was "written with the warm blood of humans." Munch's acquaintance from Berlin Adolf Paul described the main character of his 1891 novel, *A Book about a Man*, as enveloped in a blood-red fog.

The Scream got its title from Stanislaw Przybyszewski's 1894 book about the painter. His reference is from a note that Munch wrote on a sketch dated Nice, January 22, 1892, for the painting *Despair*: "I was walking along the road with two friends. The sun was setting. I felt a wave of sadness. The sky suddenly became blood red. I stopped, leaned against the gate tired to death, when suddenly the clouds flamed like blood and swords; the fjord and the town were blue-black. My friends walked on; I stood there shaking with anxiety, and I felt an enormous, infinite scream running through nature." One must keep in mind that Munch was referring to another, earlier painting which is entitled *Mood at Sundown*. Przybyszewski described the landscape as a "correlate to the naked impression; every single vibration of the highly exposed, ecstatically painful nerves, is transformed into a corresponding color sensation." Franz Servaes claimed that Munch's "artistic goal seems to be a pictoral phenomenology of the soul." Nature is the great mystery for Munch, "just as it was for the ancient creators of myths; filled with the breath of secretive life and of unfathomable mystery. He sees the majestic work of the spirits, where others see only lifelessness, and inanimate matter."[44]

August Strindberg presented his own interpretation of *The Scream*: "A scream of fear just as nature, turning red from wrath, prepares to speak before the storm and the thunder, to the bewildered little creatures, who, without resembling them in the least, imagine themselves to be gods."[45]

George Wingfield Digby launched in 1955 a psychological interpretation. He confines his interpretation primarily to the graphic print, in which several of the details that he claims exist in the painting are more clearly visible. In the sky formation in the background, he sees a glaring eye: God's eye, the father's eye, the eye representing stern, all-seeing omnipotence of the super-ego. He identifies the figure in the foreground as a woman who blocks the way of the artist. It is "The Terrible Mother" who obstructs passage to the safe harbor for which the artist longs.[46] For Munch, the picture expresses the loss of the mother and the resulting anxiety that it caused: In his childhood he had always felt that he had been treated unjustly, having no mother and with the constant threat of punishment and hell hanging over him.[47] Munch was cut off from his mother at the age of five. He used memories of her as the inspiration for several works. In a number of these paintings he himself appears as a child. In order to be in touch with his mother, Munch must revert to being a child. The screaming figure in the foreground of the picture resembles the foreground figure of another, later work, *The Empty Cross*. It is a world of chaos where hordes of humans fall off a cliff into a body of water while others pray to an empty cross. There stands "amidst the chaos...a monk who stares helplessly with the child's/ horrified eyes

at all this/ and cries why, why/..."[48] The monk is obviously a personification of the artist himself, who functions as a witness to the folly of mankind. The monk stares directly at the viewer as though attempting to convey what he has seen. What he has seen lies behind him, projected on the picture plane just as in many of Munch's works of the 1890s. It is interesting to note "the child's horrified eyes"; here is the look of the untainted; the innocent's view of the world is, in effect, Munch's view.

Frederic Jameson sees *The Scream* as "a canonical expression of the great modernist thematics of alienation, anomie, solitude, social fragmentation, and isolation, a virtually programmatic emblem of what used to be called the age of anxiety."[49] Jameson uses the painting to illustrate the deconstruction of the aesthetics of expression. The idea of expression presupposes a division inside the subject and with it a metaphysics of the external and the internal – the pain within the monad, and the instant when this is projected out and externalized. Munch depicts this instant as a scream, the external dramatization of an internal feeling. *The Scream* "...disconnects its own aesthetic of expression, all the while remaining imprisoned within it. Its gestural content already underscores its own failure, since the realm of the sonorous, the cry, the raw vibrations of the human throat, are incompatible with its medium; something underscored within the work by the homunculus's lack of ears."[50]

Some of these diverging interpretations are more reasonable than others, but even the most unreasonable can contain interesting observations about the painting. These interpretations tend to squeeze their way between the viewer and the picture, but instead of experiencing them as intrusions, one can see them as a many-colored glass through which the painting is viewed. They also bring into focus the issue of whether it is at all possible to view the painting in the way that the artist originally intended.

Madonna is another painting that has had several titles and interpretations. The painting was originally shown under the title "Woman Making Love," in 1893 under the title "Das Madonna-gesicht," and in 1895 as *Madonna*. The motif dates back to a painting from 1886 that Munch gave to Hans Jæger who described it as an unfinished painting of a woman with dark hair hanging over one shoulder, leaning back on a bed, naked to the hips, with her hands under her head and her elbows out to the sides.[51] The *Madonna* exists in five variants, all dating from the period 1893 to 1895.[52]

Munch discussed the theme in his diary both before and after his stay in Berlin. In an early entry from the fall of 1885, he wrote about the subject in connection with visits from his lover Millie Thaulow: "There is something holy in your face, lying there under the lamp of moonlight. Your hair is brushed away from your clean forehead. You have the profile of a Madonna. Your lips part as though in pain and I ask in fear if you are grieved, but you whisper softly – I love you – ."[53]

This Naturalistic account is later adapted into the Symbolist text: "The Moonlight glides over Your Face which is full of Earthly Beauty and Pain Since now it

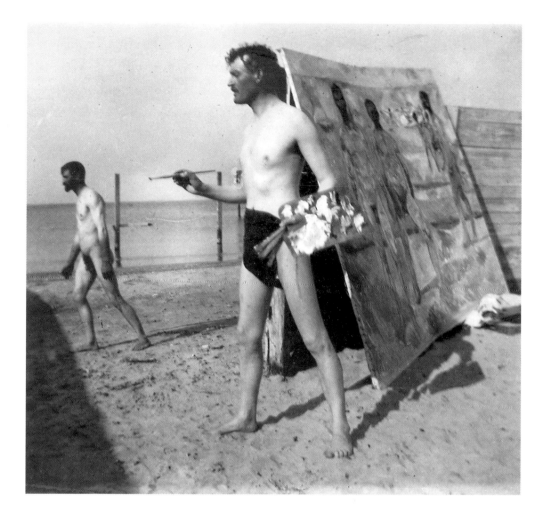

Edvard Munch on the beach at Warnemünde, summer of 1907.

is Death that offers you its hand and thus the circle is closed between the thousands of ancestors that are deceased and the thousands of descendants that are to come."[54] In later adaptations of the text, Munch adds the observation that the woman's smile resembles the smile of a "corpse."[55] It is natural to view the shift in meaning from one text version to another, from ideas about a man and woman to life and death themes that were current in the circles that Munch frequented in Berlin. These ideas are expressed in the early interpretations of the painting in *Das Werk des Edvard Munch*, 1894. There Franz Servaes saw in the picture a woman in the throes of ecstasy at the very instant before she gives in to it. This ecstasy imbues her with supernatural beauty. In the same publication, Przybyszewski described the subject as a symbol of woman's subjugation. Strindberg interpreted her, in light of his hatred of women, as exercising that which gives woman her right to existence, her status as a sexual object for men. In accordance with that view, he gave it the title *Conception*.[56] Jens Thiis, with his positive view of women, interpreted the painting as "the symbol of conception with the halo of pain around love's countenance."[57] Sigbjørn Obstfelder declared in a lecture about the painting at the Student Union on November 9, 1895: "...it is an earthly Madonna; a woman who gives birth in pain."[58]

Arne Eggum sums up the different interpretations of the *Madonna* when he claims that the painting reflects the artist's diverse personal experiences -- from his relationship to Millie Thaulow, his relationship to the liberated woman in the person of Dagny Juell, to his painful memory of the very first woman in his life, his mother.[59] Eggum claims to recognize the mother's features in the face of the Madonna, and he reminds us more than once that Munch attempted to reproduce his mother's features in drawings pertaining to childhood memories. Eggum ties the painting to the death theme by pointing to the moon behind the head as a possible symbol for the moon goddess Ishtar, a semitic goddess of fertility and death.[60]

The theme of fertility in *Madonna* is emphasized in the graphic version, where spermatozoa and an embryo are depicted on the frame. In the drawing *Madonna in the Churchyard*, the theme shifts to life and death. Eggum views the drawing as an expression of the artist's wrath at having been born without giving his consent. The woman represents the artist's mother who has laid a wreath by the family grave; a skeleton plays the role of Cupid with his bow and arrow in the lower left corner. The skeleton has the same position on the picture plane where Munch earlier had placed the embryo in *Madonna*. The skeleton aims one arrow at the woman and another arrow at a person whose back is to the mother. Above the halo, we see a dark shape that can be construed as the outline of the back of a head turned away from the family grave.[61] An alternative interpretation disregards possible autobiographical references and denies that it is a halo around the head of the woman, but rather a strange hat that resembles a halo. The man behind her back thereby vanishes and the arrow of death no longer points to anyone. The skeleton still sits in the lower left of the picture, traditionally perceived as the negative side, where a little forsaken dark

gravestone is also situated. The right side, or the positive side, has a white grave-stone with a wreath: someone has remembered the dead. The woman in the center is situated between these two worlds and connects life and death. She is herself marked by death, symbolized by the leaf falling from the tree to the left, a symbol which is repeated in the design of her dress. If one interprets the woman in light of her resemblance to the woman making love in *Madonna* and the other paintings where the same female face appears, she could be viewed symbolically as a woman who chose chastity instead of procreation and turned her back on life, wandering off among the dead. "She devotes her life to good and to eternity, to purity and chastity, in a resigned renunciation of earthly pleasures. Eros is identical with Thanatos and surrounded by darkness and destruction."[62] As we can deduce from these diverse interpretations, they appear to be in accordance with the spirit of Symbolism and to range from prob-able interpretations to qualified guesses.

Vampire belongs to a group of paintings with this title, which was supplied by Stanislaw Przybyszewski. (Munch's own title in the catalogue of the 1893 exhibition in Berlin, where the work was exhibited as part of the six-painting series *Love*, was *Love and Pain*.) Late in life, Munch described the motif as sim-ply a woman kissing a man on the neck. As is the case with all of his important symbolist works, their vagueness invites the viewer to bring his own interpreta-tion to the work. Is the man trapped in the web of the woman's hair or in the arms she wraps around his head and shoulder, or is he just seeking comfort? Is the shadow a unifying abstract ornament, or is it also the shadow of destiny holding the two in its grip?

The image of the man leaning his head against the woman's neck in *The Wave* belongs to the same thematic group as *Vampire* and *Madonna*. The woman has the same facial features as those of *Madonna* and *Madonna in the Churchyard*. Referring to this theme, Munch added a line to his notes about *Madonna*: "Like a floating body we move out into a great sea on long waves that change color from dark violet to blood red."[63] The union of man and woman in the act of love – the primal source of life – now takes place in the sea. The body of the woman in *Madonna* has a mystical quality that cannot be attributed to anything definite. There is an abstract wave design which takes on the shape of an aura. In keep-ing with the interest in Spiritualism at the time, this concept has a special signif-icance as an element that points toward the universality of life. The shape can also be interpreted more concretely as a symbol for the womb. Woman's most noble task is to perpetuate life. The embryonic water is a reminder to us that all life once originated in the sea. The waves surrounding the woman remind us of another of Munch's motifs, women posed before the sea or surrounded by the sea. He takes a leap to this metaphoric theme with the creation of *Mermaid*, a motif that he develops in both paintings and drawings. A small painting depict-ing a woman in profile against a red background is a detail from the painting *Separation*. The detail is painted in a monochromatic red, a color that is asso-ciated with erotic ecstasy and which connects the Madonna theme to the por-

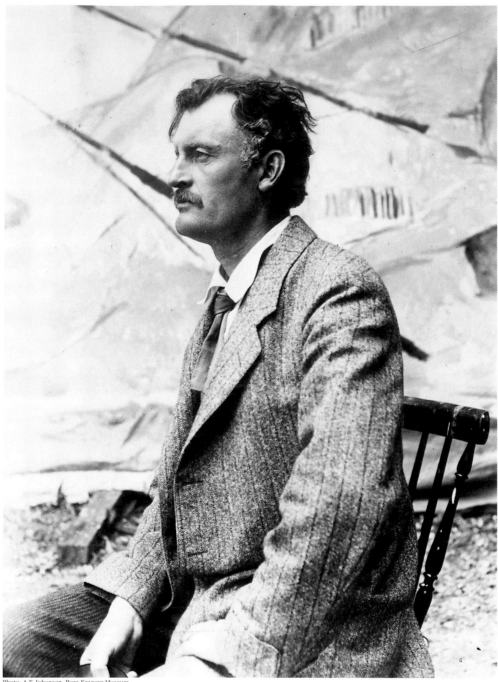

Edvard Munch seated in front of *The Sun*, at Kragerø, 1910.

trayal of a woman against a background of the sea. The first time Munch painted the motif *Separation* was most likely in Berlin in 1893, a painting that has been much damaged and partially painted over. The title he gave the picture was *Separation*. The essence of the theme is the man's feeling of being bound to a woman who has abandoned him. This is symbolized by the hair that entwines him and takes root in his heart. He later developed the theme in Paris in 1896-1897. In this later version he approaches his most ornamental and synthetic expression. The forms in the picture are similar to those he used in his graphic work of the same period. The blood flower can be seen as a symbol of the blood of the artist's own heart, with which according to Jæger's dictum, he should write his life. Munch was a man who was constantly "wounded" – by the loss of his mother, sister, father, close friends, and lovers. The wounds left by these losses nourished his artistic talent. The theme is related to a scene Munch writes about in 1889 when bidding farewell to the woman he loves who is leaving him to marry a friend of his: "We looked at each other for a while – without saying anything. He had the feeling during this interval that his life's greatest happiness was slipping away from him. The tears welled up in his eyes. He turned his head away."[64]

Seen in light of this journal entry, *Separation* is not about breaking away, which implies liberation, but rather about a bond that cannot be severed. The artist grieves at seeing the woman he loves leave him for another man. This recalls his first love, who also ended the relationship because of another man. It became a pattern in Munch's relationships with women. He learned from experience to refrain from emotional involvement from the very start, as a defense against being hurt. Munch's reluctance to get involved with a woman can also be seen from another point of view. He reached manhood at a time when the institution of marriage was in question in Norway, and he supposedly swore never to marry. There could have been two reasons for this decision. It would have hindered his work to have a family, and he believed himself to carry poor genes. When he became engaged in 1897, he instantly perceived it as an encroachment on his integrity. He attempted a number of times to escape the engagement, which darkened his existence for many years.

For Munch, the ideal relationship between man and woman was the sibling relationship. Reinhold Heller says of *The Dance of Life*: "They danced the dance of sister and brother that Munch wished for."[65] This sibling relationship can thus explain the "cloister-like" quality of the two figures. A simpler explanation is that Munch, as in *The Empty Cross* from the same period, puns on his own name and represents himself as a monk. Other interpretations are based on his first love and his memory of dancing with her on the beach. Another woman enters from the left and tries to take the flower of love, but she cannot have it, for it is already promised to another. To the right of the painting she is dressed in mourning; she has been rejected, in the same way that Munch was rejected by his first love.[66] Munch himself writes about the theme in 1908: "I who came into the World sick/ into a sick environment/ whose Youth was a hospital room and Life a gloriously

Sunlit Window – with radiant Colors and radiant Joys/ and there/ Outside/ I longed to participate in the Dance/ The Dance of Life."[67] Munch intimates a tension here between a feeling of being closed in by illness and a striving toward health. The lines were written in Copenhagen while he was recovering from a nervous breakdown.

For Munch landscape was the projection of a psychological state and had no significance when separated from his emotional reactions. Simple landscapes made up only a small portion of his production in the 1890s. In his later work, however, this genre is represented abundantly. It seems natural to interpret this in light of the changes in his art toward the acceptance of things as they are and a reconciliation with the idea of the external world as separate from himself.

The *Mystery of the Beach* (1892) is one of the few pure landscape paintings from the period when he was most deeply influenced by Symbolism. The painting has a taut symmetrical composition with a column of moonlight functioning as a vertical axis. The elements of the motif are neatly placed in relationship to this axis. Each holds a place in its respective plane, from the prominent tree stump in the foreground to the high-lying horizon where the point of vision vanishes. Just as in painting a figure, Munch confronts the landscape as it rises in front of him. He gives us a key to interpreting the picture in a note from 1889: "The stars stood upon the shallow water far, far out. They looked like a whole family of sea creatures, large and small, that moved and stretched themselves and made faces, but quietly. You could see a little bit of the moon, yellow and looming."[68] In other notes, he describes stones on the beach that "stood upon the water, mysterious as sea creatures; there were large white heads there that laughed," and he calls the stones "trolls."[69] There is no doubt that this is animated nature, where magic alludes to the human being's intense communion with the surroundings, that can be both idyllic and frightening. Natural forms are described as soft and organic. In a discussion of the painting, the stones in the water are compared to "dismembered whales," and the tree roots, to "giant octopuses with long tentacles placed spread-eagle on land."[70] Two elements predominate in the foreground, the chopped-off tree stump and the stone bearing a clearly drawn facial image. We find this grimacing face in the foreground of a drawing for the painting *Vision*, 1892, and in the ghosts on the wall behind the family that is gathered around the sister's deathbed in a lithograph from 1896. It is the stump, however, more than the stone that gives associations to the death theme. The chopped-off family tree can be seen as Munch himself, who does not carry on the family line.

Munch's winter paintings from Nordstrand (1899-1900) have been viewed as sketches intended to form the landscape background for the *Frieze of Life*. Andreas Aubert wrote that *Winter Sketch*, belongs to

> *the most brilliant work that we have of its kind; because of the intensity of its painterly feeling for nature, because of the originality of its coloristic view, it does not fade when compared to*

*the very best of the impressionists, not even a Claude
Monet...Munch's presentation of nature couldn't be further
from the photographic lens' mechanical reproduction, with its
insipid infinity. His work is the result of a cohesive and unify-
ing psychological analysis undergone in a state of strong men-
tal tension. It is his own impressions of nature that he analyzes,
rather than nature itself. And he has invented a painterly col-
oristic formula to reproduce these impressions as paintings.[71]*

Aubert traced the artistic principles in the painting to Impressionism, and,
according to him, Munch managed in this painting to make both himself and
others conscious of the laws governing physiology (optics). Aubert interpreted
Munch's landscapes as the artist's attempt to construct an objective world view
based on a naturalistic psychology. Pola Gauguin, the son of Paul Gauguin, who
wrote a biography of Munch in 1933, interpreted them as Symbolist landscapes:
"...they too are living nature. Lonely, bitter and cold nature in a death-like
sleep."[72] For Gauguin the Symbolism in Munch's winter landscape accords with
his preoccupation with life-death themes in the main body of his work in the
1890s.

It is common practice to define a radical turning point in Munch's art around
1902 and 1903 when he moved from Symbolism to a freer colorist style reflect-
ing his exploration of a new territory in which Fauvism and German Expression-
ism were the cornerstones. This is a development that culminated in 1908, when
he sought psychiatric help for depression and alcohol abuse. Heller claims to
see a development in Munch's work away from Symbolism already during his
stay in Paris in 1896 and 1897. In his graphic works he "continued to explore the
symbolic presentation of a Monistic philosophy of love and creation, but his
paintings turned almost exclusively to a stylized Naturalism."[73] The claim is
debatable. Stylistically, Munch was then painting the works that are most obvi-
ously tied to the Jugendstil and therefore fall under the categorization "stylized
naturalism," if by naturalism one means representation and not Naturalism as a
movement in painting and literature. The question, however, is not whether
Munch's paintings of this period strive toward a true likeness in their rendition
of nature, but whether he still managed to enliven them with a universal sym-
bolic content that overrides the presentation of the motif. A common thread in
Munch's art from the turn of the century is a preoccupation with the decorative
use of color, line, and the planes of the canvas, a fundamental lyrical attitude,
and a striving toward a monumental style. He turned away from the individual
to greater, enduring, life forces. He pursued a new symbolism tied to light and the
forces of light. Vitality, renewal, and creation replaced passivity and death.

Eggum has linked Munch's art immediately after 1900 to experiments with
contemporary French and German art, and a discussion of Munch's importance
for Fauvism and Expressionism cannot be considered conclusive. If we consider
these movements to be a continuation of certain elements of Symbolism, then

Edvard Munch photographed in his winter studio at Ekely on his 75th birthday, 1938.

Munch must be given his due as one of the founding fathers of Expressionism and one of its most important sources of inspiration.

Munch belongs to a generation that has been difficult to place within the great modernist epoch. This was the generation that emerged after Seurat, Gauguin, and van Gogh and before the Expressionists and the Fauves. It is a generation that does not have a common style but, on the contrary, is known for its manifold expressions: from Vuillard's and Bonnard's "intimism"; Valloton's, Munch's, and Hodler's Synthetism; the naturalism of presentation among certain German and French Symbolists; and the abstract ornamental syle of Art Nouveau and Jugendstil. It is only during short phases in his production that Munch may be identified by a personal style; otherwise he makes use of the stylistic expressions that are available during the period he was active. This absence of a heterogeneous production within one type of expression is also typical for his generation. In Munch's case it has led to his being primarily identified with specific, exceptional works or motifs, more than with a lifework.

If one wishes to grasp a unifying element in Munch's work, it has to be found on another level than that of style. Pola Gauguin points to the vitality of Munch's art as a unifying factor: He "sought after life's primal force, which all classical emotion builds upon. It was natural for him to see right through all civilization and bourgeois social convention; to discover that nature itself, in all its fundamental life functions, had not changed greatly."[74] Gauguin overlooks the fact that Munch's art had gone through several stages that reflect changes in his personality. The artist's lifework mirrors the man's diverse stages of life and the persistent developmental progression from a self-centered, rebellious youth, via the middle-aged man who sought simple pleasures in the quiet company of good friends and harmonious surroundings — to the old man who absented himself from the fuss of everyday life and reconciled himself with the thought of dying. In a number of books and articles Arne Eggum has done an impressive job of making Munch's writings available, correlating them with documented biographical information and artistic works. In addition, he has gone further than anyone in basing his research on the supposition that the work and the artist are one. He claims that Munch, similar to such artists as Félicien Rops, Fernand Khnopff, Jan Toorop, James Ensor, Ferdinand Hodler, and Gustave Moreau strove for a "personal foundation for their art... But none developed such a unique 'private' symbolism with a deliberate use of their own traumatic experiences, as Munch did. He had the courage to soberly display his own life for observation, renouncing all self-pity; a display of temperament that, profoundly speaking, became his life philosophy...In the Jungian sense, he 'crystalized' the archetypal images and symbols for man's deepest emotional experiences."[75] Since these emotional experiences cannot repeat themselves in the different phases of a person's life, it was not possible for Munch to retain the intensity of the first-time experiences of youth. As Munch grew older he became a mediator between the strong disparities that in an earlier age had been an unyielding source of tension in his psychological and emotional life.

NOTES

1. Gerd Woll's writing on Munch's paintings of workers and proletarian life is an example of the wealth of interpretations on the subject. The exhibition and book (see Woll 1993) treat this aspect of Munch's work in a new and convincing manner and make a strong argument for interpreting his work in a larger, social context, rather than focusing on the private and anti-social aspects of his work.

2. Ludvig Ravensberg about Munch, see Munch 1946a, p. 21.

3. Hans Jæger was the leader of the so-called "Christiania Bohemia," a literary and artistic coterie that numbered around thirty or forty persons. The Christiania bohemians presented their own nine commandments for living in their literary organ, *Impressionisten* 8, (1889), most likely written by Jæger. See Jæger 1886/1889. The relationship between Munch and Jæger is treated in Brenna 1976.

4. Malmanger 1987, pp. 47-48.

5. Gierløff in Munch 1946a, p. 66. Christian Gierløff was a close friend of Munch from the turn of the century until the artist's death.

6. Benesch 1963, p. 9.

7. Heller believes that Munch was actually a convinced atheist, but that after his father's death, Munch worked toward a reconciliation with his father's belief in an invisible higher force, but this time on a scientific basis. According to Heller, Munch could accept the idea of immortality based on a combination of the theory of evolution and the idea of the constancy of energy (nothing is lost in nature, matter merely changes form). "Faith in life as life, faith in life as never-ending, became the new secular religion of the times, and Munch happily embraced it." Heller 1984, p. 63. This new belief demanded a universal validity which led Munch back to the monism of his childhood. Another consequence of this newly found monism was that each painting had to be seen as a link in the greater whole. The idea of connecting paintings in a series was a natural outgrowth of monism. "Isolated paintings did not correspond to a world-view in which the essential truth was the harmonic unity of all." Ibid., p. 103.

8. Gierløff 1953, p. 43. Gierløff quotes here from a pamphlet put together during the time Munch lived in Grimsrød.

9. Edvard Munch in a letter to his family, Munch 1949, p. 270.

10. Nergaard 1978, p. 124.

11. Krohg 1989, p. 62.

12. There is good reason to question the legitimacy of such a relationship between assertion and intention. One person who knew him well emphasized that Munch cultivated irony and ambiguity in his social contact with people: "He, the lonely one, found it very relaxing and entertaining to confuse people with his talk. He experienced a spectator's joy at giving others a wrong impression or distorted understanding of himself, his art, his habits, his working methods." Gierløff 1953, pp. 72-73. This man had known Munch for forty years when he wrote this, and his remark should be a warning to take Munch's word with a grain of salt. Even when he expresses his intentions, and we can assume that his wish is to enlighten and not lead astray, they should be interpreted—and they have been interpreted—with the result of being used as evidence for diametrically opposed views. In his autobiographical writings, he expresses himself in the first person, looking back in time. Munch makes observations about himself in earlier periods; he reconstructs and reviews his childhood, at the same time that he projects the current state that he is in back to his childhood.

13. The painting was exhibited at the annual state exhibition in 1886 under the title "Study," which emphasized its unfinished quality. The term "abortion" was Andreas Aubert's in the daily *Kristiania Morgenbladet*, November 9, 1886: "As this study (!) appears now, it is merely a ruined, half-scraped out sketch. He grew tired of it himself during its execution. It is an abortion; one of those that Zola portrayed so well in *L'Oeuvre*.

14. The *Frieze of Life* understood as an inclusive concept is treated in Eggum 1990. In his book, Eggum emphasizes connecting individual motifs to Munch's literary writings and to the artist's life.

15. Krohg, 1989, p. 62.

16. Strindberg: "Du Hasard dans la production artistique," *Revue des Revues*, November 15, 1894. The Swedish translation is: "Nya konstriktningar! eller Slumpen i det konstnörliga skapandet." See Sødertrøm 1989, pp. 47-53, which presents this and other writings by Strindberg on painting and photography. Arne Eggum points out that Munch and Strindberg were "totally in agreement with regards to cultivating the spontaneous expression and appreciating the importance of coincidence during the execution of a work of art. Munch was, in fact, the very first painter to experiment with spraying color directly onto the canvas and allowing it to drip, in order to achieve special effects." Eggum 1983, p. 105.

The interaction between Strindberg and Munch during the 1890s is treated in depth in Dittmann 1982.

17. Gierløff 1953, pp. 72-73, quotes from the memoirs Munch wrote in St. Cloud. Gierløff uses the term "memoirs" when referring to Munch's writings, the term that the artist himself used according to Gierløff. Munch published this in a little pamphlet after a manuscript from 1889. In his commentary to Munch's description of his experience, Gierløff stresses that what spurred Munch to write down his impressions was the sexual tension that arose at the sight of a beautiful woman in an entertainment establishment in the Boulevard des Italiens. Gierløff treats the outcome of the memoir as a characteristic example of how Munch reworked an external impression in dreams, subliminating and transforming the impression into a picture.

18. Obstfelder 1950, 3, p. 291.

19. Thiis 1907, 2, p. 428.

20. Rapetti, in Eggum 1990, p. 149.

21. Rops, Redon, Lautrec, Gauguin, Bernard, Besnard, Sérusier, Delville, Khnopff, Böcklin, Klinger, Thoma, and von Stuck are those most often named. A specialized study that focuses on such influences is Sherman 1976, pp. 243-258.

22. Munch painted his first landscapes in Christiania in 1883. He chose an extremely high vantage point in which the vanishing point is sometimes placed high on the picture plane and the subject is viewed from above. Both Krohg and Werenskiold must have been well acquainted with Caillebotte's art by 1882; for Werenskiold mentions him in an article on Impressionism, and Krohg painted pictures that are similar to Caillebotte's in their perspective. In Norway it was Munch's friend Kalle Løchen who was most radical in his use of extreme cropping and angles. The relationship between Munch and Caillebotte has been treated in Varnedoe and Lee 1976-1977, pp. 149-150, and later by Varnedoe in various other publications.

23. Carl Nordenfalk introduces this theme, see Nordenfalk 1947. Johan H. Langaard develops the theme in part as a polemic against Nordenfalk, see Langaard 1949, pp. 50-56, where he identifies the listed formulas.

24. Thiis 1933, pp. 230-232.

25. Eggum 1984, p. 126.

26. Schapiro 1994, p. 12.

27. Obstfelder 1950, 3, p. 284.

28. Andreas Munch to Edvard Munch, April 12, 1894, in Munch 1949, Letter 152.

29. Dittmann 1982, pp. 47-48. Dittmann views the painting as Munch's first completed Symbolist work and proof that he had been in touch with French Symbolism before his second longer stay in France.

30. Eggum 1987/1989, pp. 42-43.

31. Heller 1984, p. 63.

32. Digby 1955, p. 48, points to Munch's use of an emphasized shadow in this and other paintings of figures and interprets it as a Faustian theme—the human and its shadow or the dark side of life: "His feeling for the symbolic significance of the shadow is remarkably expressed in his portraits. ...The shadow takes part in the self-balancing system of energies which the colours portray."

33. Krag 1930, pp. 18-21.

34. Thiis 1907, p. 176.

35. Goldstein 1892, see Heller 1984, p. 60.

36. Noted in Sketchbook T 127, 1890-1894. Munch-museet.

37. The Danish art historian Julius Lange gave a lecture in entitled "Erindringens kunst" [The Art of Reminiscence], the contents of which were passed on to Norwegian artists by Andreas Aubert. It had a significant influence on both the Naturalists of the 1880s as well as the younger artists of the 1890s. The theme is treated in Malmanger 1985. It was probably due to this debate that Munch began to reminisce. That which he chooses to uncover from the past and to adapt in his paintings are experiences related to death, betrayal in love, angst, and desperation. Nergaard 1978, treats the selectivity of Munch's reminiscences.

38. Eggum 1994, p. 55.

39. Heller 1973b is a thorough monograph on the painting.

40. Obstfelder 1950, p. 284.

41. Skredsvig 1943, p. 152.

42. Krohg 1989, p. 49.

43. This aspect of Munch's work was treated early on in a book by the two poets Maxmillian Dauthenday and Gustav Uddgren. *Verdensaltet. Det nye Sublime i Kunsten,* Copenhagen, 1893.

44. Przybyszewski and Servaes in Przybyszewski 1894.

45. Søderstrøm 1989, pp. 59-61.

46. Digby 1955, p. 38.

47. Stang 1977, p. 31.

48. Hougen 1977.

49. Jameson 1991 treats Munch's *Scream* pp. 11–16.

50. Ibid. p. 14.

51. Jæger 1886.

52. Four of the pictures are very similar and were most likely painted in a short span of time: one in a private Norwegian collection (93 x 75 cm); National Gallery in Oslo (91 x 70.5 cm); Kunsthalle, Hamburg (93 x 75 cm); and Munch Museum, Oslo (136 x 110 cm). In his 1895 exhibition in Oslo, Munch showed three of them, perhaps the three with an almost identical format. The paintings in the Oslo National Gallery and Hamburg are quite similar. They seem to have been painted in a sequence in which the design of the waves in the background was developed through stages; the waves move from the merely suggestive to the strongly articulated, and take on an almost graphic effect in the version in a private Norwegian collection. The picture in the Munch Museum has an atypical color scheme and is more detailed than the other three. In the fifth picture, which is in a Japanese collection (100 x 70 cm), the female figure is drawn with exactitude and partially developed, but the background does not have the characteristic wave designs of the other paintings. It consists rather of an unevenly executed, thin layer of sprayed paint.

53. Eggum 1990, p. 195.

54. Ibid. See also Stang 1982, p. 136.

55. Ibid. p. 196.

56. Søderstrøm 1989, p. 60.

57. Thiis 1933, p. 216.

58. Obstfelder 1950, p. 289.

59. Eggum 1990, p. 197. Eggum discusses the subject in a separate paragraph, pp. 185-203, where Munch's different comments about the painting are also presented.

60. Eggum gives an exhaustive treatment of the death theme in Munch's work in Eggum 1978, pp. 143-183; in the same publication, see pp. 163-164. See also Eggum 1990, p. 198.

61. Eggum 1990, p. 198.

62. Høifødt 1990, pp. 169-170.

63. Eggum 1990, p. 92.

64. Ibid.

65. Heller 1984, p. 173.

66. Høifødt 1990, pp. 166-181.

67. Hougen 1977, pp. 223.

68. Eggum 1990, p. 71. See also Stang 1982, p. 94.

69. Eggum 1990, p. 71.

70. *Aftenposten* Kristiania, September 14, 1892.

71. Aubert in *Morgenbladet* Kristiania, May 8, 1902.

72. Gauguin 1933, p. 145.

73. Heller 1984, p. 163.

74. Gauguin 1933, p. 120.

75. Eggum 1984, p. 10.

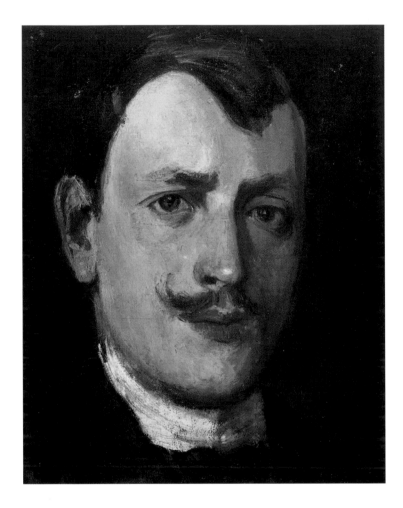

Harald Sohlberg, *Self-portrait,* ca. 1892.

HARALD SOHLBERG

arald Sohlberg (1869-1935) fostered an image of himself as isolated in his private life and as an artist. He referred to himself as a person who viewed the world from a distance. The four walls of his home became a bastion against unfriendly surroundings. While he gave the impression of being reserved and cool to the outside world, he was fun-loving and warm toward his family. Indeed Sohlberg's family was to remain his most important support throughout his life. Colleagues found it difficult to accept him. Many artists thought him snobbish, so Sohlberg sought out other outsiders. The lack of friends among artists contributed to his precarious position in a milieu that was controlled and dominated by the artists themselves.

Unlike Munch, Sohlberg did not come from a family of the old class of government officials. He was the son of a fur trader and a well-to-do farmer's daughter, and he grew up in a small pocket of affluence amidst threatening destitution. He came from a section of Christiania that had once been a respectable neighborhood of craftsmen and traders, but was on the verge of becoming a slum. When he was eighteen, his family moved to an elegant apartment in Victoria Terasse, one of the city's most exclusive addresses at the time.

Letters exchanged between Sohlberg's parents and their children bear witness to a pleasant style of life. There were endless numbers of theater visits, concert evenings, and visits to exhibitions. As a young man Sohlberg's father had traveled throughout Europe for his fur business. Both he and his wife had ambitions for their children and wished them to have the education they themselves could only dream of. Music was the major interest. Harald Sohlberg was himself a competent pianist and had a magnificent voice. His oldest sister studied opera with the legendary Marchesi in Paris and Chicago during the 1890s. His youngest brother, Thorlief (1878-1958), was a pioneer opera singer in Norway. There were also four other brothers and two sisters. During the 1890s and just after the turn of the century, the Norwegian economy suffered two serious depressions. In 1906, Harald Sohlberg's father went bankrupt.

During his youth, Sohlberg grew from an awkward young man with a poor self-image into a charming and attractive party-goer who had his way with women. His wife-to-be, Lilli Rachel Hennum (born 1878), was known as a

beauty. Daughter of the orchestra conductor of the Christiania Theater, Lilli was musically gifted. She was reared in a home frequented by artists, actors, and musicians. At the age of fifteen she passed Sohlberg on the street. She decided then and there that this was the man for her and introduced herself to him. During the summer of 1900, when Sohlberg was living confined and isolated in the almost inaccessible Rondane district, Lilli resolutely moved there to be near him; they were married that fall. After 1900 the demands of Sohlberg's artistic work were in constant conflict with the obligations of supporting a wife and children. Later he prided himself on having become a family man and reproached Munch for not being willing to take on the responsibility of a family. Sohlberg's spouse, however, reproached herself for having a family and thus hindering her husband from developing freely as an artist.

Sohlberg began drawing at the age of fourteen and early on dreamed of becoming an artist. The family hardly looked forward, however, to their son becoming a part of a professional group known for its fast life style and radical ideas. His father told him that he was not talented enough to become a great artist and placed him as an apprentice to a decorator. It was not until he was in his twenties that he was allowed to practice fine art. As most Norwegian artists did, he received his basic education at the School of Design.

Sohlberg's first works are marked by a locally influenced confluence of nationalistic and impressionistic styles dominant among young artists. During the summer of 1890, he studied in Åsgårdstrand under the Naturalist painter Sven Jørgensen, who only the year before had studied under Léon Bonnat in Paris. Jørgensen won a bronze medal at the Exposition Universelle in Paris in 1889. But Sohlberg had no interest in empathizing with the cultural history or human fates tied to the places he painted. He had a falling out with the social-minded Jørgensen who had made it his life's task to paint the living conditions of the poor. Sohlberg dissociated himself at the same time from the national ideology of the followers of Erik Werenskiold – at that time the most influential among the generation of Naturalists and recognized as one of the greatest painters Norway had fostered. Sohlberg was never interested in being Norwegian in the nationalistic sense of the word. On the contrary, he felt that Norwegians were sadly conceited: "Everything has to be so nationalistic, so Norwegian. If you do not have something Norwegian about you, then you are nothing," he wrote during the 1890s.[1] He dismissed nationalistic art as political advertising.

During the winter of 1891-1892 Sohlberg studied in Copenhagen where he made contact with a group that cultivated Symbolist art. Among others he met Munch's friend, the poet Emanuel Goldstein. Several Danish Symbolists had personal contact with Gauguin and painters from the Nabis group. There was, as well, ample opportunity to see Gauguin's paintings at the home of his Danish spouse.

The Danish group of Symbolists moved quickly away from the Nabis school toward a stylistic art influenced by the Pre-Raphaelites and fifteenth-century Italian art. The attempt to combine observation of nature with subjective feeling and individual experience, that is Synthetism, continued to be the main aesthetic

ideal. To this another stylistic direction was now added, and Sohlberg was one of the few Norwegian painters who allowed this amalgam of styles to have a lasting influence on his work. He started a series of Symbolist drawings that he collected in a book.[2] *Young Girl with Daisy*, an etching from 1896-1897, was first developed as a theme in ink drawings and painted studies. The girl stands as a symbol of fertility under a young, slender tree that is in its first growth. That the future lies ahead of her is symbolized by a house with lights in the windows, closed in by a fence – worldly security – and above it in the background is a church, representing spiritual security and grounding. Sohlberg had intended to paint this subject in a large format, but the image never developed beyond a number of painted and drawn studies. The form is influenced by the young Danish Nabis painter Mogens Ballin and by Jan Verkade and Paul Sérusier.

Sohlberg's Symbolist figure compositions made use of the typical themes of the 1890s: spirit, faith, eroticism, and death. He also wrote poetry and short prose pieces, obviously influenced by Sigbjørn Obstfelder and Vilhelm Krag. Sohlberg's detached attitude, however, resulted in his making fun of the reverent spirituality of Symbolist poetry. The essence of his writings is that a scientific, that is a positivistic, world view is incompatible with the aesthetic understanding of form. The materialistic human becomes, in light of his egotism, petty and spiteful. Some of his lyrical prose writings are precise descriptions of moods that can be found in his paintings as well.

In the period between 1893 and 1897, Sohlberg developed his thoughts about sexuality in writings, drawings, and paintings surrounding the mermaid theme. Throughout Norwegian art of the 1890s, from Theodor Kittelsen to Munch and Sohlberg, bevies of mermaids are depicted. Nearly every painter of significance treated the theme. The representation of mermaids encompassed everything from pornography in a socially acceptable guise to symbolic portrayals of the life and death cycle.

In October 1893, Sohlberg drew in quick succession sixteen studies that constitute a pictorial series telling the story of a man who discovers a mermaid and is attracted to her. In one of the drawings, a man with the artist's own features lies drowning in the foreground. In a note about the mermaid theme, Sohlberg wrote that she represents "the almighty passion, the meaning of life, upon whom all things depend, that which causes sorrow and happiness, life and death, wealth and destitution, brings life, brings murder, genius and idiots and fills the insane asylums."[3]

Sohlberg allowed the theme to rest until, in 1895-1896, he took it up again during a stay in Paris. He gave his mermaid the features of a beautiful and sensuous woman, not dissimilar to Munch's *Madonna*. "You are the tempting woman who lives abandoned in the sea," Sohlberg wrote. Munch's *Madonna* and development of the mermaid motif in drawings and subsequent paintings seem to have had a strong influence on Sohlberg. In Munch's lithograph *The Wave*, printed in Paris in 1896, the motif is given a more explicit reference to the sexual union of male and female that takes place in the sea, the primal source of

all life. Munch placed five stars – five of the seven stars that make up the Big Dipper constellation – in the upper left section of the picture. This is reminiscent of Sohlberg's use of a stylized representation of the Big Dipper in the same position in *The Mermaid*. That Munch was aware of Sohlberg's mermaid painting is evidenced by a postcard he sent Sohlberg where he drew a caricature of Sohlberg's painting in the lower left corner. In addition to Munch, one of Sohlberg's favorite artists, Theodor Kittelsen, was a source of inspiration. Sohlberg's mermaid is partially a take-off on Kittelsen's water troll who lies waiting in the pond on the lookout for prey with its yellow eye, large as a full moon, reflected in the water.

Besides the myriad influences from contemporary painting and illustrative art, there are literary references from Friedrich de la Motte Fouqué's *Undine* (1811) to Henrik Ibsen's *The Lady from the Sea* (1888). In a short story by Vilhelm Krag, published in 1893, a mermaid rises up out of the moonlit sea and then dives down when the sun once again reddens the sky – an analogy between the course of a day and the course of human life, from birth to death.[4] In the 1896 version of the painting, Sohlberg placed a sun-halo over the head of the woman, and the twinkling stars of the Big Dipper appear to the left in the picture. Symbols of night and day in one and the same picture represent the instant that life and death meet. Death was a subject that was used repeatedly in Symbolist painting of the 1890s. In *Death* the viewer is confronted by a figure with a peaceful and firm expression, face to face. His features resemble those of the Belgian artist Fernand Khnopff. There is no expression of pain. This is an articulation of the essence of death that Sohlberg would have found in Schopenhauer. The figure stands against a background of thick black ink smeared all over the sheet. The black expanse is a part of the picture and not merely a frame surrounding the figure. The undifferentiated space symbolizes all-encompassing nonexistence or death as obliteration. Sohlberg had also planned to use this motif in a painting, but he only got as far as making a sketch where the same figure stands dressed in red – a tunic made of life's blood – against a monotone black background.

Sohlberg's view of death as obliteration was, for a short while, replaced by a more pragmatic attitude. In a text from 1893, he wrote a manifesto-like polemic against the contemporary Symbolist painters: "you are among the living, you must finally understand that, strike out in the name of life, hold mankind with all that it encompasses firm with a hand of steel, criticise it...for you stand with both your feet and with your existence planted in life, and do not stand there with one foot in life and the other in an imagined kingdom. Set your goals high enough so that a person can achieve them, do not hang them outside of earth."[5]

Sohlberg himself did not follow the advice he gave his contemporaries. The end of his struggle with existential questions was the idea that faith was the answer to the reconciliation of the earthly and the supernatural. The last straw that the artist was able to cling to in his need for a spiritual dimension in everyday life was belief itself. Sohlberg writes about this existential problem claiming that it is a

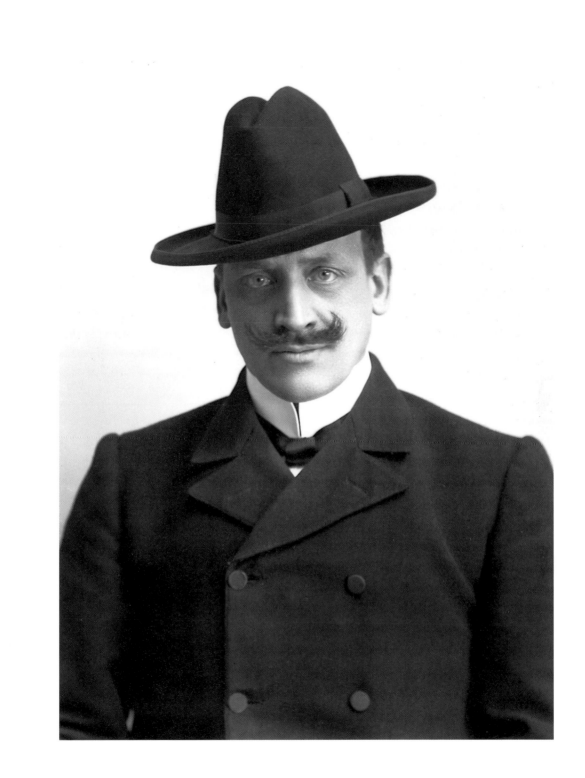

Harald Sohlberg, 1904.

question of believing unconditionally: "You shall hunger for the bread of life which is called faith. But until it comes to you, you will misunderstand each other."[6] The importance of faith as a premise for living one's life is the foundation of Sohlberg's later existence. His pictures repeatedly refer to this in symbolic form. He created ever new formulations of his fundamental picture: the individual human being alone in the unfathomable universe, standing in quiet awe at his own place in it. He himself was a chosen one who had come to an understanding of what cannot be fathomed other than through the act of faith. From this, it followed that all understanding was intuitive. In this way, a symbolism in which the symbolic concept is unspecified became his natural form of expression.

Sohlberg chose the motifs for his first significant works from the area surrounding Langøya in the Christiania Fjord. *Night Glow*, begun during the summer of 1893 and finished in the late winter of 1894, is at once a summary and a repudiation of the most widespread experimentations with form at the time. He imbued it with what he had learned from the Danish Symbolists, and at the same time he concluded that observation of the specific landscape should have a leading place in the process of creation. The picture combines the diverse influences that circulated among Norwegian artists, from Danish synthetists, Munch, Pre-Raphaelism, and the early Renaissance. Sohlberg's early training as a decorative painter became a decisive factor in the technical execution of his paintings. His glazing technique was looked down upon by many of his colleagues as unpainterly.

After Munch had exhibited in the the state exhibition for the last time in 1891, it became easier for young unknown artists to attract public attention. In 1894, two newcomers stood out. Both foreshadowed the beginning of a new era in Norwegian art: Harald Sohlberg and Halfdan Egedius. Egedius died in 1899, not quite twenty-two years old. Sohlberg's *Night Glow* was the sensation of the year at the state exhibition of 1894. It placed him at the center of new Norwegian art, and the picture was purchased for the National Gallery with profits from the exhibition. The freshness that contemporaries found in *Night Glow* can be explained by the fact that when compared to it, the mood landscapes of the previous decade were seen for what they were – Naturalistic paintings of subjects seen in evening light and not nature symbolic of the artist's soul.

Sohlberg was one of the few artists of the younger generation who came to question Naturalism's objectiveness. The artist of the Naturalist school attempted to give the illusion that his subject was just a random glimpse of nature that had caught his attention. Sohlberg made no such attempt. Quite the contrary, his subjects were chosen for their potential as symbols. There was another change as well, one in which the elements of expression were filtered out and accentuated. The goal was to make, as far as possible, a concentrated composite picture, charged with meaning, independent of the elements' reciprocal relationship in a specific landscape. From his sketchbook, we can see how Sohlberg collected details from different locations with the intention of including them in his picture. The mountaintops in the background are observed from a high vantage

point, while the detailed vegetation in the foreground is observed from a low one. Breaking from linear perspective, he created space as separate spheres. In the connecting borders between the spheres he achieved a precise silhouette effect, where space simultaneously gives the impression of great depth and respects the flatness of the picture plane.

Sohlberg's *Night Glow* functioned as the gateway to his lifework. With this painting he first became aware of "the awesome beauty of detail: This predilection for details as a part of the whole, like rich and lavish ornamentation in a church interior."[7] While in Munch's work anxiety is expressed by a blood red sky, eroticism was Sohlberg's underlying theme for the red sky in *Night Glow*. It was painted from a lookout point where Sohlberg had had secret rendezvous that summer. A woman who asked him what he had in mind when he painted the picture received the reply: "there were women lying behind the bushes."[8] Similar to Munch, Sohlberg drew on a number of literary references for his understanding of nature. A red sky, moreover, is a frequently occurring natural phenomenon on summer nights in Norway.

At the state exhibition of 1895, Sohlberg showed a painting he called *Study*. Several years later he explained the title in this way: "called so by me in order to show in this work how strongly one could become absorbed in one's work, how painstaking one should be in one's work."[9] The picture is a comment upon the criticism Lorentz Dietrichson (1834-1917) raised against the young Norwegian artists at the state exhibition of 1883. He issued a warning to young artists not to emulate Impressionism: "Drawing is and shall always be the Skeleton, over which Color shall build its Flesh and Blood if the representations are not to be Mollusks instead of Humans."[10] The demand that artists not neglect the plastic side of painting is echoed in the criticism that Andreas Aubert raised somewhat later with Munch as his main target. Aubert warned against the tendency to present sketch-like pictures as finished products. In line with his adherence to the Dietrichson-Aubert view, Sohlberg later came to reject the expressive arts' concept of art as spontaneous productions. When Sohlberg had seen Munch's retrospective exhibition in the National Gallery in 1927, he concluded that the earliest works were masterful, but that when Munch based his art on the "inspiration of the moment, but not on thorough work," his art became cold and empty. And, as Munch grew older, he no longer could maintain the intensity of his emotional life.[11]

In *Study* Sohlberg makes use of diverse levels of abstraction between Naturalism and Synthetism, as can be seen in the contrast between the stylized sunspots and the remaining details in the picture. They form large free-standing shapes that cross the path. The detail functions as a reference to the Danish Symbolist Jens Ferdinand Willumsen who had been criticized for depicting stylized sunspots hanging in an abstract decorative design in an otherwise naturalistically portrayed motif. In Munch's paintings, one can also see how individual elements are isolated, lifted out of an otherwise naturalistic environment, and given an independent shape detached from the surroundings.

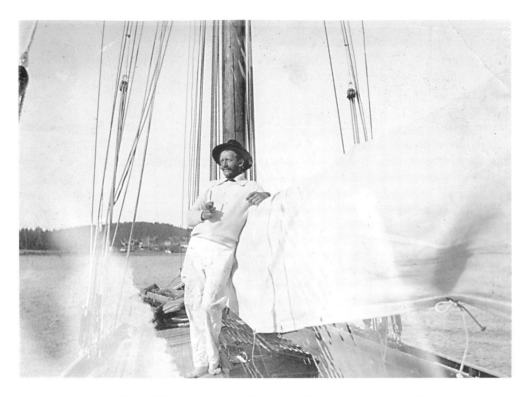

Harald Sohlberg on the sailboat of a friend in the late 1890s.

The theme of light sunspots against a dark path and light green leaves against darker vegetation is reversed in the upper section of *Study*, where dark, detailed trees form a grill that filters light from the sunlit sea and the high heaven. The closed, limited space of the foreground, the line of trees forming a grill in the middle ground, and the light, open space behind describe a compositional formula Sohlberg used here for the first time.

Country House, 1896, exemplifies Sohlberg's technique. It reveals the systematic building up of the painting from a drawing to a finished painting. *Country House* is in the middle stage, somewhere between the underdrawing for a painting and a fully worked-out picture. The first stage of the process is a precise drawing of the subject on canvas. The drawing is then covered with layer upon layer of paint. The paint is applied in dense strokes with a relatively small brush. For Sohlberg, the relationship between drawing and painting was important. The drawing was the supporting skeleton of the picture. He felt that the drawing must be evident at all times, even when totally covered by paint. The composition rests on a grid which accentuates the picture plane as a kind of structural foundation onto which the subject is lowered. Sohlberg's repeated accentuation of the horizontal-vertical structure points to the symbolic dimension of the spa-

tial structure itself. He symbolized the interplay between the horizontal and the vertical, the resting and the active. The horizontal stands for that which is earthly and energetic; the vertical stands for that which is supernatural and spiritual.

The restful shape of the building shows that the house is a secure human abode in contrast to the surrounding trees that reach upward. The rays of the descending sun are reflected in the windows. They are gradually toned down, from left to right, until they achieve a counterpoint in the black window under the eaves of the neighboring building to the right. The light that touches the windows connects nature and the buildings.

The theme of the rural summer house harmoniously situated in a lush landscape was one of the most popular motifs of the 1880s and 1890s. A summer vacation by the Christiania Fjord with a house and sailboat was an aspect of upper-class life style that was considered the greatest luxury. It became fashionable among Christiania's inhabitants to take vacations. Moving out of the city to the islands or small towns along the fjord was most attractive. There one could escape from the ritualized existence of bourgeois life. One could bathe, sail, and dress in loose, comfortable clothing. All this took place in surroundings that were cultivated and park-like, the enviroment nevertheless possessed enough unrestrained elements to be called picturesque. The way of life on this brief annual holiday suggested and even celebrated the ideal of a perfect harmony between person and place – mankind and nature represented in Sohlberg's painting in the form of the human dwelling and its surroundings. We also find the motif of the summer house in the work of the Swedish-Norwegian artist Prins Eugen and in the work of Munch's close friend, Thorolf Holmboe. Through the work of these artists, it was transferred to German painting in the work of Walter Leistikow (1865-1908) – Munch's friend and supporter in Berlin. While Sohlberg, Prins Eugen, and Leistikow emphasize harmony between nature and the human dwelling, disharmony characterizes Munch's treatment of the theme with the lonesome house in *The Storm* and in *Red House*. During his childhood, Munch had not experienced a life style that included these kinds of vacations. He was an adult by the time his family rented a cottage in Åsgårdstrand, which was one of the popular spots for such summer excursions. The importance that he attached to the little cottage he later bought in Åsgårdstrand must be seen in the context of the status value that was and still is tied to the cult of the "country place" or "cottage" in Norway.

The landscape Symbolism of the 1890s was created by artists who had a different image of the relationship between man and nature than the generation of artists that Christian Krohg described as "nationally worried" or the socially critical Naturalists. The artist's role as a radical critic of society or as the creator of a national identity became invalid to a generation that placed the individual before society. Edvard Munch's many self-portraits illustrate this tendency. It is perhaps best exemplified in the lithograph *Self-portrait with Skeleton Arm*. The artist observes his own pale countenance as it takes shape on paper. A new literary element is introduced through the skeletal arm that immediately calls to

mind Arnold Böcklin's well-known self-portrait with a skeleton. Munch's self-portrait has been interpreted as a symbol of the "unbridgeable gap between body and spirit, or between technique and idea, which is the artist's curse. The face, 'the mirror of the soul,' emerges from the darkness with visionary force. It obscures the ephemeral body and triumphs over the dead and powerless artistic means symbolized by the skeletal arm."[12]

One of the main goals of Synthetism and Symbolism was a fusion of form and ambition, and we can presume that *Self-portrait with Skeleton Arm*, contrary to the above mentioned interpretation, is symbolic of the power of the artistic genius to X-ray the mere appearance of things – in this case the surface of the body – and bring forth the essence – the skeleton. The artistic means becomes, not inadequate, but on the contrary, the necessary tool to build a bridge between appearance and essence.

In his *Self-portrait* with a landscape background of 1896, Harald Sohlberg has given us the new type of artist in a purely symbolic form, cleansed of allegory. He is fashionably dressed in outdoor clothes, a striped white coat with a velvet collar. The little canvas is nearly filled with his pronounced features as he fixes his gaze to stare down at the viewer. The picture represents a contrived reality, in which the image on the canvas is a mirror image. The viewer that the artist stares at is not an outside observer but himself. He defines the "new artist," which he himself symbolizes, in a strong, penetrating look that sees through the surface to his inner self. It is the gaze of the seer – not directed at the outer appearance of reality but penetrating reality to find profound inner truth. In accordance with a popular belief about a connection between physiognomic appearance and psychological disposition, a high brow is proof of genius and intelligence. Sensual lips tell us of strong emotions. The landscape reflected in the background is a sketch for *Ripe Fields*. The Norwegian landscape is not there to illustrate the artist's origins; it is there to represent and echo the strong emotions that wrack him. The picture of nature he stands before can be compared to the projection of an emotional state onto canvas. It is similar to the way Munch makes use of the background in his portraits as a place to project the figures' feelings and thoughts. For Sohlberg, the picture was a vehicle for portraying his more profound self – the Sohlberg to be found under the aloof bourgeois social mantle. He was a man who loved to play the actor. In his life, as in his art, there was often an unclear boundary between the authentic and the staged.

Ripe Fields was begun in the early 1890s and finished in 1898. It is marked by influences from the Danish milieu with which Sohlberg had contact. From the pictures that circulated among the Danish Symbolists, we find a study from Brittany attributed to Paul Sérusier and a painting based on the study made by either Jan Verkade or Mogens Ballin.[13] The composition of *Ripe Fields* has strong similarities to these paintings. The foreground with pronounced vegetation creates a repoussé effect; a road leads across the top of the landscape where the wavy greenery has an indentation in the middle. A soft light illuminates the grass in the middle ground. There is a pronounced contrast between a light sky and a

dark strip of trees. Sohlberg differed from his contemporaries in that he accentuated depth. One senses depth as a definite distance from the viewer inwards toward that point in the landscape which is as far away as possible where the earthly, measurable distance is lost in the infinity of the sky.

Sohlberg's favored compositional form gives the viewer the feeling of stepping into a space and being led from a precisely defined foreground to an undefinable and infinite, cosmic background. Along the way, the artist may lay down diverse obstacles to be surmounted, bushes, fences, buildings, hills, or mountains, but the goal – absorption into the great, infinite cosmos – always takes the form of the sky as a symbol of the transparent and the transcendent. Sohlberg's best pictures are characterized by a pronounced "longing for eternity." In his masterpieces, he developed this type of Symbolist landscape to perfection.

During the summer of 1899, Sohlberg became engaged to Lilli Hennum. He celebrated the engagement with the picture *Summer Night*, a vision over the Christiania Fjord as seen from his attic room in a house at Nordstrand. This is not far from where Munch painted his landscapes at about the same time. In *Summer Night* Sohlberg strives for, as elsewhere in his work, unity in complexity. Two areas of space mirror one another. One space is the place where the human has his dwelling, the cultivated space. The other is nature itself, the universe. These are not two separate worlds. They are two aspects of the same world mirrored in one another. The border between them is defined by the flowers on a balcony railing which represent both nature and culture and where Sohlberg's engagement gift to Lilli – a hat – is placed as though it were a part of the flower decorations. The unifying element is light – light which calls the whole scene forth and makes it visible.

Sohlberg intended the painting to express "festivity and a sensually intoxicating nature experience,...one of those moments when anxiety does not exist, only joy."[14] He almost regretted that the National Gallery bought the picture rather than the collector Olaf Schou. He would have preferred it to be hung in a place full of parties, brilliant lights, and life.

Summer Night could have been an illustration for Baudelaire's poem "Le Balcon," where it says: "Que les soleils sont beaux dans les chaudes soirées! /Que l'espace est profond! que le coeur est puissant!"[15] Comparisons of the heart and infinite dimension of space can be found in Sohlberg's work. The infinite quality of space is more than a physical reality; it is also a metaphor for the mind's search for the boundless. As in Baudelaire's poem, an act between two persons is woven into the space using nature as a mirror for the human emotions. With Sohlberg, cohesion is expressed symbolically by the balcony door left slightly ajar, creating a link between interior and exterior space. The half-opened door is also an unambiguous sexual symbol, strengthened by the symbol of love that the woman has left behind on the table: her gloves. At the time of Sohlberg's painting, the glove was a metaphor for the violent debate over the decline of sexual morality initiated by Bjørnstjerne Bjørnson's play of 1883, *A Glove*. Max Klinger, whose works were well known among Norwegian artists, had made the

glove into an erotic fetish in a series of etchings from 1881 in which a young man chases a glove until he finally brings it down. In the last picture it is depicted lying stretched out and limp under a rosebush with a cupid by its side.

As always with Sohlberg, his means of expression is closely tied to his technique. The intense, transparent light in the sky is achieved by painting that part of the canvas with a thick layer of white which is then smoothed and glazed. The structure of the canvas support is used to give the remaining areas of the picture a rougher, more textured quality. The meticulousness of Sohlberg's technique is evident in his use of varnish. He empasizes the different material effects by varnishing the picture in sections, as he always did. This is an important quality that conservators have often overlooked and thereby obliterated by varnishing the paintings uniformly.

Sohlberg's best known painting is *Winter Night in the Mountains.* Several versions of the scene exist, the majority of which are studies and preparatory sketches. *Winter Night in the Mountains* is perhaps that painting in Norwegian art which best epitomizes the distinctive quality of Symbolist painting developed by the generation of young Norwegian painters following Munch. Its distinctive quality stems from the consistent use of symbols from nature. The version of the painting that hangs in the National Gallery in Oslo has become a Norwegian national icon.

During Easter week of 1899, Sohlberg went with a group of men on a ski trip to the Rondane mountains. Such trips to remote mountain plateaus and fields became increasingly popular during the 1890s, in the wake of Frithjof Nansen's polar expeditions. One afternoon Sohlberg came sleepily out of a mountain hut where he had taken a rest. That was when he saw his subject. He described the experience in 1919: "There was the motif for me just as I had imagined it." Documentation shows that a long struggle ensued before this motif finally achieved expression. Sohlberg had fantasized about painting a picture of the mountains from the time he was a boy. One of his first drawings depicts a view from a hut overlooking the mountain wilderness. The drawing shows an unspecified mass of peaks lacking in dramatic effect. The existence of the childhood drawing is an indication that he had long sought in nature motifs that depicted his moods. He sought out places that suited him, places that he experienced as being integral to his own existence. Such places made it possible for him to combine fleeting emotion and mood with something constant which made them part of a lasting order.16) From 1900 on, he lived in the mountain wilderness in order to be near the subject of *Winter Night in the Mountains.* On New Year's Eve in 1900, he climbed one of the Rondane mountains in order to spend the first hours of the new century in quiet meditation under the starry sky. Regardless of the role he himself attributed to it, it was not personal communion with nature that was the basis for the sublime in Sohlberg's mountain scenes. His gaze was guided by his intimate knowledge of an artistic tradition that began with the Norwegian landscape paintings of the early 1800s and continued in the 1890s with a rediscovery of the mountain as a symbol of the sublime in nature. Sohlberg's references to

Harald Sohlberg and his wife in the Røros mountains.

the treatment of the mountain motif in Romantic landscape painting is more an issue of identity with a certain kind of experience and feeling for nature than of a style.

The idea of the sublime in nature was known to Sohlberg from the time he heard art historian Lorentz Dietrichson's lectures as a young man.[17] In his studies of aesthetics from 1870, Dietrichson made use of the mountains and the sky to illustrate a concept of the sublime. The mountains lacked the simple, pure, limited shape of beauty. They were at the same time both formed and shapeless. The sky with its myriad stars personified the unlimited and infinite. Later Sohlberg studied Kant's writings and the poetry of Goethe and Byron, in which the same concept is treated in similar ways.

It has been proposed that Sohlberg was familiar with Caspar David Friedrich's art, but there is no documentation of such knowledge. He may have seen important works by Friedrich in Berlin in December 1895, while traveling through on his way to Weimar. In the Schlossmuseum and in Goethe's house in Weimar he may have seen mountain subjects, three sepia drawings, and a painting of a mountain. Otherwise, Sohlberg had more obvious examples among the sublime landscape paintings in the Norwegian Romantic tradition, with painters like Johan Christian Dahl, August Cappelen, and Thomas Fearnley. Hokusai's *Thirty-six Views of Mount Fuji* also belong among possible influences. Among contemporary artists, Ferdinand Hodler, Félix Vallotton, Giovanni Segantini, Jens Ferdinand Willumsen, and Walter Leistikow had all painted mountain pictures with an emphasis more or less on symbolic content.

Sohlberg's claim that he had always carried the picture of the mountain inside him shows that he wished to dissociate the experience of the sublime from its geographical anchor. It was his concept, his vision that was supposed to count. This was a concept he formulated as "desolate and dead, yet so poignantly beautiful in its majesty, in its magnificence." Elsewhere he writes that "the mountains in winter make one silent, overwhelmed; one has something of the same feeling underneath the mighty vault of a cathedral, only a thousand times stronger."[18] Sohlberg summed up his thoughts on this theme in a letter from 1915:

> *The longer I stood gazing at the scene the more I seemed to feel what a solitary and pitiful atom I was in an endless universe. I grew uneasy. I could hear my heart beginning to beat loudly. It was as if I had suddenly awakened in a new, unimagined and inexplicable world.*
>
> *The deep, long moor where I stood was bathed in a half light and mysterious shadow. I saw deformed, gnarled and overturned trees, mute expressions of inconceivably strong forces of Nature, of the might and rage of storms. Now, everything lay calm and still, with the silence of Death. I could hear my own quick breathing.*
>
> *Before me in the far distance rose a range of mountains,*

beautiful and majestic in the moonlight. Like petrified giants. The scene was the grandest and most fantastic that I have ever witnessed. Above the white contours of a northern winter stretched the endless vault of heaven, twinkling with myriads of stars.

It was like a service in some vast cathedral.[19]

Sohlberg investigated his theme in quiet meditation and by crossing it on skis and climbing in the mountains. He scrutinized it with the help of maps and a camera. And he drew detailed studies and rough compositional drafts. He found the angle of the scene by climbing a steep hill in the distance, a couple of kilometers south of the massif, and recording different lookout points along this route. The view has largely been taken from a high-lying mountain dairy farm. Sohlberg combined this high vantage point of the mountain with a low viewpoint of the vegetation.

Although not content to look at things from a distance, he did not regard himself as a conqueror of the mountain, but as a friend. He entered the landscape to establish an intimate relationship. He climbed the peaks from which he directed his gaze in every direction, and he then withdrew from the mountain to regard it from a distant viewpoint, now contrasting it with the sky. The explanation of this rigorous approach to the scene implies that he did not direct the self-controlled and objective gaze of the Naturalist on nature. He did not wish to be superior to his theme. He shared in it and imparted the experience of being part of it rather than being confronted by it. On the mountaintop, between earth and sky, he was able to experience the sensation of being a part of two cosmic spheres at the same time – the earthly and the heavenly. He descended, and, seen at a distance, the mountain appeared as a symbol of equilibrium, tranquility, solidity, security, and stability – qualities that Sohlberg himself wished to possess. The picture of the mountain combined the dizziness of being on the verge of passing into another cosmic sphere with the security that comes from the durable material and the solid shape of the mountain. The compact, basic, pyramidal form of the mountain appears as a symbol of unity.

A large-scale charcoal drawing forms a point of departure for the first painted studies. Two mighty trees form a portal to the mountain wilderness. In the middle of the sky is a boldly shaped star which sheds light over the mountains. At the top left of the picture is the Big Dipper – in the same stylized form as in *The Mermaid* – a widely used symbol of the northerly regions at that time. The mountains appear to be an enchanted mirage from another world. The mountain plateau in the middle distance is hardly articulated in the study.

In the first version, the mountains soar above the trees in the foreground, which are gathered in two groups along the sides of the picture. The effect of space is created by graduated surfaces placed at short and then longer intervals behind each other. The picture is painted in a uniform bluish green color drawn against white in the light regions and against black in the dark regions. The pic-

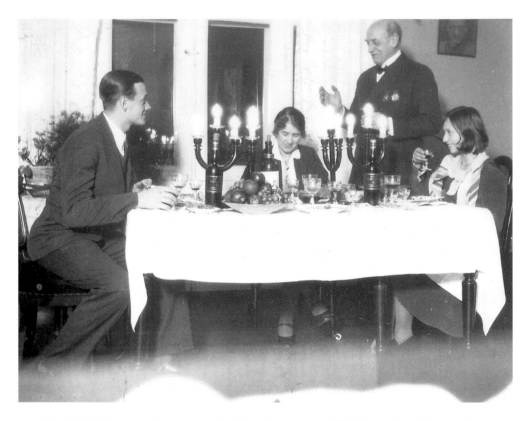

Harald Sohlberg makes a speech, New Year's eve, 1930. From left: his son Dag,
his wife Lili, and daughter Kari. The medals were bought in a toy store.

ture acquires its intense illuminating power from a glaze through which the
white-colored ground shines, except in the black regions. Different spaces have
acquired different textures, determined by their roles in the picture. The trees
have been painted with colors rich in oil. They have a smooth surface which
gives an impression of cutout silhouettes. The mountains are built up with white
impasto painting in a decorative pattern of incisions and irregularities that have
been made and then glazed. The wall-like texture is supposed to emphasize the
rugged and heavy form of the mountain. The sky is painted in nuances of blue
applied in thin strokes, contributing to an ethereal and transparent effect.

As a rule, Sohlberg composed his subjects according to a strict geometric
order on the picture plane. This helped to express the feeling of serenity and
monumentality. He combined details in a way that contributed to the imposing
whole. The mountains should be experienced as "radiant and brilliant in the
moonlight, like an enormous, dazzling white mass of marble, with deep, dark
clefts; and below them, in the shadow, an endless, desolate mountain plateau,
seen as if through a veil of lace, through the finest filagree of slender, black twigs
of birch."[20]

In addition to conveying the experience of locality, the theme of life and death is formulated in symbols from nature. Through a portal of living and dead trees, we look out on the snow-covered mountain marsh. The trees live, grow, decay, and die. The contrast between young, fresh trees and rotting stumps is symbolic of the cycle of life. The snow-covered log cabins at the edge of the marsh bring to mind the human presence in the landscape. To Sohlberg, a small building in the vastness of nature is the recurring symbol of the ordinary man who has built himself a shelter for refuge. The middle distance, the desolate mountain plateau reminds us of the name given to the mountain plateaus by Ibsen in his play, *When We Dead Awaken,* of 1899: "the vast wastelands of death." The mountains soar like cathedrals of stone, cleansed of organic life and clad in ice. On the dark side of the Høgroden mountain peak a cross is formed in the rock wall – a natural formation in the side of the mountain which may be interpreted as a stylized cross. When Sohlberg took up the motif again in 1911, the cross bore an unmistakable resemblance to the Christian cross, a symbol of man's atonement representing both the fear of death and the hope of eternal life. In the early versions, painted at a time when Sohlberg vacillated between atheism and agnosticism, the symbol had not yet been clearly articulated. He established a connection between heaven and earth through the light that illluminates everything, rendering it visible to mankind. In the middle of the picture, in the foreground, is the rotting stump of a tree, while another tree has fallen over nearby. Above them in the hollow between the two massifs shines a star, reminding us of the vast dimensions of the cosmos.

For a long time Sohlberg had been thinking of painting a picture of a churchyard. Among his symbolistic figure compositions there is a sketch for a picture with a man standing before an open grave. He gave the drawing the title of *Love and Death*. Sohlberg also treated the theme in a general way, contrasting love as an expression of vitality and the basis of the renewal of life, with death as a brutal finish. Before he left Christiania, he made a sketch for a picture of Aker churchyard that he used as a study for the painting *Night*, which takes its subject matter from the town of Røros.

The picture was intended to express feelings of deep depression and despair. Sohlberg wanted to show the world as seen by a person who has no belief in life after death. He writes that the point of the picture lies in the contrast between life and death, the contrast between the urban houses of the living and the churchyard where the dead find their final rest. The new grave in the foreground is decorated with fresh roses, a reminder of the futile struggle of the survivors to hold on to the dead. Around the grave stand crosses in various states of disrepair. The arm of one cross is shaped like a hand pointing to the new grave. Engraved on the arm are the words: "You will never be forgotten," emphasizing Sohlberg's ironic comment that everything is forgotten.[21] He established an invisible tie with his first formulation of the theme in the drawing of a grave digger, *Love and Death,* by writing "Love and Death" in small penciled letters to the right of the landscape before he started to paint.

The picture is largely a construction in spite of the photographic naturalism of the details. Sohlberg used professional photographs, taken expressly for his purposes, as a point of departure to describe the town and the church. He painted in the churchyard at night. Røros is located so far north that the sun vanishes for only a short time on summer nights. Sohlberg chose to paint the scene at the moment when the sun climbs over the crest of the hill to shed the first gleam of light on the church steeple and factory chimney. The first golden ray of light is reflected in the upper window of the church: "The deathly silent, anxious moment, when the world lies staring out in the glaring daylight with wide open eyes, but without daring to take a breath – as if ridden by a terrible nightmare."[22] Sohlberg concentrates on the scene from different perspectives. The church is seen from a steep incline nearby. To preserve the monumentality of the building, he has removed the sacristy. The town is depicted from an elevated and distant spot where only the upper half of the church building would be visible. The churchyard itself lies perpendicular to the church, and it has been turned ninety degrees so that the crosses and the graves are perceived as if they lead to the building and the town. The emphasis on frontality and symmetry creates solemnity and provides a reference to devotional images. Sohlberg devised his compositions according to simple, geometrical divisions of the picture plane with contrasting close and distant views. The tension between what is the close, physically pressing and earthly, is contrasted abruptly with the distant and remote, and its intimation of the hereafter. But in addition to its metaphysical nature, the picture is largely a social portrayal. Sohlberg's look at Røros was not that of the fascinated tourist who today sees a historical monument preserved by the Norwegian government and placed on UNESCO's list of urban environments worthy of protection. Røros was founded in 1644 as a mining town for copper which had been discovered in the area. The buildings date from the period after 1679. Sohlberg saw Røros with a critical eye, bitter and accusing. He examined and revealed to the viewer a living mining town rather than an antiquated cultural monument.

Sohlberg characterized the town as a "malodorous privy."[23] The discharge of sulphur from the copper works killed everything that wanted to grow. The community was concentrated around the mining operations, and the people suffered from wretched living conditions. Social classes were divided according to the roles they played in the local economy.

The church, dating from around 1784, is an octagonal building. Its design was influenced by the rationalistic reform at the end of the seventeenth century. Aside from the spiritual, it was a center of social life and a guide for secular power. The initiator of the construction of the church was the director of the copper works. He was originally a theologian and an outstanding representative of rationalistic theology. He is buried in the chapel building at the lower right corner of Sohlberg's picture. The smelting plant, with its characteristic chimney and monumental slag heaps, forms a counterpoint to the church building. This area is emphasized by the pale moon that sits on the crest of the distant ridge.

The dwellings of the workers were built of transitory, humble wood. They are grouped in two clusters at the sides of the church. The mass of buildings has no clear boundary but gradually thins out into an area of scattered farm buildings. Working in the mines did not provide a decent livelihood. Those who could manage to do so got themselves a farm outside of town where they planted a small patch of land and kept a couple of cows. Sohlberg presents a detailed account of the life of this society in its entirety, both topographically and organizationally.

Flower Meadow in the North forms a lyrical companion piece to *Night.* Here Sohlberg also uses frontality to create the feeling of a devotional image, but there is nothing uneasy about the motif. The picture shows the landscape just as dawn is breaking. The fields slant gently up to the ridges in the background, following a natural course. The viewer gazes undisturbed without the barriers which are so often encountered in Sohlberg's pictures.

When the picture was criticized as artificial, Sohlberg countered with a photograph of the scene, which in his opinion revealed that the painting merely reproduced the simple truth. A comparison with the photograph, however, disproves his claim. Sohlberg's concept of "simple truth" obviously included his personal interpretation as well as the naturalistic representation of the scene.

The painting is a construction in which the individual elements point to a concrete motif, but the general effect and symbolic content of the work rely on abstract principles of composition, such as the pyramid with its base in the meadow and its top in the crescent moon, creating a formal link between the two separate elements. The building on the left is Gullikstad farm, which Sohlberg rented in 1904 and 1905. He fled from Røros after having been accused of stealing wood by the most powerful man in town. It was an accusation he refuted in court in a case that took up much of his time but which he won – a case that made him extremely popular with the ordinary people. The local upper class had treated Sohlberg as a social outcast. He compared Røros to the penal island of Sachalin under the czar. When citizens of Røros wanted to make him an honorary citizen in the 1930s, he declined. Today the town is a favorite tourist attraction. In a square named after the artist, a bust has been put up in his honor, a bust he himself detested.

Sohlberg's pictures have strongly contributed to creating an aura around Røros. After the city was marked for preservation, the pictures were used in the reconstruction of several buildings. In addition, the buildings in the town have been painted in colors based on Sohlberg's palette, a fact which has undoubtedly been misleading, considering the liberties he usually took with his subjects.

After Sohlberg left Røros in November 1905, he preferred the level and undramatic landscapes along the Christiania Fjord and the districts around the city. He had a fondness for the west side of the fjord – Vestfold – where he could look at the dramatically lit water from the shady side at sunset and at night. The summer of 1906 found Sohlberg back in Åsgårdstrand. He settled with his family at

Hytten – where he had stayed with his teacher Sven Jørgensen in 1889. Jørgensen was now married to a girl from a neighboring farm. Sohlberg found a view with great pine trees that stood out clearly against the water and a simple fisherman's home. He painted a small version of the scene.

The following year Sohlberg went to Venice and stayed there from February to May. On the basis of drawings and photographs, he painted a larger version of *Fisherman's Cottage*. For the first and only time, he painted a picture without any physical contact with the subject. He tightened the composition from the smaller version. The tops of the trees are concentrated, and he closed the space along the left side. In the open space in the middle of the picture, trees appear as curved church windows against the light.

The picture was sold in 1914 to an American collector. Sohlberg wrote:

> *As you know, we have light summer nights here. It was one of those glorious, calm summer nights that I was wandering aimlessly around, enjoying the delights of witnessing the wonderful, dreamy northern night, when suddenly I found a great motif in the peacefully slumbering, little fisherman's home, a tiny modest human abode in a setting of natural beauty and mystery. It was perhaps a commonplace, very ordinary and poor motif in itself, and could be seen by the hundreds along our endless coast; but in the stillness of the night – when, as it were, one could almost hear nature breathing – and in the highly receptive mood that happened to possess me at the time, all moved me profoundly, told me much, and awakened intense interest.*
>
> *This is really all there is to tell. I painted what I had seen, cut out disturbing elements, emphasized what I desired to bring into prominence, and, in short, tried to put on the canvas what I have felt.*[24]

Christian Krohg wrote about the picture in 1908 that it "gives rise to an organ tone full of the melancholy of the world."[25]

In the vicinity of the Kjerringvik customhouse, Sohlberg had found another view which, of all the places he had been, best expressed the bewitching and mysterious mood of the Nordic midsummer night. He started on *Midsummer Night, Nordic Mood* in 1907, but it was not finished until 1912-1913.

We look down at an inlet from a forest-clad ridge. Our gaze is directed out to sea at a white sail in the center of the picture plane. The meeting of sea and sky is marked by changes in the nuances of blue against green and black. The picture is as far as Sohlberg was to go in reducing the landscape into basic elements. *Midsummer Night, Nordic Mood* is a lowland version of the contrast between the intimate and the sublime in nature united under one all-encom-

Harald Sohlberg and family, 1917.

passing heavenly vault. In a commentary to the related drawing *Man and the Universe* from the same time, Sohlberg wrote:

> *a starry sky with a patch of land under myself …. a bit of the most ordinary reality… But when, upon further consideration of the motif, I ask myself the most juxtaposed, obvious questions, I become confused and dizzy. This everyday, starry sky becomes so tremendously large and enigmatic, so immense and incomprehensible for thought; the question forces itself on one with such intensity, that one trembles and feels so extremely tiny and imperfect and ignorant, that one remains standing, humble as if during the most moving devotions.*[26]

Nature itself, the Creation, has become the symbol of the sacred.

The "sanctification" of nature connects Sohlberg to the Romantic tradition. The conventions in this spiritual tradition constitute the interpretive framework of his Symbolism. The picture of the solitary man who beholds the stars is an iconographic archetype with countless offshoots in the eighteenth century. It is seen among others in the Nordic Romantic landscape tradition in such paintings as those of Caspar David Friedrich's friend, the Norwegian Johan Christian Dahl. Sohlberg's treatment of the subject again raises the question about the possible influence of Friedrich. Sohlberg visited the Kunsthalle in Hamburg in 1907. There he had the opportunity to see the large collection of Friedrich's works which had been acquired in 1904-1906. Among the drawings was *Meer mit aufgehender Sonne* in which the elements of sky and sea are given an emblematic form greatly reminiscent of *Midsummer Night, Nordic Motif.* In Sohlberg's painting the source of the light is beyond the horizon, but we are aware of the reflection in the form of radical strokes in the sky which describe the rays of some heavenly body. In some variations on the motif, he also painted a descending moon.

In *Andante*, Sohlberg continued the technique of the monochrome blue landscape with the simple division of land, sea, and sky. He used two iconographic elements, which point to an interpretation of the picture as a variation on the life and death themes – the ship and the crow. We encounter the crow for the first time in a drawing by Sohlberg from about 1903, where it perches on the arm of a cross. The drawing is a study that was made with the idea of adding it to *Night.* In classical mythology the crow is a symbol of hope, but in Nordic mythology the crow is a symbol of death. Crows follow battles and feast on the dead. Sohlberg may have found the symbolism too obvious. He later used the sketch, however, and put the crow in *Andante,* placing it in the pine tree in a way that suggests its appearance on the arm of the cross. The formidable size of the bird gives it a surrealistic character and contributes to an atmosphere of unreality and gloom. It is an omen of a terrible fate. Perhaps the fully rigged ship, heading out from land, is yet another symbol that Sohlberg has taken from Romantic art as well as from the Symbolism of the 1890s.

The title of the painting is supposed to emphasize the emotional mood imparted by the picture, a state of sublime calm, or as Sohlberg expressed it: "the silence of the night. It resounds like music. It does. It cannot be explained. It is easiest to express in music; if I succeed in painting it, only the picture will show. ... For I have heard so much music, that I have felt the same mood and mystery many a time therein."[27] Sohlberg's choice of a musical tempo for his title is charachteristic of an artistic attitude – one in which the artist is striving for an immediate contact with the abstract and spiritual.

Sohlberg moved back to Christiania in 1911, where he set to painting subjects from the city and its surroundings. The most significant of the later pictures is *Spring Evening at Akershus*,1913. The subject chosen by Sohlberg is saturated with references for someone acquainted with the area: the artist has been standing on the Dronningens Battery at Akershus Castle and Fortress gazing along the fjord. Oscarshall, the king's hunting lodge, is a luminous point on the bluish violet Bygdø peninsula. The hills in the background are the same as those he painted twenty years earlier in *Night Glow*. Akershus is the most dominating architectural monument in Christiania – and the spot from which the modern city was organized. The castle and fortress represented one of the most central places in Sohlberg's life. It stood as a monument within his range of vision throughout his childhood and youth. When he finally paints it, he paints the view from it and not the place itself. The place is a sounding board for the emotions that are aroused when he directs his gaze away from the spot to what he really wishes to paint. This is a mood which originates in the artist's local knowledge of the place – its historic role as a castle and fortress. But these are not his subject. The symbolic content of the picture is suggested by the contrast between the mighty old ash on the left, standing alone and secure with roots deep in the ground as a witness to the passage of time and history, and the young trees on the right, branches touching lightly, intense anticipation at the beginning of life. Here, as elsewhere in Sohlberg's work, the picture is characterized by a systematic repetition; two ships below the ramparts, two young trees on the right, a castle from which one looks at another castle on the opposite side of the fjord. The fjord is framed by ridges which tower above one another. He repeats the formula in which the subject is seen frontally, with a clear disposition according to a vertical and horizontal grid of pictorial elements. The contrasts in size create the feeling of space in the contrasts between light and dark. The color is the local color which he forces up to its greatest intensity by simplifying the play of colors into sharp contrasts. He wishes to convey an "aggressive mood."[28]

The picture was one of a selection of Sohlberg's works shown at the San Francisco World's Fair in 1915. When Munch saw it, he told Sohlberg that along with *Winter Night in the Mountains* it was his best work.[29] Munch's enthusiasm for the picture may have been a recognition of its expressive aspects. But perhaps he also recognized the theme of the tree as a symbol for history and remembrance, much like what he himself had sketched for the decorations in the Uni-

Harald Sohlberg painting in 1924.

Harald Sohlberg in his studio, August 19, 1924.

versity Aula in Christiania, exhibited in 1911. Sohlberg's shaping of the tree is closely related to the ash in Munch's sketch.

Symbolist that he was, Sohlberg always sought the transcendental in the discernible. His relationship to nature is not the relationship in which the artist projects meaning onto a motif which is, in itself, devoid of meaning. The relationship is characterized by an experience of reality in which nature has a meaningful pattern corresponding to one the artist carries inside himself. To Sohlberg the universe was full of meaning. In a small way he took advantage of elements that had conventional meanings, such as the Christian cross on the wall of the mountain in *Winter Night in the Mountains*, or the crow and the ship in *Andante*. The kind of symbols he employed most often are those in which there is a conventional correspondence between natural phenomena and meaning based on height, length, size, content, limits, and relationship. For this reason, Sohlberg's landscapes are more than topographical descriptions. He expressed the character of a place through the concrete qualities of the scene. In Sohlberg's pictures, the space between trees, the relationship between elements of nature – such as sky and water, the placement of buildings, the alternation of closed and open passages, the contrast between things in the landscape that are closed (buildings) and open, conditions of light, and the time of day generate a vision of the place in which he stood.

After Sohlberg returned to the south of Norway, to Christiania, he turned his gaze more and more to the ordinary aspects of nature, which he soberly rendered. These pictures were characterized by a desire for reconciliation with his surroundings. They do not have the quivering excitement which reveals a mind struggling with the material or seeking the underlying meaning in nature. About *Autumn Landscape*, 1910, he wrote that, unlike earlier works, the picture "contains no story, no philosophy, is only a landscape."[30] This formulation is not typical of Sohlberg and reflects a new direction in contemporary Norwegian art. From the turn of the century, increasingly louder voices could be heard demanding concentration on the purely pictorial. Sohlberg saw the necessity for renewal of his art to maintain his standing as a contemporary painter of importance.

Around 1909, a French-dominated formalism won a definitive victory. It became the star by which the Norwegian art scene navigated well into the 1970s. It established a heterogenous art world that found its prototypes in French art. Influences from other sources – such as Germany between the wars and the United States in the post-war period – were rejected as alien to Norwegian culture. Opponents of the new trends used Sohlberg as an example of an artist who did not give in to fashionable trends. In this way, Sohlberg came to occupy a position as someone who opposed new trends. A view was formed of him as an artist who was out of touch with the main currents of Norwegian and international art.

Color was now regarded as the principle means of effect. According to young Norwegian painters around 1910, color rather than drawing was supposed to

separate shapes. In Sohlberg's case, however, drawing fulfilled that role. He became one of the few Norwegian painters who did not seek a renewal of his art in the influence emanating from Matisse and his pupils. While he paid lip service to the new trends, he continued to work within the idiom of Symbolistic landscape painting, creating a number of large pictures more simplified than ever.

Pictures of sunsets and landscapes in strong sunlight are more or less visions of paradise in which the artist stares into the sun to discover the unifying element in nature. After completing the spring picture from Akershus, the yellow evening sky came to be his principal motif. Blue gave way to yellow as the predominant color on his palette. Harmony, reconciliation of man's contribution, and nature itself characterize a considerable part of Sohlberg's art, especially after 1914. The idea of reconciliation clashed with the "manic-depressive tension," which had been characteristic of the modernist mainstream searching for discord, conflict, and antagonism, whether in the mind of the individual or in society.[31] The reason the conciliatory attitude was predominant in Sohlberg's art as he became older may be attributed partly to a mature man's acceptance of the limitations of his potential. To Sohlberg, the process was connected with his role as a husband and father. Gradually, it was no longer his goal to create a work of art but to create a harmonic and economic framework for his family. His search for harmony and a perfect idyll was also an expression of a desire to deny and push into the background overwhelming physical pain, which, after 1919, chronically afflicted him. After this, he spent much of his time trying to alleviate pain, and he wrote detailed notes about it, which he kept separate from those about his surroundings. For long periods he was unable to earn a living. Sohlberg did not exhibit paintings in Norway after 1914, and only his pictures hanging in the National Gallery were accessible. He survived by painting two large pictures a year – one in summer and one in winter. Some years, he also managed to paint several smaller studies. During one period he had a good income from the sale of graphic works, but after 1920 he had problems engraving the plates and had to give this up. The buyers of his pictures were largely members of his own generation whom he had known from his childhood and who were now well to do. Among artists, his only contacts during these years were Ludvig Ravensberg and the sculptor Gustav Vigeland, who also helped Sohlberg with the sale of his pictures and later was helpful to his widow. Sohlberg died of cancer on June 19, 1935.

In an obituary, Pola Gauguin wrote that as an artist, Sohlberg was alone and forgotten: "A name which was famous in its day." Now that Sohlberg was dead, Gauguin thought, "the coldness which he helped surround it with, will thaw."[32] Sohlberg's isolation was partly the tragic result of his wholehearted endorsement of the myth of genius as formulated by Romanticism and adopted by the Symbolists. Like Munch, he was obsessively preoccupied with denying that the influence of other contemporary artists had been important to him. He dissociated himself from the discussion about where he belonged in the history of art,

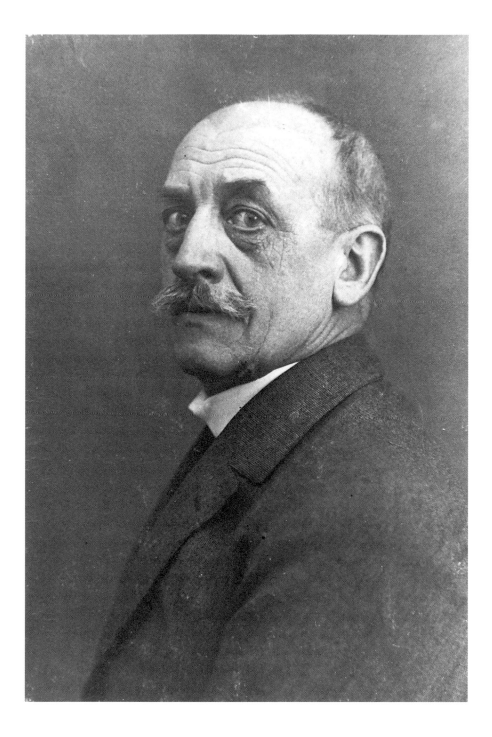

Harald Sohlberg photographed by his friend, the sculptor Hans Holmen, ca. 1930

relegating the origins of his artistic awakening outside of art – to his own psyche. Sohlberg wrote that his form sprang forth subconsciously from his first awareness of the landscape. The difference in texture of the sky and earth gave him a sense of standing on a heavy and firm planet gazing out into boundless space. He attributed the simple forms and great lines of his pictures to this first awareness of the landscape. The point of departure was the personal experience. Thus, the artist's experience of his subject preceded the picture. Sohlberg was preoccupied with the concrete local landscape that surrounded him and his emotional reaction to it. The place, in itself, was charged with meaning. For this reason, where he sought his subjects was important. He experienced the landscape in Norway as nature in strong and intense moods and gave form to the echoes of these moods in his mind. He agreed with many of his generation who, taking their point of departure in Andreas Aubert's writings about Norwegian art, were of the opinion that there existed distinctive, Nordic colors, clear and strong colors created by the clear, intense light of the North.[33] Once artists realized this, it would be possible for an independent Nordic art to develop. Sohlberg believed that, along with the unique construction of the Nordic landscape, local color ought to result in a style of its own. Experience and interpretation of nature determined the choice of colors. For Sohlberg, the main color should assemble the picture and be as strong as possible. The function of line in painting according to him was to express feelings. It could be lonely, down-to-earth, or melancholy. It could be willful and persevering as required. It should be developed according to the nature of the subject and the artist's dialogue with nature. Because the picture was bound by a perceived reality, Sohlberg paid tribute to reality by portraying it naturalistically. But his gaze carried with it the legacy of picture formulas that transformed and adapted nature. He was an artist who rarely put a stroke on the canvas before the picture was clear to him in his imagination. As an artist, he was a substitute viewer. What interested him was his own experience and interpretation, regardless of how naturalistic his pictures appeared to be. Ideally everything in the picture was controlled by his will.

As an older man, Sohlberg longed for confirmation that the public saw the values he wished to impart: "It is probably true that for simple and naive reasons my works have aroused sympathy. But I maintain that they have by no means been properly understood for the pictorial and spiritual values on which I have been working consistantly throughout the years."[34] The quotation contains three words which are keys to an understanding of Sohlberg: "Pictorial," "spiritual," and "consistently." The pictorial is means for expressing the spiritual, and one was obliged to stick to the spiritual values one held true.

NOTES

1. Sohlberg in a notebook from 1892-1894, Sohlberg papers, on deposit Håndskriftsamlingen, Universitetsbiblioteket, Oslo (hereafter cited UBO).

2. Perhaps he had in mind to make these as etchings. The interest in creating a series of etchings was a natural consequence of the strong influence that Max Klinger had on the Norwegian art milieu. Sohlberg acquired etching tools in 1896 and made an etching during the time he studied at the Weimar Art Academy between the fall of 1896 and the spring of 1897, most likely with the intention of making etchings of the motifs in the book that he had brought with him.

3. Sohlberg in personal notes from the fall of 1893, UBO.

4. Krag 1893, pp. 129-135.

5. Written autumn 1894, see Bjerke 1991, p. 70.

6. Ibid.

7. Sohlberg, in a rough draft of a letter to the art historian Leif Østby, 1934, UBO. In this letter, Sohlberg refuted the claim that he had been influenced by oriental art. He believed that he had achieved this insight intuitively.

8. As told by Ludvig Ravensberg to Arne Stenseng, November 6, 1946. Stenseng's papers, UBO.

9. Sohlberg to the art historian Carl W. Schnitler, January 17, 1926, Archives of the National Gallery, Oslo.

10. Lorentz Dietrichson in a lecture to the Student Union in Christiania in 1883, see Dietrichson 1885, p. 197.

11. Sohlberg on Munch in notes dated July 23, 1927, and January 24, 1931, UBO. Sohlberg placed Christian Krohg's art above Munch's. It was the works of Munch that were most influenced by Krohg which Sohlberg valued most in his old age.

12. Nergaard, 1978, pp. 113-141.

13. The relationship between the three painters is treated in Boyle-Turner 1989, see especially pp. 125-126 with reproductions of the mentioned paintings.

14. Sohlberg to Olaf Schou, 1900, UBO.

15. Baudelaire in Gide 1949, pp. 499-500.

16. The excerpt is a paraphrasing of Christian Norberg-Schulz: "Human actions exist; they seek out a suitable setting. The setting is thus an integrated part of existence, and its meaning contributes to determining our existence in the world. Actions and needs are fleeting … the setting however has a certain amount of constancy, and allows experiences and events to become a part of a lasting order." Norberg-Schulz 1978/1992, p. 107. Norberg-Schulz has developed a "theory of setting" based on phenomenological analysis.

17. Lorentz Dietrichson (1834-1917) was from 1875 the first professor of art history at the University of Oslo. He was known as a brilliant lecturer and author. In 1870 he published a general introduction to aesthetics that was widely read in Sweden and Norway.

18. Sohlberg to his father, undated, 1900, and to his brother, August 12, 1901, UBO.

19. Sohlberg to Byron L. Smith, Chicago, January 1915, ibid.

20. Sohlberg to Olaf Schou, November 1900, ibid.

21. Sohlberg to Schou, January 21, 1903, ibid.

22. V. Krag in the *Morgenbladet* Kristiania, November 19, 1905.

23. Sohlberg to Ravensberg, December 12, 1903, UBO.

24. Sohlberg to Smith, Chicago, January 1915, UBO.

25. Christian Krohg in the *Dagens Nyt* Kristiania, October 15, 1908.

26. Sohlberg to his sister Dagny, February 7, 1909, ibid.

27. Sohlberg to his sister Ragna, September 14, 1908, ibid.

28. Sohlberg in letter to the artist Olaf Gulbransson, June 11, 1913, ibid. Gulbransson bought the painting the same autumn. He had known Sohlberg from the early 1890s and was at this time a famous caricaturist in Germany. He invited Sohlberg to exhibit along with him in Galerie Tannhäuser in Munich, but due to the ourbreak of World War I the exhibition came to naught.

29. Sohlberg in his diary 1915, UBO.

30. Sohlberg to his sister Ragna, July 21, 1910, UBO.

31. Donald Kuspit writes: "Edvard Munch's paintings, whether or not they overtly deal with depression – like the sickroom pictures and such works as *Melancholy (Laura)* 1899 – are stylistically manic-depressive. I would venture that any work that does not show a manic-depressive tension is not part of the Modernist mainstream." Which painting the author has in mind is unclear, see Kuspit 1993, p. 74.

32. Pola Gauguin in *Dagbladet* Oslo, June 20, 1935.

33. Sohlberg wrote down his thoughts on these topics in a notebook, see Aubert 1896/1917, pp. 21-37,

34. Sohlberg to Jens Thiis, 1925, UBO.

EDVARD MUNCH AND HARALD SOHLBERG

Two Artists and Their Relationship
to the Local Norwegian Art World

Edvard Munch's relationship to the Norwegian cultural milieu alternated between periods of close integration and periods of complete dissociation. In the short period between 1892 and 1897, for example, it might be asserted that Munch was among the most radical and revolutionary artists in Europe. But in regarding Munch's work as a life's work, it is easy to see many references to a Norwegian context. During certain periods, it is obvious that he derived as much from the local context as he contributed to it. As another Norwegian art historian has claimed, without Munch's close relationship to the Norwegian Naturalist painters of the 1880s, he would undoubtedly have "screamed," but would not really have known how to express it.[1] The artistic debates among Norwegian artists and critics during the 1880s imply that Munch had the means at his disposal to create *The Scream*. His position in relation to those debates easily becomes a discussion of whether his intentions had changed during a short visit to Paris in 1885 and his later trips outside the country beginning in 1889. A discussion of this kind is countered with the response that the difference between Munch and the rest of the Norwegian and Nordic artists is a qualitative one.[2]

Every Norwegian painter after Munch has had to accept growing up in his shadow. Strangely enough, no one has tried to systematically trace Munch's influence on Norwegian painting. In his own generation, there was no one who followed him. In the next generation, to which Sohlberg belonged, it appears as if most artists preferred Continental Symbolism to Munch's version. Nor was Sohlberg among Munch's public admirers. On the contrary, what little he had to say about Munch was largely negative. If one studies Sohlberg's art, it soon becomes apparent that in many respects it emerges as a series of negations of Munch's art. These negations sprang from a necessity on the part of the younger painter to conceal his relationship to his idol – and Munch is undoubtedly the all important idol whom Sohlberg would never acknowledge. Sohlberg's maneuvers are so successful that it would never occur to most people to connect the two men. They were, however, compared in a review of an exhibition held in 1991: "In many respects Edvard Munch was Sohlberg's opposite in his view of the picturesque, and this is a far cry from the bold strokes of the former to the delicate transparent glazes of the latter. Nonetheless, they resemble one another

in the view of imparting a philosophy of life through pictures, and with an intensity of expression which they only confided to painting, even though people are absent from Sohlberg's suggestive visions."[3]

In the initial phase of Sohlberg's career, the one artist with whom every other Norwegian artist had to contend in order to make headway was Munch. Sohlberg himself had unusual artistic ambitions. In an age when "newness" was already a requirement for a work to claim authenticity as a work of art, Sohlberg had to distance himself from the artist who stood out as a genius and at the same time served as an idol. In the words of T. S. Eliot: "To conform merely would be for the new work not really to conform at all; it would not be new, and would therefore not be a work of art."[4] At the same time that Sohlberg is concerned with showing his independence, he is equally aware of another demand which is made on the artist if he is to be of historical significance. This is the requirement that T. S . Eliot stated when he wrote that, "No poet, no artist of any art has his complete meaning alone. His significance, his appreciation is the appreciation of his relation to the dead poets and artists. You cannot value him alone; you must set him, for contrast and comparison, among the dead."[5] Sohlberg met this demand through his extensive study of art history.

For a short time during the years 1900 to 1906, there were signs of a "school" of Munchians in Norway. These young painters largely attached importance to the external features of the master's style, but they did not take up his iconography. Nor did they continue the Symbolistic aesthetics which are at the bottom of Munch's work. Rather, they attached themselves to French Post-Impressionism and "art for art's sake." To this young generation, Munch's iconography was connected with the out-of-date Symbolism of the early 1890s.[6]

Exporting culture from the periphery, with the profusion of local myths and traditions resulting in a national ideology of self-identity, creates problems for those who do not understand and accept local codes. The greater the familiarity of the individual artist with the local milieu, the greater the difficulty. Even with an international artist like Munch, there are problems of reception. Munch has an unclarified art-historical status in relation to the fame he enjoys with a large public in Scandinavia, Germany, the United States, and in recent years, also in Japan. Munch has never been fully accepted in England and France. This is due to the dominating formalistic orientation within these two cultures. Munch's egocentricity and exhibitionism, his preoccupation with themes like sickness and death, melancholy, anxiety and despair, and his deformation of nature are to this tradition, all expressions of poor taste.[7] He is famous for a few images – *The Sick Child*, *The Scream*, *Madonna*, and *The Vampire*. Outside of these motifs, there are few of his paintings that are generally well known. The diffusion of large editions of graphic works with the best known motifs has probably resulted in Munch *the painter* being overshadowed by Munch *the printmaker*. His position as a painter is not as incontestable as his position as one of the world's leading graphic artists. The critic who wrote the following evaluation is not alone when he says: "to the random question whether Munch was really a

good painter and not merely an artist of genius, I can only give the final – and rather banal – answer, that he was probably both, though not always simultaneously."[8]

There have been repeated attempts to place Munch at the center of the canon of modernism by including him among the artists with whom some feel he "naturally belongs." Recent exhibitions, such as "Munch and France" and "Munch and Germany," place Munch in relief against the Symbolists as well as the Fauvists or German Expressionists. These clearly reveal, however, that Munch is an artist who simply can't be reduced to a French or German Symbolist or Expressionist. His art is far too complicated a phenomenon to be positioned unreservedly as a phase in the development of mainstream modernism.

Munch was solidly anchored in the dawning Norwegian art scene, and, at the same time, he was rooted in a European network of artists, art dealers, and museums. On the basis of his far more modest position, Sohlberg was only based in Norway. The generally favorable comments he received when he exhibited his paintings outside Norway held out hopes of someday finding a broader base for his work. His difficulties in making a living in Norway made him consider emigrating to the United States, but the outbreak of World War I hindered that plan. Important aspects of the art of both painters placed their work on a periphery. At the same time, their work signaled an acceptance of the general currents of the time, such as Naturalism, Synthetism, and Symbolism. This connection enabled them to communicate above and beyond just the local.

By virtue of being Norwegian, Edvard Munch and Harald Sohlberg found themselves on the geographic periphery of the European cultural community. Each in his own way represented attitudes that were different from the generally accepted ideals of serenity and harmony.

As early as Vasari, we encounter the idea of an ideal center of the art scene, intellectually and geographically located in the southern part of Europe. In order to take part in the highest forms of culture, it was necessary to move to the ideal center. The Norwegian artist finds himself on the periphery of the civilized world in the presentation of European art history. According to Clement Greenberg, an attempt to eliminate provincial status by "orienting" oneself to what is going on in the center without physically moving there is like pulling oneself up by one's own bootstraps. It is merely a way of confirming one's provincialism.[9]

The center-periphery scenario is connected with an idea of hegemony that could be looked upon as an integral part of modernity. The center will try to dominate the periphery in the name of integration and globalism, while the periphery tends to guard its own periphery in the name of pluralism. This localism appears as a critique of both modernity and centralization. Munch is among the few artists who have succeeded in transgressing the boundaries this organization of cultural patterns puts upon the individual artist. His ability to communicate with a public both in the center and on the periphery to a large extent can be explained by the openness of his aesthetics which permits a range of different interpretations of the selfsame work.

If we posit a scenario in which the center is not fixed, anyone can reconcile himself to a status as the inhabitant of his own place instead of localizing himself as a point on a cultural axis with one defined center. This situation arose in Norway with several artists of the generation preceding Munch and Sohlberg. Until the 1880s, only in exceptional cases did Norwegian artists move back to Norway after completing their training at one of the academies in the more southerly regions – generally German. Around 1880, however, an entire generation moved back. This generation intended to establish a Norwegian school of painting on Norwegian soil. Despite their common educational background in Germany, French Naturalism was the main source of their development. The trend toward Impressionism and other more radical currents were observed with curiosity.[10] These artists pursued Naturalism as their main form of expression, convinced that an artist can only maintain his identity by paying attention to the objective world in which he has his roots. This is the world around him, a world which is waiting to be discovered, released, and expressed in art. Norwegian art was to consist of works of art that called attention to the down-to-earth, everyday life – the commonplace, the intimate, and the personal – an art that turned away from the significant themes and heroic exploits of the great tradition. Norwegian Naturalists turned their gaze in different directions. Some took a conciliatory look at their surroundings in order to record them as phenomena. Others took a critical and ideological look at the human condition. Common to all of them was a fundamental attitude that they were seeking their center in themselves in their own fundamental values.

This attitude must not be confused with the nationalistic ideology that feeds on dividing everything into the domestic or the foreign. In the Norwegian debates on art, the national and the international have ideally found interplay, a contrapuntal harmony that is still the motivational force in Norwegian art. It aims at an equilibrium between tradition and impulse. This is a system that is unsympathetic to the ideology of an avant-garde which, in a single leap, pursues art to a new phase in development.

Both Munch and Sohlberg had a "distorted" view. It was only with considerable effort that they were able to regard reality with a conciliatory eye. Each man's relationship to his surroundings was characterized by uncertainty and alienation. This is expressed in their work through heightened awareness of art as the bearer of meaning. Munch and Sohlberg represented in their anti-positivism fundamentally different attitudes to reality than that of the preceding generation. At the same time, they were so strongly attached to it that they were never quite able to break away from the promises and the ideals of art advocated by their older colleagues. As artistic personalities Munch and Sohlberg were molded by the approaches to artistic problems in the local milieu and in the metropolises of Germany and France. Munch's genius was characterized by the fact that he moved more or less like a somnambulist in whatever milieu made up the center of intellectual power in his day, whether in Christiania, Berlin, or Paris. Both artists belonged to a generation that grew up with the conflicts

that finally resulted in the formation of Norway as an independent nation in 1905. In addition, strong feelings for the Nordic and the domestic brought them close to the Norwegian landscape. Even though they took nourishment from activities in the urban milieu, they found their greatest productivity in a rural enviroment – in the small towns along the Christiania Fjord or, in Sohlberg's case, the lonely mountains and mountain plateaus as well.

In Norway the period from 1880 to 1910 was dominated by a small number of central actors. Among the art critics and art historians, Andreas Aubert and Jens Thiis held unique positions. Aubert originally studied theology.[11] For a short time, he contemplated becoming a painter before taking up the history of art. He was a contemporary of the Naturalists of the 1880s, whom he observed at close quarters. In many cases, he was to provide an ideological foundation for their later development. Internationally, he is known for reviving interest in Caspar David Friedrich and Philip Otto Runge. He wrote the standard biography of Johan Christian Dahl – the first Norwegian painter to make a name outside of Norway. Jens Thiis started as the spokesman of Symbolism in Norway.[12] In the 1890s he studied the art of the early Renaissance before becoming the director of the Museum of Applied Art in Trondheim. In 1909 he became the first director of the National Gallery in Christiania. Among the painters, the ideological leaders were Christian Krohg, Erik Werenskiold, and Frits Thaulow. Krohg represented a socially conscious realism; Werenskiold advocated the artist's obligation to foster a national spirit; and Thaulow was a spokesman for art for art's sake. In the 1890s Thaulow made quite a succcss in Paris with his masterly landscape paintings. These made him the most internationally known Norwegian painter before Munch. In the background was Olaf Schou, a patron of the arts and mainstay to almost every Norwegian artist of the period.[13] In the 1890s he acquired several of Munch's most important works. From the turn of the century to 1909, at the end of his life's work as a collector, he was also a close friend of Sohlberg.

THE TRANSFORMATION IN NORWEGIAN ART FROM
NATURALISM TO SYMBOLISM

While it has been customary to call attention to the Symbolist aspects of a number of Norwegian painters of the 1890s, Munch is the only one who had the label "Symbolist" attached to him by his contemporaries.[14] It is not surprising that it was Munch's former teacher, Christian Krohg, who saw reason to indicate that his artistic progeny had now outgrown him by calling him a Symbolist. In an analysis of Munch's art from 1902, Krohg wrote that the implications of his pictures were:

> Munch's own, *personal, individual mood on each separate occasion Not only the mood he gets into by seeing the motif in question, but also the mood he was already in, beforehand,*

regardless of the motif. And then he paints the motif, just the way it looks through this mood in which he happens to find himself. It therefore follows that nature and the motif cannot resemble nature, because this or that changes according to his mood....He does not paint nature, he paints his own mood. He is not a "mood-painter," but a painter of his mood.[15)]

Krohg emphasized the distinction between Munch and the Naturalists by pointing out that while the great goal of his own generation was nature, whether it was rendered with painstaking accuracy or as an abstract, Munch shifted the goal to the idea. In an interview in 1892 Munch said that one should not "paint the way one sees it, but the way one saw it."[16)] Here, we see, Munch connected to the widespread idea in the contemporary Nordic art debate that the artist should seek his ideas in memories. The busy workday was confusing with its variety and prevented the artist from concentrating on essentials. He should direct his attention to the tranquility and solitude of night in order to choose in silence from among his reminiscences. "Then pictures become visible to the mind's eye, hazy, dim pictures from the productive night of the unconscious soul, from its dark, murky depths."[17)]

Munch's goal, and Sohlberg's, was to give expression to the subjective experience of the motif. The concept of nature which is at the bottom of their understanding of reality was never the dead and inanimate matter of Positivism which may be understood by methodically approaching it. In order to understand reality, one had to be indistinguishable from it. Sohlberg expressed this attitude toward the concept of nature in notes from the 1890s when he wrote that through his contact with nature he "felt its mysticism and intangibility, and...instinctively tried to get to know and understand it. There is a great deal that I am unable to understand; in a way I become more uncertain from one day to the next, and I feel more and more ignorant." He asked the naturalistically minded artist: "Does your own personality no longer count; is your understanding of the world supposed to be worth nothing; are you only supposed to feel and investigate with your thoughts and not with your spirit?"[18)] The feeling of being shut out from a complete understanding of nature does not end here in a belief that one is gradually supposed to conquer it and understand everything. To the contrary, the doubt only becomes greater and greater. The conclusion is that the artist must approach nature with his spirit and not with his thoughts alone. This generation of painters sought their answers in metaphysics. Jens Thiis, the art historian, regarded Naturalism in art and Positivism in the sciences as things of the past: "It is undeniable that there are feelings, impressions and concepts which cannot directly be transformed into words or pictures...The new art trend sees in this the last great aim in art, on which it bases its greatest justification. Thus, to a considerable extent, the expression of art becomes the symbol." He defined the symbol as:

a rewriting, a conversion to a solid, perceptible form of that
which cannot be said and portrayed outright. Symbolism must
not be mistaken for allegorization. The Symbolist makes use of
that which gives rise to misgivings and insinuations, for the
purpose of correctly strengthening and expanding the presen-
tation of his personal feelings. And he feels justified in reveal-
ing not only the clear and general feelings, which are more or
less common property but also that which is vague and myster-
ious, and cannot rationally be understood as long as it deeply
moves him alone.[19]

Sigbjørn Obstfelder, the poet who greatly admired Munch, described his style as a "groping for harmony between the characteristic features of the outside world and those of the mind...."[20]

Krohg regarded the desire to give human thought "pride of place" as a further development of the desire of Impressionism to transpose the artistic goal from inanimate nature to the human spirit.[21] It was the way in which an object was interpreted which was interesting. But, unlike the work of Impressionists, Munch's work was, according to Krohg, not attached to time, place, or objective truths. His expression was independent of nature. The artist is able to select, uti- lize, compare, and transform according to his own free will. The individual parts were subordinated to the whole. Krohg identified Symbolism with attempts at a stylization and simplification. Krohg's sympathy for Symbolism may be regarded against the background that a part of the movement was connected with anar- chism: "...Symbolism has declared that absolute freedom must prevail."[22] To Krohg, the Naturalist, Symbolism was a radical continuation of Naturalism, for it drew the human soul itself into the critical examination of reality.

Krohg was sympathetic to Symbolism for his own reasons. Frits Thaulow, Krohg's old friend and Munch's former supporter, took the opposite view. Thau- low went on the warpath in making ironic remarks about the new trend:

Remember, these are concepts you are going to paint, things
which no one has ever seen. These concepts must be experi-
enced, and for this reason they have introduced their philoso-
phy of life. You must speak, speak night after night, and you
must bare your soul with hysterical honesty. – And, in passing,
I may remark: In so doing you will make friends among the
poets who write in the periodicals of the neighborhood and the
local cafe, and like all the others, you will win your fame, if not
of the hour, then of the next ten minutes. During your chatter
you must immortalize a hereditary taint and, as quickly as
possible, render an account of your obtuse salubrity. The Sym-
bolists subsist on mutual ostentatious admiration, aperitifs and
bitter enmity.[23]

Thaulow dismissed Symbolism in a mixture of moral indignation and aversion to its artistic goals. This tendency characterized most of the painters of the older generation. This antagonism hit Munch hard. It was becoming more and more apparent that he sought other artistic goals than the goals of his masters of the preceding generation.

Andreas Aubert acknowledged Munch's genius, and he had a degree of understanding for the new elements in Munch's art. But he also had an ambivalent attitude to Munch based on his ideological standpoint: "I find that morbidness may have a fascinating beauty...but I prefer it to be healthy." Aubert favored a healthy art and culture for Norway. He advocated outdoor life, hiking, and skiing as alternatives to discussions in cafes and a bohemian, debauched way of life.[24] In a review about Munch from 1890, Aubert wrote: "He belongs to those natures with refined, sickly sensitive nerves...who often find a certain satisfaction in calling themselves Decadents; children of a refined, overcivilized period....there is something of a pleasure-seeking self-admiration in his temperament."[25]

According to Aubert, Munch let himself be carried away by the "wildest subjective thoughts" of the day. During his stay in Berlin, "the bastion of neo-Romanticism," Munch began to "create a philosophy out of his art, he took up...the problems of life: the mystery of life, the source of life, the fear of life, the breakdown of life...brilliant here as well, and, above all, interesting as a phenonenon of time, but in danger of ending in an ingenious dilettantism, in a dissolution of pictorial art itself as a form."[26] For Aubert ingeniousness, by definition, was neither healthy nor normal. Similarly, genius was closely connected to the contemporary idea that the ingenious artist was a neurotic person. Munch internalized this idea about himself by writing on the painting *The Scream*: "This picture must have been painted by a madman!"

Norwegian art historians tended to regard Symbolism as a brief, and more or less regrettable, intermezzo. The explanation for this lies in the fact that constructive values in society were identified with formal aesthetic values. These, in turn, were connected with the civilizations of the Mediterranean. A large dose of Mediterranean culture was a necessary antidote to the Scandinavian's supposedly inherent desire to lose himself in chaos.

The prevailing interpretation of the achievements of the period was articulated in a standard work from 1934 by the scholar Leif Østby. Here it was written that the Symbolists in the 1890s "considered it their task to express moods, sensations and impressions which cannot actually be expressed directly in painting." Østby dissociated himself from such an endeavor because "this is an art for 'the great, lonely ones,' who invite 'artistic abracadabra.' "[27] Because it was presented as a fact, that Symbolism represented both a break with the study of nature and contempt for technical problems in painting, it was "doomed to oblivion....An art form must seek its strength first and foremost in that which distinguishes it from all other art forms. But a trend which touches on the areas of poetry and music, and rejects its own means, has lost its raison d'être."[28] On the

basis of this formalistic perspective, Symbolism becomes an unsuccessful project that makes use of art as a means with its goal outside itself and not a means of expression with its goal within itself. In the treatment of Norwegian art from the 1890s, emphasis was placed on decorative endeavors in which the concept of Naturalism was no longer understood as the true-to-life rendering of the details in an object, but as a study of the structure of nature. This new definition of Naturalism was proposed and promoted by Aubert. By emphasizing a study of the structure, there was a renewed interest in the organization of the picture as far as form and color were concerned. The earlier Norwegian Naturalists were able to convince themselves that the decorative art they were creating was a higher form of Naturalism. Around the turn of the century, "decorative" became a key word in the description of what was interpreted as a uniquely Norwegian view of art. Norwegianness was concretely identified as the use of specific colors, forms, and motifs. While "Symbolism" was associated with a metaphysical, speculative attitude connected to the focusing of the individual on the state of his own soul, the "decorative" concept was associated with the positive values embodied in the socially constructive feeling of solidarity. This was supposed to be the contribution of decorative art – to the beauty of useful objects and adorning public spaces – to fulfilling the duties of easel pictures.[29]

SYMBOLIST AESTHETICS AND THE OPEN MIND

The literature about Symbolism in pictorial art constantly reminds us that Symbolism is not identical with every picture that has a symbolic meaning. Symbolism as a trend is limited to pictures in which the content has been depicted in such a way that the form substantiates the content. The symbolic meaning is not connected to a literary content which is being illustrated. The ideal of an identity between form and content found expression in early references to Symbolistic pictures.

The concept of the symbol in Symbolism deviates from the the concept of the symbol in literature and art history, which does not aim to define the concept in relation to Symbolism as a limited trend in art identified by a specific period. Instead it operates with a general concept of the symbol that, in principle, concerns every work of art.[30] General definitions lay the groundwork for the literature about the role of the symbol in culture and in art, independent of a connection to any specific period. The interpretation of the concept of the symbol, which forms the basis of Symbolism in art, must be interpreted as a special case. It is based on a distinction between sign and symbol in which the symbol is defined as inexhaustible, while the sign is unambiguous.

In the literature about Symbolism, it is the concept of the sign and not the allegory that forms the antithesis of the symbol.[31] The allegory is understood as unambiguous and, accordingly, as unartistic.[32] The picture is regarded as Symbolistic in that the viewer discovers an indirect meaning in the picture and ini-

tiates a process of interpretation. The nature and character of the interpretation are decisive factors in the constitution of the Symbolist picture. The picture is interpreted not as a window through which we see nature, but as an experience which will always be new in the encounter between viewer and picture. The Symbolist picture presupposes an active, participating viewer who not only understands but is also a fellow-creator. This is partly why the traditional, rhetorical formulas are victims of a subjectivist vocabulary.[33] In principle, by supposedly being untranslatable, the symbol in this context shows considerable signs of arbitrariness. The symbol opens itself to newly established subjectivism while the allegory is enclosed in an established definition. A tradition is developed in which the two concepts are understood antithetically, culminating in a Symbolism and leading into modernism. In this tradition the symbol is connected with open, Romantic aesthetics, while the allegory is connected with closed and classicistic aesthetics.

Symbolism is a designation for different forms of romantic art. It cannot be identified with a style but with an attitude. This attitude is characterized by the interpretation of reality as something different from and more than what rationalism wishes, without reservation, to explain through reason. Symbolism links different periods of the 1890s together just as Romanticism connects different attempts at ideal art at the close of the century, which are usually recapitulated under the concept of Symbolism. In the twentieth century the tradition continues in the forms of Expressionism and Surrealism as well as in formalism. This tradition is interrupted by the return to the allegory as a form of expression in post-modernism.[34]

The Romantic tradition, with its fixation on the symbol, has been contrasted with what has been characterized in German art as *Gedankenmalerei*, "thought painting." Like Symbolism, *Gedankenmalerei* wishes to give shape to the invisible world of the psyche, but it does not seek the unity of Symbolism in form and content. Form and content remain parallels. The pictures become personifications or allegories. In German art, the trend forms a tradition from Arnold Böcklin, Moritz von Schwindt, and Hans Thoma down to Max Klinger and Franz von Stuck – a tradition which was quite familiar to Norwegian artists.

This *Gedankenmalerei* is often referred to as Symbolism, and any sharp distinction between the two is difficult to draw. We also encounter the term "allegorical Symbolism" in connection with the artists who undertook a naturalistic presentation of esoteric themes.[35] In the 1970s and 1980s, a renewed interest in allegory has also given rise to doubts about Romanticism in so far as it has been alleged to be free of allegory, in the sense of underlying programs or texts. Rather, it is instead a question of secularized allegories based on the artist's individual experiences.[36] On closer examination, the attempts to create a "private" imagery in Romantic and Symbolist art turn out to be full of conventions.

Symbolism assumes forms which are in accordance with the understanding of the symbol as "indeterminable." It may appear to be anticlassical, antinatural, ironic, primitive, melancholic, reminscent, pessimistic, perverse, or historiciz-

ing. In Symbolism, the artist is not required to imitate nature. This fact did not prevent most Symbolists from keeping to a modified naturalistic style. The use of a naturalistic mode of expression in a trend where imitation was not a goal may appear contradictory. It has to be seen, however, in light of an idea that has been handed down to us from Romanticism: "Nature was...the highest norm and the guideline of art. The basis of an authentic work lies in artist's own encounter with nature. The conventions are rejected, and memorized methods are regarded as more harmful than beneficial."[37] It is in a perspective such as this that Sohlberg's detailed photographic naturalism can sometimes be understood.

A mixture of styles is a characteristic of Nordic painting of the 1890s. At times this painting may be interpreted as symbol-saturated representations of motifs, at times as Symbolism with synthetising forms, and at other times as neutral representations without symbolic layers. The classification of the material is encumbered by the same subjective evaluation as the interpretations. "Eclecticism" in symbolic painting reflects a fundamental ambiguity as a principle. This is in agreement with Symbolism's understanding of the symbol as "indeterminable." Ambiguity of content is accompanied by a mixture of styles, and of permutation – a union of the incompatible and illogically connected – and a deformation of the object of nature. [38] Deformations in Symbolistic pictures have been interpreted as an expression of the desire to break with classical demands for beauty. This break expresses the wish to portray nature as unharmonious, threatening, and hostile. [39] Stylistically, deformation is a deliberate transformation of the natural motif that leaves the point of departure still recognizable. Aesthetic formulas and classical values such as order and rationality are broken down. This is one of the prerequisites for subjecting the picture to persistent "reframing," at the same time that traditional interpretations settle like a transparent coating, a thick veneer which unites the original substance and through which we interpret the work. In formalist criticism, permutation as well as deformation have been condemned for contributing to a "breach of style" and breaking down the classical norms. In criticism which places greater emphasis on imparting content than on whether the form fulfills a demand for unity, the significance of techniques of style will be emphasized as necessary to the specific expression the artist wishes to convey and the content he wishes to express.

The often unfinished quality is a special characteristic of Edvard Munch's art. He never stopped hearing about this characteristic from the time he completed his first independent work. This characteristic is also a part of, and a consequence of, the open and ambiguous association with aesthetic categories, norms, and interpretations of the work that characterize the phase of Symbolism to which Munch belongs.

Even at an early stage, Sohlberg developed a working method in which expressive detail was focused precisely and reproduced naturalistically as a decorative whole. Detail was not to break the surface into disturbing fragments. Detail was supposed to characterize a motif and was to be subordinated to the whole. Sohlberg was attached to that which was overlooked. He said of himself

that the beauty and learning in the least little thing was enough to drive him to despair. Unlike Aubert, who interpreted the "unfinished" as an expression of carelessness, the emphasized fragment, the unfinished, and the coincidental bear witness to a confidence in the unity in the universe. Every part of the visible world has a share in the essence. Sohlberg expresses an interpretation of this kind when he writes: "If only I might use my ability as a painter to describe the greatness which in my best, most receptive moments, extends like a breath from the divine, the inexplicable greatness, down in my little, imperfect soul!"[40]

The Romantic idea of naturalistic descriptive form has its roots in respect for a greater principle which is latent in each little fragment of reality. From Friedrich and Dahl, down to Munch and Sohlberg, Romantic artists hoped to share in something great and divine by portraying nature. Naturalistic portrayal is not opposed to the idea of a distinction between the finished and unfinished work. To the contrary, the finished and perfect picture was something unattainable. It could only be approached. Sohlberg was known as an artist who could work on his paintings for years. The reason for this was not so much that he sat working on the paintings but that he was unable to make up his mind whether or not they were finished. The need for money often determined when the work had to be signed. Even so he was never willing to do "sloppy" work.

Only a limited number of landscape paintings in the 1890s fell within the framework of the concept of Symbolism, characterized by the idea that the symbol is open to differerent interpretations. If we make a supposition that a connection between man's spiritual life and the moods of nature is fundamental to Symbolist landscape painting of the 1890s, then Munch and Sohlberg occupy a unique position in Norway. They are the artists who were most obviously influenced by it in their art. Also, they are the artists who most clearly represented attitudes suggesting that they had deliberate intentions in agreement with a "symbolistic program." This, in itself, distinguishes their approach from the attitude toward reality held by the older generation of Naturalists. A concept like "Neo-Romantic mood-painting" – which is commonly used in the Scandinavian literature on the period – overshadows the new elements which come into painting around 1890. Parallel to the emergence of modern psychology, this approach emphasizes the importance of the unconscious. New meaning was given to the concept of "subjectivity," and there was a new grasp of the irrational to which the artist attempted to give form. The identification of the mood landscape with the symbolic landscape has contributed to overshadowing Symbolic painting in the North as an original contribution to European painting of the time.[41] Landscape painting played a subordinate role in Symbolism, except in the North, where there was a strong representation of the landscape genre and pictures representing a rapport between figure and landscape.

The development of landscape Symbolism in northern Europe was conditioned by the fact that Romanticism's break with the allegory was especially useful to landscape painting. Romanticism undermined the established definitions which had traditionally been given to natural phenomena and broke down the

genre hierarchy by doing away with the established decorum. The aim was to find spontaneous communication unimpeded by convention. Historical painting was pushed out of the center by a kind of landscape painting in which the two extremes of Romanticism – realism and art for art's sake – could reach a synthesis. This was a landscape painting that revealed latent meaning, the hidden meaning of nature.

The breakdown of decorum makes it difficult to limit the elements which are entitled to interpretation. The evaluation of whether an interpretation is true or false gives way to an evaluation of whether it is more or less reasonable. Everything that can be isolated – every difference – implies a meaning, from the format and division of the picture surface to the framing and placing of the work. Layer upon layer of interpretation can be uncovered, and everything is charged with meaning. This is an art which, to varying degrees, is aware of, adapts, and refers to the nature of its construction. There is nothing in the picture that has not been put there. Even the accidental is part of the artist's method, revealing his unconscious mental state. In a culture in which the individual elements in a picture are not relegated to their places on the basis of decorum or rule, a higher or lower ranking of the meanings that are to be emphasized becomes an ideological operation. The distinction between the arbitrarily selected fragments, which have "hidden meanings" forced upon them, and the "specific symbol" is removed. Interpretation becomes a dialectical process in which the work is an activator. It engenders interpretations that result in new interpretations that, through the entire process, point back to the preconceived conceptions, ideological convictions, cultural and social affiliations, and the schooling of the interpreter.

Consistent with Symbolism's predilection for the equivocal, landscape Symbolism develops a picture formula which has its equivalent in the composition of the picture. The motif can be the encounter between the surface of the sea and the sky, or a plain and the sky. The colors are more or less monochrome, most often blue. Historically, this goes back to Friedrich, but it is Whistler who devotes considerable space to both the motif and its form in late nineteenth century art. The type of picture is an illustration of the idea of the picture plane as a membrane. There are three different attitudes among the artists in relation to this membrane. Ideas may be projected onto it, penetrate it, or cover it. [42] When the Symbolist paints his ocean and sky upon this membrane, he is projecting his idea of the picture plane as a surface which conceals other, underlying and deeper layers. By painting an ocean surface onto the membrane, the picture plane is doubled and pointed out as a membrane in itself which carries the symbol, "ocean surface," as a symbol of that which covers greater and more hidden depths.

Munch and Sohlberg both treat the picture plane as a membrane. They are concerned with breaking through the membrane and reaching the hereafter. Creating a good ornament is not a goal in itself. For this reason, the use of the terms Art Nouveau and Jugendstil in reference to these artists is misleading. The

wavy lines in Munch's art of the 1880s are often referred to as an example of the sinuous line of Jugendstil. But where Munch uses the line to create expression and meaning, the Jugendstil line moves in the direction of the purely decorative and tempers both meaning and content. In his study of Symbolism, Robert Goldwater introduces a distinction between Symbolism and Art Nouveau based on two different approaches to the formation of space. Symbolism is characterized by the fact that the different areas are projections on the level of observed perspectives and values. Art Nouveau aims at flatness and is distinguished by silhouettes which, from the beginning, exist and are composed only in two dimensions.[43]

The concept of a radical distinction between the Latin South and the German North is frequently made the basis of speculations about a "Nordic identity" in art. Even Thiis connected Munch's art with Germanic culture and race:

> *When* (there was) *a new Romanticism, entirely different from the old, because it was saturated with naturalistic psychology ... when minds were in a ferment throughout the world, but especially in the Germanic lands, there was no greater enthusiast than Edvard Munch. In terms of race, temperament and environment he was destined to be the liberator – Ibsen's compatriot, neurasthenic and anarchist, but with ancient religious mysticism smouldering in his veins. The ancient aspirations of the Germanic race`for ideas and lyricism have found no greater modern expression than in Munch's art of the 90s... and this explains his early and lasting fame in Germany.* [44]

To Aubert the Positivist, this mention of "religious mysticism" and ideas about, the qualities of the "Germanic race," must have brought back associations to Romanticism he thought had been surmounted through Naturalism. With the outbreak of World War I, it was no longer good form to emphasize ancestry of this kind for Munch's art.[45] As for Sohlberg, he always felt that his art was closely connected with German culture without seeing any connection to racial explanations in this. To him German culture was identical with the heritage of Goethe, Kant, and Schopenhauer.

Aubert and the artists of the Naturalist movement had a strong wish for dissociating Norwegian culture from German culture. This resulted in the claim that there is something "Un-Norwegian" in Continental Symbolism with its contrived and hypothetical character. The understanding of the mood-landscape as a continuation of the Naturalism of the 1890s implies an extrapolation of Naturalism to a new group of motifs. This could be accepted on the condition that it did not involve any aspirations to mysticism. By the turn of the century, however, the young painters of the 1890s had grown up. With relief, critics and art historians ascertained that Munch had come out of the shadow of the 1890s. After the turn of the century, he moved in the direction of a more colorful art and gradually

played down the symbolic undertones. This was regarded as a confirmation that Norwegian art was seeking wholesomeness. Munch himself had fallen into the fold. According to the same critics and art historians, Sohlberg continued his wandering in the "valley of shadows." His position became more and more marginal until he stood alone as a special case and an anachronism.

In connection with the gradual rehabilitation of Symbolist currents in the 1950s and 1960s, the distinction between North and South was removed from race and connected to religious factors as a link in the explanation of the differences between French and German-Nordic Symbolism. According to this hypothesis, Nordic pietism has created conditions for an attitude which rejects doctrine and outer form, as opposed to Catholicism's doctrinaire and ritual character. The concept has been significant to the understanding of what is included in the concept of "Symbolism" in different cultural circles. For example, it forms the basis of the claim that French Symbolism emphasized the analogy between an artistic symbol form and outer reality, and formal objective criteria gave the work a closed microcosmic character. [46] The background was the admiration of the French Symbolists for the classical masters. The result was a synthetic, logical-rational style, formally closed and with a generalizing content. German Symbolism, on the other hand, emphasized subjectivity, the projection of emotions and an identification with nature with a background in the transcendental, idealistic philosophy with its solipsism. The result was a concretizing of the artist's own feelings, an open metaphorical structure that invites identification, as well as an introspective and irrational message. Related concepts lie behind Robert Rosenblum's hypothesis of an alternative tradition within modernism, different from that which has its center in Paris and which runs from David to Picasso. The alternative tradition reaches from Friedrich to Rothko, and has its main area in northern Europe and the United States.[47] Symbolism is not a central concept for Rosenblum. For him, the crux of this tradition is found in the search for the sublime experience of nature as an expression of the longing to find something sacred in a secularized world.

Rosenblum's hypothesis gave more weight to the art that found itself on the outskirts of the European cultural community. In Rosenblum's book, the Norwegian Romantic landscape painters of the 1850s are placed in a connection in which they are understood as participants in a continual artistic project. They are part of a great tradition that continues into the present and one that has given rise to some of the most important art of modernism.

Rosenblum's hypothesis has as a condition the cultural South-North axis in Europe. This is identical to the axis that determines the center-periphery connections of Europe. Here the Alps form the geographic center through which the dividing line runs between a South searching for harmony and balance in cultural expression, and a barbaric North characterized by disharmony. Related concepts were prevalent among art historians in the German-speaking countries from the turn of the century to World War II.

Placing the art of the Symbolists in a conceptual framework relating to style,

cultural geography, psychology, and ideology will always be problematic. Symbolism, by its very nature is open-ended; rather than one distinct style, it is characterized more as a way of seeing beyond appearances. Extremely diverse and often intensely personal, Symbolist paintings, like Symbolism itself, are open to interpretation. This open-ended aspect of Symbolism parallels the fundamental ambiguity of modernism, in which the artist's representation of reality is continually questioned.

NOTES

1. Messel 1994.

2. The idea of placing Munch in the Norwegian context encounters resistance because it can be mistaken for a revisionist attempt to discover what has been overlooked and omitted. The critic Joseph Masheck experienced the Scandinavian art presented in the *Northern Light* exhibition as a home-grown, half-conscious provincial art. To his opinion the exhibition tried to drown Munch's art in an "ethnic typicality" to which it can never quite be subjected. According to him, Munch was saved from the remaining Symbolists by his vital Expressionism. See Masheck 1993, p. 151.

3. Harald Flor in the *Dagbladet,* Oslo, September 12. 1991.

4. Eliot, "Tradition and the Individual Talent," in Kermode 1975, pp. 38-39.

5. Ibid.

6. Messel 1989, p. 122-136.

7. Herbert Read called attention to this point, see Read 1963. He writes that he himself grew up in an English province and became aware of Munch's art thanks to his own position as a dweller in a periphery in Yorkshire, "The part of England which is most Scandinavian." Read wrote the introduction to the catalogue of the first exhibition of Munch in England, in the London Gallery in 1936.

8. Blomberg 1951, p. 58.

9. Greenberg 1986, 2, p. 3 (written in 1945). According to Greenberg: "There are two sorts of provincialism in art. The exponent of one is the artist, academic or otherwise, who works in an outmoded style or in a vein disregarded by the metropolitan center—Paris, Rome or Athens. The other sort of provincialism is that of the artist—generally from an outlying country—who in all earnestness and admiration devotes himself to the style being currently developed in the metropolitan center, yet fails in one way or another really to understand what it is about." The last passage was in reference to Wassily Kandinsky. Greenberg never discusses Munch in his writings but presumably would have put him in the second category, while Sohlberg would have fitted the first category.

10. The concept is used in this text according to the use in Weisberg 1992. Weisberg makes special reference to the Scandinavian Naturalists, pp. 242-273, with emphasis on Krogh, Werenskiold, and Heyerdahl among Norwegian artists.

11. No monograph has been written on Aubert. The most informative study of Aubert is Messel 1994.

12. On Thiis see Mæhle 1970.

13. On Schou see Skedsmo 1988.

14. Krohg 1989, p. 48 (first published in *Verdens Gang,* November 27, 1891). The article is about *Evening:* "The picture is serious and severe—almost

religious ... related to Symbolism—the latest trend in French art."

15. Krohg 1989, pp. 49-51 (first published as "Edvard Munch, en analyse," *Verdens Gang,* December 28-29, 1902).

16. Ibid., p. 49 (first published in Krohg, *Kunstnere,* 2nd series, 1892). Stang 1977, p. 34, quotes a note by Munch dated around 1890, saying: "I do not paint what I see—but what I saw."

17. Lange's thoughts about the importance of the art of memory, published in 1889, was of considerable significance to the aesthetic debate in Denmark and Norway around 1890 and was regarded as a cry for a new art. See Lange 1903.

18. Bjerke 1991, p. 37.

19. Thiis 1920, p. 10 (first published in 1893).

20. Obstfelder 1950, p. 285.

21. Krohg 1989, pp. 61-62 (first published as "Edvard Munch, et forsøg," *Samtiden* 1896, pp. 17-22).

22. Ibid.

23. Thaulow 1992, pp. 143-144.

24. Lange 1990. Lange points out that when Heller (1978), taking as his point of departure an article by Aubert in the *Dagbladet,* Christiania, November 5, 1890, about modern decadence, interprets Aubert as a spokesman for this, he is turning the situation upside down. In his article Aubert wished to express his fear of decadence.

25. Aubert, *Dagbladet,* Christiania, November 5, 1890.

26. Aubert 1904, p. 93.

27. Østby 1934, p. 114.

28. All the quotations are from ibid., p. 115. It is evident from the context that "the actual world" is identical to nature as it appears to the eye.

29. Aubert 1917, pp. 21-37.

30. The theme is treated in Messel 1982 and elaborated on in Malmanger 1985.

31. This antithetical interpretation of the two concepts is to be found in Arnold Hauser's interpretation of the distinction: "In comparison with the symbol, the allegory always appears as a simple, general, and to some extent superfluous transcription of an idea to which nothing has been added by being translated from one sphere to another. The allegory is a form of rebus which has an obvious solution; while the symbol can only be interpreted but can never be solved." See Hauser 1951/1962, p. 184.

32. Gadamer 1960/1975, p. 67 "Symbol and allegory are opposed as art is opposed to non-art, in that the former seems endlessly suggestive in the indefiniteness of its meaning, whereas the latter, as soon as its meaning is reached, has run its full course." In German aesthetics the symbol concept takes precedence over allegory around the end of the eighteenth century. Previously they had been regarded as synonymous.

33. Malmanger 1991, pp. 67-89. Malmanger takes as his point of departure a claim that Romanticism was not concerned with the artificial means as such, but had the intention of finding out what exists before anything is constituted as art (p. 67). In order to realize this goal, conventions and doctrines had to be rejected, and with that the rhetoric as well (p. 74).

34. Owens 1992, pp. 52-87. Owens attacks the concept of allegory as "inartistic." The concept that the symbol is a fragment which indicates and represents the whole presupposes that the whole can be reduced to an inner essence of which the elements in the whole are only the phenomenal expressions. The essence is present in all the parts as an inherent principle; the inner essence and the external expression are identical. The symbol comprises this essence, which is reached through intuition, while the allegory rests on convention and is the antithesis of it. Naturally enough renewed interest is paid to the allegory under postmodernism where interpretation can no longer assume the same central position as in modernism but is succeeded by appropriation where existing signs or codes are taken over or acquired. The return of allegory is intimately connected to the breach with the concept of a story where a theme is developed. This coordination of different options with an inconclusive relationship to the question of whether they should or could be reconciled or combined forms an illuminating contrast to what Walter Pater writes about the attempt in the Renaissance to "reconcile forms of sentiment which at first glance seem incompatible, to adjust the various products of the human mind to one another in one many-sided type of intellectual culture...." This attitude sprang out of a "lack of the historic sense," which prevented them from being regarded as "stages in the gradual education of the human mind.... In their attempts to reconcile the religions of the world, they were ... thrown back upon the quicksand of allegorical interpretation." Pater 1980, pp. 23-38 (quotes are on pp. 23, 25, 26).

35. Nasgaard 1984 introduces a distinction between allegorical Symbolists and the genuine Symbolists: The *allegorical* Symbolists, while inventing new esoteric subject matter, represent it in conventional styles and thus continue to parallel rather than fuse content and meaning; the *true* Symbolists do not so much search our new themes and subjects as invest the given ones with subjective and transcendental meaning. The latter achieve seamless continuity between external forms and states of inner feeling, freely transforming their belief that meaning and form are inseparable." (Nasgaard 1984, p. 5). This last position is characteristic of the Synthetists, with the emphasis they place on the fact that formal transformations of the content provide a direct and unintegrated expression of the meaning.

36. Paul de Man points out allegories in works which are ordinarily read as filled with symbols. De Man 1969/1983 pp. 00. Inspired by de Man is Joseph Leo Koerner's discussion of allegories in Friedrich, see Koerner 1990, pp. 122-142.

37 Malmanger 1991, p. 74.

38. Hofstätter identifies ten pictorial methods of procedure that he believes are characteristic of Symbolistic art. Hofstätter 1965, pp. 81, 86.

39. Loge 1991, discusses "Nedbrytingen av det klassiske naturbildet i norsk landskaps kunst" [The breakdown of the classical nature picture in Norwegian landscape art]. The point of departure is Nietzsche's concept of "the Apollonian as a "defence" against the Dionysian—nature and the horror of existence (p. 15). In classical Greek culture the Dionysian is displaced. In the eighteenth century, this "classical esthetics of moderation and rationalism was regarded as insufficient." The concepts of the sublime are expressions of the return of the Dionysian elements in European culture.

40. Harald Sohlberg in his diary, August 11, 1921, see Bjerke 1991, p. 240.

41. The large Nordic exhibitions "Northern Light" (1982-1983) and "Nordiske stemninger" [Nordic Moods] (1987) were both attempts to present a more homogeneous picture of the Nordic painting of the period than had previously been the case by emphasizing the transition from Naturalism to Symbolism as a change within Naturalism and not as a breach.

42. McEvilley 1993, pp. 9-56, under the heading "The Monocrome Icon," discusses the concepts and the tradition about the monochromatic painting from Whistler to contemporary art.

43. Goldwater 1979, pp. 18, 23-25. Naturally enough, Munch occupies a prominent position in Goldwater's presentation. Goldwater's account of Art Nouveau is based on Schmutzler, but he adapts the attempts to provide a description of style to his own purpose—to create a polarity between Symbolism and Art Nouveau-a fact which is outside Schmutzler's presentation.

44. Thiis 1907, p. 419.

45. Märtz 1994, pp. 131-138. Belting 1992.

46. Rossholm 1972, pp. 95-112, and Rossholm 1974.

47. Rosenblum 1975/1983.

Edvard Munch Chronology

1863
December 12, Edvard Munch is born on Engelhaug farm in Løyten, the son of Army Medical Corps doctor Christian Munch (1817-1889) and Laura Cathrine, née Bjølstad (1838-1868). The couple had five children.

1864
The family moves to Christiania (Oslo) in the spring.

1868
EM's mother dies of tuberculosis. His aunt, Karen Bjølstad (1839-1931), takes charge of the household.

1877
EM's favorite sister, Johanne Sophie, born in 1862, dies of tuberculosis.

1879
EM enrolls in the Technical College to study engineering.

1880
EM starts painting in oils. At the end of the year, he decides to become a painter and leaves the Technical College.

1881
In August EM enters the Tegneskolen [School of Design] in Christiania. He sells two of his paintings at an auction.

1882
EM rents a studio with six young painters. His work is influenced by Christian Krohg.

1883
EM exhibits his paintings for the first time in the Summer Exhibition of Industry and Art. In August he attends the «Open Air Academy» for young artists organized by Frits Thaulow at Modum outside Christiania. EM participates in the state exhibition for the first time. His painting is purchased by Frits Thaulow.

1884
Frits Thaulow awards EM a scholarship, enabling him to study in Paris, but the journey is postponed owing to illness. He receives a grant from the Schäffer Bequest Fund. He attends the Open Air Academy in September. He becomes acquainted with the Christiania bohemians.

1885

In May, EM visits the World's Fair in Antwerp where he sees works by Puvis de Chavannes and Jules Bastien-Lepage. EM goes to Paris and stays for three weeks. He visits the Louvre and the Salon and may have seen Impressionist art in the galleries of Durand-Ruel and Georges Petit. EM spends the summer in Borre. He has an affair with a married woman—Millie Thaulow. He acquires a studio away from home. He receives a grant from the Schäffer Bequest Fund.

1886

EM paints outside Arendal during the summer. He exhibits *The Sick Child* and three other paintings at the state exhibition. The picture is disparaged because it appears to be unfinished. Later he partially paints over the picture.

1887

EM spends the summer at Veierland outside Tønsberg. He exhibits six paintings at the state exhibition.

1888

EM visits Copenhagen to see an exhibition of French art, including work by the major artists of the nineteenth century, as well as a selection by Naturalist and Impressionist painters and Jean François Raffaëlli, an artist who was to be of great importance to EM in the years to come. At a Nordic exhibition in Copenhagen he is represented by two paintings. He stays with the painter Karl Andreas Dørnberger outside Tønsberg and visits Åsgårdstand.

1889

In April EM holds his first retrospective, one-man exhibition in Norway with 110 works. Six prominent Norwegian artists support his application, and in July he receives a government travel grant. He exhibits *Inger at the Seashore*, painted during a stay in Åsgårdstrand, at the state exhibition, and it is purchased by the painter Erik Werenskiold. EM goes to Paris in October where he studies under Léon Bonnat. EM exhibits a painting at the Exposition Universelle. He has the opportunity to see large exhibitions of the Impressionists and Synthetists, as well as the Salon des Indépendants, featuring work by van Gogh, Seurat, Signac, and Toulouse-Lautrec. EM writes an illustrated diary in which he develops some of the themes for the project titled *Frieze of Life*. He learns of his father's death on December 4.

1890

An influenza epidemic breaks out in Paris. On January 2, EM moves to St. Cloud by the Seine, just outside Paris. He gets to know the Danish poet Emanuel Goldstein. He spends the summer in Norway and exhibits ten paintings at the state exhibition. His government scholarship is renewed. On his way to Paris he stays at the hospital in Le Havre for the treatment of a rheumatic ailment. He has a short stay in Paris.

1891

From January to April EM visits Nice. He arrives in Paris at the end of April for the closing of the Salon des Indépendants, in which van Gogh is given a place of honor with ten paintings. A large number of paintings by Seurat and the Neo-Impressionists, and by Toulouse-Lautrec, are also displayed. EM returns home by way of Antwerp on May 29. He spends the summer in Åsgårdstrand, where he keeps in touch with Christian Krohg and his wife, the painter Oda Krohg. EM exhibits six paintings at the state exhibition (the

last time he will exhibit there). The National Gallery purchases its first painting by him from the exhibition, a radical purchase that implies considerable recognition. He receives a government scholarship for the third time, and in November travels to Nice with the painter Christian Skredsvig, by way of Copenhagen, Hamburg, Frankfurt, Basel, and Geneva. In Copenhagen, he may have seen paintings by Paul Gauguin in the Cafe Bernina or in the home of his wife, Mette Gauguin. In Hamburg, he pays special attention to Arnold Böcklin's *The Sacred Fire*. In his sketchbooks he elaborates on several of the motifs for the *Frieze of Life,* which he will continue to work on in years to come.

1892

EM works under the influence of Gauguin, Toulouse-Lautrec, and van Gogh. He returns home by way of Paris at the end of March. He stays in Christiania and, during the summer, in Åsgårdstrand, where he paints Symbolistic landscapes. In the fall he has an exhibition in Christiania and is invited by Verein Berliner Künstler through the Norwegian painter Adelsteen Normann, then living in Berlin, to exhibit fifty-five paintings at the Architektenhaus. The exhibition opens in November, causes a scandal, and is closed after a week. The uproar in the Berlin art milieu leads to the formation of the Berlin Secession. The exhibition travels to Düsseldorf and Cologne.

1893

EM resides in Berlin. He exhibits in Copenhagen where he meets the Symbolist painter Johan Rohde and sees his extensive collection of reproductions and graphic works, which includes works by Odilon Redon and the Nabis. Two friends of EM, C. G. Uddgren and Max Dauthendeys, publish *Verdenssalt. Det nye sublime i kunsten* [The Salt of the World: The New Sublime in Art] in which EM is associated with French-Belgian Symbolism. There are exhibitions of EM's work in Copenhagen, Breslau, Dresden, Munich, and Berlin. Five paintings by him are included in the World's Columbian Exhibition in Chicago.

1894

In February EM exhibits in Ugo Baroccio's Gallery in Berlin along with the Finnish Symbolist Axel Gallen-Kallela. The Polish-German writer Stanislaw Przybyszewski edits *Das Werk des Edvard Munch*, published in Berlin in July. EM exhibits seventy paintings as well as drawings in Stockholm's Konstförening in October. He begins his graphic production with etchings.

1895

EM exhibits in Berlin in March and stays there until June. Julius Meier-Graefe publishes a portfolio of eight EM etchings. He pays a short visit to Paris before returning to Norway, where he spends the summer in the Skjeggedalstindene mountains, and with his family in Christiania and Åsgårdstrand. After a visit to Paris in September, he travels to Christiania by way of Amsterdam and opens an exhibition that later goes to Bergen and Stavanger. In addition to the ticket sales, the exhibition in Christiania brings in money from the sale of one painting and six etchings. He shares a studio in Universitetsgaten with the Symbolist painter Alfred Hauge. EM's brother Andreas dies.

1896

EM travels by train from Christiania to Paris by way of Berlin on February 26. He has an affair with the Norwegian painter Tupsy Jebe. He exhibits ten paintings at the Salon des

Indépendants which opens April 1. He prints his first woodcuts. EM is commissioned by Les Cent Bibliophiles to illustrate Baudelaire's *Les Fleurs du mal,* and he makes sketches, but the book is never published. In May and June he exhibits twenty-five paintings and fifty graphic works in Siegfried Bing's L'Art Nouveau Salon. On June 1, 1896, Strindberg publishes prose poems to the paintings in *La Revue Blanche.* Andre Gide reviews the exhibition in *L'Aube.* EM visits Daniel Monfried, who is storing Gauguin's paintings while the artist is in Tahiti. In July EM has a short stay in Norway and in August, in Knokke-sur-mer in Belgium. He is commissioned by Lugne-Poe to illustrate the program for Henrik Ibsen's *Peer Gynt,* for the Theatre de l'Oeuvre, a theater closely connected with the Nabis.

1897
EM exhibits seven graphic works at La Libre Estethique in Brussels from February to April. He exhibits ten works from the *Frieze of Life* at the Salon des Indépendants. He designs the program for Henrik Ibsen's *John Gabriel Borkman* at the Theatre de l'Oeuvre. He spends the summer in Åsgårdstrand, where he buys a small house. He exhibits in Christiania in September and later in Berlin. He spends the autumn and winter in Christiania. He has an affair with Tulla Larsen, daughter of a rich wine merchant. He participates in a Scandinavian exhibition in St. Petersburg.

1898
EM is invited to participate in the Free Exhibition in Copenhagen. He goes to Berlin in March and then to Paris in April, where he exhibits at the Salon des Indépendants. He stays in Paris barely two months and spends the summer in Åsgårdstrand and the autumn in Christiania.

1899
EM participates at the Biennale di Venezia and has a one-man show in Dresden. In the spring, he travels with Tulla Larsen to Florence by way of Berlin, Paris, and Nice. He goes to Rome, where he becomes enthusiastic over, and inspired by, Raphael and wishes to create decorative murals. He is back in Paris by the middle of May and spends the summer in Åsgårdstrand. The National Gallery purchases two of his large paintings. He spends the autumn and winter at a sanatorium in Gudbrandsdalen.

1900
In the spring EM travels to Berlin, Nice, Florence, and Rome. He stays in a Swiss sanatorium and spends July in Lake Como, Italy. He exhibits in Christiania and Dresden. During the winter he paints landscapes at Ljan southeast of Christiania.

1901
EM spends the summer in Åsgårdstrand. He goes to Berlin in November. He participates in a Scandinavian exhibition in Vienna and an international exhibition in Munich as well as exhibitions in Christiania and Trondheim.

1902
EM spends winter and spring in Berlin. He is invited to exhibit at the Berlin Secession, where he exhibits twenty-two paintings under the title "22 bilder aus dem modernen Seelenleben." Albert Kollman takes on the task of handling Munch's art in Germany and works at this unceasingly. Through Kollman, Munch is introduced to Dr. Max Linde—an eye specialist and patron of the arts in Lübeck. EM exhibits graphic works in Lübeck, Dresden, Christiania, Rome, Vienna, and Bergen. He spends the summer in Åsgård-

strand, where he ends his relationship with Tulla Larsen after a dramatic shooting episode in which he loses part of a finger on his left hand. In the autumn, he stays with Dr. Linde and completes a portfolio of sixteen etchings with motifs from Lübeck. Linde publishes *Edvard Munch und die Kunst der Zukunft* [Edvard Munch and the Art of the Future]. EM is introduced in Hamburg to Gustav Schiefler who will catalogue his prints.

1903

In January, EM has an exhibition of prints in Paul Cassirer's gallery in Hamburg and later of paintings at Galerie Commeter. He goes to Paris in the beginning of March and exhibits at the Salon des Indépendants. The Russian art collector Morozov buys a version of *Girls on the Jetty* now in the Pushkin Museum, Moscow. EM enters into an intimate relationship with the violinist Eva Mudocci, one of Matisse's friends and models. In April, EM paints Max Linde's sons in Lübeck. He spends the summer in Åsgårdstrand. In September, he exhibits the *Frieze of Life* at Blomqvist's gallery in Christiania. In November, he exhibits at Paul Cassirer's gallery in Berlin, where his works share the main room with a collection of Goya's works.

1904

In January and February, EM exhibits graphic works in the Gesellschaft Hamburgischer Kunstfreunde and sells 800 prints. He becomes a member of the Berlin Secession and is given a room of honor at the Secession exhibition in Vienna. EM influences Austrian painters such as Richard Gerstel, Egon Schiele, and Oskar Kokoschka, who in 1952 writes an article in praise of EM. In the spring, he is invited to stay in Weimar by Count Harry Kessler. EM exhibits five paintings at the Salon des Indépendants, and is labeled a Fauvist by the critics. He spends the summer in Åsgårdstrand. In the autumn he travels to Lübeck, Travemünde, Copenhagen, Berlin, and Hamburg. He exhibits at international exhibitions in Prague, Düsseldorf, and Copenhagen and has a large one-man show in Christiania in October.

1905

EM exhibits portraits in Berlin in January. During the year he has exhibitions of graphic works in Copenhagen, Vienna, Stockholm, Berlin, and Munich. At the Manes artists' association in Prague, he is enthusiastically received and has a great influence on a number of young Czech painters. He exhibits graphic works at the Salon d'Automne in Paris. He spends the summer in Åsgårdstrand, where he quarrels with the painter Ludvig Karsten. A rumor that Munch fled the country to escape being called up for military service upsets him so much that he does not set foot in Norway for the next four years. He comes into contact with Ernst Thiel, a Swede, who purchases a considerable number of his works in the coming years. EM receives several commissions for portraits and initiates a new series on a monumental scale. Hermann Esswein's *Edvard Munch* is published in Germany.

1906

EM spends the winter 1905-1906 in Germany. He undergoes treatment at two German clinics. He spends the summer in Weimar where he paints portraits of Count Harry Kessler, Elisabeth Förster-Nietzsche, and Friedrich Nietzsche. EM makes designs for Ibsens's *Ghost* and *Hedda Gabler* for Max Reinhardt's Deutsches Theater in Berlin. He has one-man shows in Magdeburg, Dresden, Hamburg, Chemnitz, Berlin, Hagen, and Weimar. He participates in the Norwegian exhibition in Copenhagen, the Berlin Secession, and the Salon des Indépendants.

1907

In Berlin during the winter and spring, he paints a *Frieze of Life* as a decoration for Reinhardt's theater. In April in Stockholm he paints the portrait of Ernst Thiel, who also buys several other paintings. EM spends the summer in Warnemünde where he paints *Men Bathing* [Three Ages], sold to Ateneum, Helsingfors in 1911. He exhibits at Clemati's art gallery in Hamburg. He exhibits in Bielefeld and has two one-man shows, one in the spring and one in the autumn at Cassirer's in Berlin. He also exhibits at the Berlin Secession and the Biennale di Venezia. Gustav Schiefler publishes *Verzeichnis des graphischen Werkes Edvard Munch's bis 1906*.

1908

EM exhibits four paintings at the Salon des Indépendants. He spends the summer in Warnemünde where he starts painting subjects from modern work and industry. He goes to Copenhagen, where he has a nervous breakdown and undergoes treatment at Dr. Daniel Jacobson's clinic. He is appointed a Knight of the Royal Norwegian Order of St. Olav. In the autumn he participates in an exhibition of the Brücke in Dresden and the Berlin Secession and has one-man shows in Breslau, Munich, Copenhagen, and Cologne.

1909

EM exhibits the *Frieze of Life* at Blomqvist's gallery in Christiania. An extra grant from the government enables the National Gallery, where his lifelong friend Jens Thiis has become director, to acquire five paintings at a cost of 10,000 Norwegian kroner. (A few months later Olaf Schou donates his collection of Norwegian art, including ten paintings by Munch, among them *Madonna* and *The Scream*). EM moves back to Norway and settles in Kragerø in the south. Large exhibitions of his paintings and prints are held in Helsinki, Trondheim, Bergen, and Bremen. The collector Rasmus Meyer makes large purchases (now in the Rasmus Meyer Collection, Bergen).

1910

EM exhibits one painting and four lithographs from the *Alpha & Omega* series at the Salon des Indépendants. In Kragerø in the spring he works on the Christiania University Aula decorations. He buys Ramme, a property at Hvidsten, southeast of Christiania.

1911

EM lives at Hvidsten. In August he wins the competition for the Aula decorations. He spends the autumn and winter in Kragerø. Exhibitions of his work are held in Christiania in April and August.

1912

EM stays the winter in Kragerø. He takes a trip to Copenhagen, Paris, and Cologne. He makes contact with Curt Glaser, curator of prints at the National Gallery in Berlin. He participates in a Norwegian exhibition at Künstlerbund Hagen in Vienna, as well as the Sonderbund exhibition in Cologne, Salon des Indépendants in Paris, and the Secession in Berlin, one-man shows in Munich, Christiania, Berlin, and Gøteborg. Six of his paintings are shown at an exhibition of contemporary Scandinavian art in New York.

1913

EM rents the estate Grimsrød at Jeløya. He visits Berlin, Frankfurt, Cologne, Paris, London, Hamburg, Lübeck, and Copenhagen. His work appears in the Armory Show in New York, Boston, and Chicago. He also exhibits paintings and prints in Stockholm, Dresden, Breslau, Berlin, Hamburg, and Christiania.

1914

EM visits Copenhagen, Frankfurt, Berlin, and Paris. The University of Oslo accepts his Aula murals. He exhibits in Frankfurt, Bremen, Berlin, Kragerø, Düsseldorf, Christiania, and Leipzig.

1915

EM travels in Norway and then goes to Copenhagen. He has several exhibitions in Norway and one exhibition of prints in Berlin. His proposals for the Aula murals are shown in Copenhagen, and he participates in a Norwegian exhibition there.

1916

EM buys Ekely outside of Christiania. The Aula murals are inaugurated in September. He visits Bergen and has exhibitions there and in Stockholm and Hamburg.

1917

EM visits Bergen in the summer. Curt Glaser publishes the monograph *Edvard Munch*. EM participates in a Norwegeian exhibiton in Stockholm and has one-man shows in Gøteborg and Copenhagen.

1918

EM exhibits the *Frieze of Life* at Blomqvist's gallery in Christiania. He exhibits in Gøteborg, Stockholm, and Berlin.

1919

EM contracts Spanish influenza. He exhibits in Christiania and New York (57 prints at the Bourgeois Galleries).

1920

EM travels in Germany, France, and Italy, and has exhibitions in Berlin and Bremen.

1922

Exhibitions of EM works are held in Zurich and at the Berlin Academy. He paints mural decorations for the canteen of the Freia Chocolate Factory.

1923

EM is given his own room at the exhibition in Göteborg.

1926

EM exhibits in the Kunsthalle at Mannheim. His sister Laura dies.

1927

Exhibition of EM's work is held at the National Gallery in Berlin, arranged by Ludvig Justi. The exhibition includes 223 paintings – all from public collections and EM's collection – and 21 watercolors and drawings. At the same time, shown in the Kupferstich Kabinett is an exhibition of 150 graphic works, which Max J. Friedländer had been collecting since 1908. Jens Thiis arranges an exhibition at the National Gallery in Oslo with a total of 286 paintings, in addition to graphic works.

1928

EM participates in an international exhibition in San Francisco and a Norwegian exhibition at the Royal Academy in London. He has three exhibitions in Munich.

1929

EM has several large print exhibitions in Germany.

1930
EM suffers from a complaint of the eyes.

1932
EM receives the Goethe Medal in silver from German President Paul von Hindenburg for his contributions to art. On this occasion he remarks that he is not a supporter of such awards but feels it is an honor to receive a medal connected to these two German people.

1933
Jens Thiis and Pola Gauguin publish the first monographs about EM in Norwegian. EM is made a Knight Grand Cross of the Order of St. Olav.

1934
EM is awarded the French Legion of Honor, part of the French efforts for many years to persuade him to exhibit his works in the Jeu de Paume. EM turns down the offer of a large exhibition in 1939.

1936
EM has his first one-man show in London at the London Gallery.

1937
EM exhibits five paintings and three graphic works in the Norwegian pavilion at the Exposition Universelle in Paris. Eighty-two Munch paintings are confiscated from German museums. Most of the works were acquired after World War I, especially in the late 1920s (Munch was unwilling to sell works from his early production). There were a few early works in private German collections. Exhibitions of his paintings, prints, and watercolors are held in Stockholm and at the Stedelijk Museum in Amsterdam.

1940
EM lives in seclusion at Ekely. He refuses to have any contact with members of the German occupation or the Norwegian collaborators.

1944
EM dies at Ekely on January 23, leaving all of his works to the city of Oslo: 1,008 paintings, 15,391 graphic works, 4,443 drawings and watercolors, and 6 sculptures. The Munch-museet is inaugurated in 1963.

Harald Sohlberg Chronology

1869
Harald Oskar Sohlberg is born November 29, at Store Vognmandsgade 12, in Christiania, the son of the fur merchant Johan M. W. Sohlberg (b. 1811), and Johanne Viker (b. 1837), daughter of a well-to-do farmer.

1881-84
HS makes his first drawings during summer vacations on the small island of Ormøen near Christiania.

1885
HS works as an apprentice in a decorative painting firm. In January he registers as a pupil at the School of Design in Christiania.

1887
The Sohlberg family moves to Victoria Terrasse, a new and fashionable block of luxury flats near the royal castle.

1889
HS paints for the first time without guidance during a summer vacation in Valdres.

1890
HS becomes a pupil of the Naturalist painter Sven Jørgensen in Slagen, a short distance from Åsgårdstrand. He rents a small cottage, however, wanting to paint without the interference of his teacher.

1891
HS leaves the School of Design and works on his own in a small studio at 12 Vognmandsgade. He lives with the painter Thorvald Erichsen at a farm, Rokvam, in Gausdal from June to September. He takes drawing lessons under the guidance of the Naturalist painters Eilif Peterssen and Erik Werenskiold. In December he visits Copenhagen.

1892
HS becomes a pupil of the Danish painter Kristian Zahrtmann. He shares lodging with Erichsen, an ardent admirer of the Danish Symbolists.

1892
HS does military service at Oscarsborg in July and August. He makes his debut with two drawings in an exhibition of drawings in Christiania.

1893

HS stays with his family on the island of Norde Langø and paints *Night Glow*.

1894

Night Glow is exhibited at the state exhibition in March and is bought by Eilif Peterssen, who gives the National Gallery the right of refusal. The museum acquires the painting at the close of the exhibition. HS draws for four months under the guidance of Eilif Peterssen and Harriet Backer.

1895

HS receives the A. C. Houen Bequest. He travels to Paris via Rouen in September.

1896

In the summer HS paints at Norde Langø for the last time. In July he receives the A. C. Houen Bequest for a second time. He goes to Hamburg in December and then to Berlin and Weimar.

1897

HS becomes a pupil of the Norwegian painter Carl Frithjof Smith at the Art Academy in Weimar. In the autumn he moves to Schafteløkken, on the outskirts of Christiania.

1898

HS's father goes bankrupt but is soon back in business. The family moves to Nordstrand on the southeast side of Christiania. He exhibits *Ripe Fields* and *From a Working District in Christiania* at the state exhibition. The art historian Jens Thiis, a childhood friend of Sohlberg, initiates the purchase of *From a Working District in Christiania* for the Trondheim Art Gallery. At the same time, Thiis asks HS to launch his candidacy as director of the National Gallery in Christiania. HS finds Thiis manipulative and their friendship suffers. HS moves to Nordstrand in the autumn.

1899

HS stays in the mountain district of Rondane during Easter. He becomes engaged to Lilli Rachel Hennum and to celebrate the occasion paints *Summer Night*, which is exhibited at the state exhibition and is purchased by the National Gallery. He meets Olaf Schou, collector and patron of the arts, who for the next six years is his principal supporter, both financially and morally.

1900

Assisted by money from Schou, HS moves to the Rondane mountain region to start work on *Winter Night in the Mountains*.

1901

HS and Lilli Hennum are married on October 16.

1902

In March, HS moves with his wife to Røros. He starts painting *Night*, which is completed in February of 1904. The painting is bought by the Art Gallery in Trondheim, to replace *From a Working District in Christiania,* which was damaged in 1901. On November 11, HS receives news that his brother Einar has been killed in South Africa. His mother dies the day after.

1904

In June HS moves to Gullikstad, a small farm that is about a thirty minute ride by horse

carriage from Røros. He sues for libel the district forester in Røros, who has wrongly accused him of stealing wood from his neighbors. After winning the case, HS becomes a local hero among the working class. The accusations embitter him for years to come, and he scorns Røros thereafter.

1905
HS receives the A. C. Houen Bequest. On November 23 he travels by train from Røros to Christiania in what he himself describes as a flight from his creditors.

1906
In February HS travels to Amsterdam, The Hague, Haarlem, Brussels, and Paris. In Paris he associates with Jans Thiis and the painter Ludvig Karsten. He finishes *Flower Meadow in the North* in Paris and exhibits it in the state exhibition in Oslo, where it is bought by the National Gallery. He takes his family to Slagen and stays with his former teacher Sven Jørgensen for the summer. He exhibits in an official Norwegian exhibition in Copenhagen.

1907
In January HS travels to Hamburg, Munich, and Venice. He stays in Venice until May and exhibits *A Fisherman's Cottage* at the biennial. He returns to Christiania via Burano, Verona, and Hamburg. In June the family settles in Kjerringvik, a small fisherman's village by the sea in Vestfold. He begins to work on a series of paintings with the earth, sea, and sky as his motif.

1908
In March HS travels to Copenhagen to view an exhibition of contemporary and historical British painting, but is not very impressed.

1909
A collector in Bergen, Rasmus Meyer, orders three paintings by HS. HS's father dies.

1910
HS moves to Skovly at Norberg in Vestre Aker, a short distance from Christiania.

1911
HS travels to the Rondane region where he spends the spring making studies. In the autumn he moves with his family to 32 General Birchs Street, Christiania. He exhibits four paintings at an exhibition of Norwegian art in Helsinki. He is also represented at Esposizione Internazionale di Roma.

1912
For the next four summers HS lives in Åsgårdstrand, north of Oslo, and paints landscapes of this agricultural district. He exhibits eight paintings and six drawings at Künstlerbund Hagen in Vienna. In an exhibition arranged by the American-Scandinavian Society, he is represented by five paintings, including the first version of *Winter Night in the Mountains*. This Scandinavian exhibition is shown in New York, Buffalo, Toledo, Chicago, and Boston and is a great success, with nearly 200,000 visitors.

1914
At the Jubilee Exhibition (commemorating the 100 years of the Norwegian Constitution) HS is the only living artist honored with an exhibition space of his own. The National Gallery declines the acquisition of *Winter Night in the Mountains* against the advice of

its director Jens Thiis. HS exhibits prints for the first time, and sales of prints become a main source of his income in the coming years.

1915
HS wins a first place medal at the Panama-Pacific International Exhibition in San Francisco, where he shows seven paintings. Among the paintings is *Winter Night in the Mountains*, which is also shown at the Carnegie International Exhibition in Pittsburgh.. He exhibits six paintings at a Norwegian exhibition in Copenhagen.

1918
HS spends the summer at Skjeggestad, not far from Kjerringvik. He starts to paint a series of large landscapes with a bright yellow setting sun as the main motif. The collector J. B. Stang buys *Winter Night in the Mountains* and presents it to the National Gallery.

1919
HS contracts Spanish influenza. He is hospitalized for a gallstone operation. He never fully regains his strength.

1920
HS spends the summer in Værvågen at Helgeroa in Vestfold. In the autumn he finds a large new studio in Wilhelms Street.

1926
HS meets Johan Throne Holst, the owner of the Freia Maribou chocolate company, who invites him to spend the summer at his residence at the Leangbukta, outside Oslo.

1928
In June HS travels to Hedemarken where he meets the young Arne Stenseng and encourages him to become a painter. (Stenseng became an art historian and honored HS, who he looked upon as a father, with a monograph published in 1963.) HS is represented by five paintings in an exhibition of Norwegian art in London.

1929
HS travels to Stockholm in February. He participates in the World's Fair exhibition in Barcelona and is honored with a first place medal.

1932
The Norwegain parliament denies HS a state honorarium. As a protest, the Artist's Society awards him the equivalent of one year's salary.

1935
HS is hospitalized for cancer of the spinal cord. The Norwegian parliament gives him a state salary in March. He dies on June 19.

1936
A memorial exhibition is held at the Artist's Society House in Oslo in August. The art historian Leif Østby publishes the first monograph on Sohlberg.

EXHIBITION CHECKLIST

Edvard Munch (1863-1944)

I. Paintings

1. EVENING, 1888
 Oil on canvas
 37 x 75 cm
 Private Collection

2. INGER AT THE SEASHORE, 1889
 Oil on canvas
 126.5 x 162 cm
 Rasmus Meyers Collection,
 Bergen, Norway

3. LA SEINE À ST. CLOUD, 1890
 Oil on canvas
 61 x 50 cm
 Frances Lehman Loeb Art Center,
 Vassar College, Poughkeepsie,
 New York
 Gift of Mrs. Morris Hadley
 (Katherine Blodgett, class of
 1920), 1962.1

4. NIGHT IN ST. CLOUD, 1890
 Oil on canvas
 64.5 x 54 cm
 Nasjonalgalleriet, Oslo

5. BY A POND WITH WATER
 LILIES, ca. 1892
 Gouache and pastel on board
 28.5 x 44 cm
 Private Collection

6. LANDSCAPE, ÅSGÅRDSTRAND,
 ca. 1892
 Oil on canvas
 69 x 52 cm
 Private Collection

7. PORTRAIT OF LUDVIG MEYER,
 1892
 Oil on canvas
 214.5 x 103.5 cm
 Trondhjems Kunstforening

8. WINTER-MORNING (STREET,
 RAINY WEATHER IN
 CHRISTIANIA), 1892
 Oil on canvas
 71.2 x 66.7 cm
 Courtesy of Kaare Berntsen A/S,
 Oslo

9. MYSTIC SHORE, 1892
 Oil on canvas
 100 x 140 cm
 Courtesy of Kaare Berntsen A/S,
 Oslo

10. VAMPIRE, 1893
 Oil on canvas
 100 x 110 cm
 Private Collection

11. MADONNA, ca. 1894
 Oil on canvas
 93 x 75 cm
 Private Collection

12. WOMAN'S HEAD AGAINST
 RED LANDSCAPE, 1894
 Oil on cardboard
 63 x 47.5 cm
 Munch-museet, Oslo

13. SEPARATION, 1896
 Oil on canvas
 96.5 x 127 cm
 Munch-museet, Oslo

14. STORMY DAY (LANDSCAPE
 WITH RED HOUSE), before 1905
 Oil on board
 79.5 x 64.5
 Private Collection

15. SEASHORE, 1898
 Watercolor on cardboard
 55.5 x 79 cm
 Rogaland Kunstmuseum,
 Stavanger, Norway

16. WINTER, 1899
 Oil on panel
 60.5 x 90 cm
 Nasjonalgalleriet, Oslo

17. ÅSGÅRDSTRAND LANDSCAPE,
 1895-1896
 Oil on board
 57.5 x 83.5 cm
 Collection of Nelson Blitz, Jr.
 and Catherine Woodard

18. TRAIN SMOKE, 1900
 Oil on canvas
 84.5 x 109 cm
 Munch-museet, Oslo

19. WINTER, NORDSTRAND, 1900
 Oil on board
 64.5 x 80 cm
 Courtesy of Galleri Bellmann,
 Oslo

20. RED CREEPER, 1900
 Oil on wood panel
 32.5 x 48 cm
 Nasjonalgalleriet, Oslo

21. BIRCH IN THE SNOW, 1901
 Oil on panel
 60 x 67.5 cm
 Private Collection

22. ON THE VERANDA, 1902
 Oil on canvas
 86.5 x 115.5 cm
 Nasjonalgalleriet, Oslo

23. EVENING, MUNCH'S HOUSE IN
 ÅSGÅRDSTRAND, 1902
 Oil on canvas
 115.9 x 100 cm
 Private Collection

24. BY THE SHORE, ca. 1898-1904
 Oil on canvas
 69.5 x 100.25 cm
 Courtesy of Kaare Berntsen A/S,
 Oslo

25. FOREST, 1903
 Oil on canvas
 82.5 x 81.5 cm
 Munch-museet, Oslo

26. GIRLS ON THE JETTY, 1903
 Oil on canvas
 92 x 80 cm
 Collection of Vivian and David
 Campbell

27. FROM MUNCH'S GARDEN IN
 ÅSGÅRDSTRAND, 1903
 Oil on canvas
 Private Collection

28. GARDEN AT TAARBECK, 1905
 Oil on canvas
 99.5 x 61.5 cm
 Private Collection

29. BOYS BATHING
 Oil on canvas
 94 x 99.5 cm
 Courtesy of Galleri Bellmann,
 Oslo

30. PORTRAIT OF IDA DOROTHEA
 ROEDE, 1909
 Oil on canvas
 248 x 90 cm
 Lillehammer Art Museum

31. WINTER LANDSCAPE, KRAGERØ
 Oil on canvas
 Private Collections

32. WOMAN IN A ORCHARD
 Oil on canvas
 52.5 x 85 cm
 Private Collection

33. MEETING, 1921
 Oil on canvas
 127 x 108 cm
 Collection of Nadia and Jacob
 Stolt-Nielsen

34. COASTAL LANDSCAPE, 1922
 Oil on canvas
 74 x 92 cm
 Private Collection

35. OLD TREES, ca. 1923-1925
 Oil on canvas
 73 x 92 cm
 Private Collection

II. Drawings

36. MYSTERY ON THE SHORE, 1892
 Wash on paper
 34.8 x 45.7 cm
 Munch-museet, Oslo
 MM T 2387

37. MERMAID IN FRONT OF THE
 MOON, 1892
 Charcoal on paper
 48 x 28.3 cm
 Munch-museet, Oslo
 MM T 327

38. THE VOICE (SUMMER NIGHT),
 1893
 Charcoal and wash on paper
 50 x 64.7 cm
 Munch-museet, Oslo
 MM T 2373

39. SEPARATION, 1896
 Watercolor and crayon on paper
 33.2 x 59.7 cm
 Munch-museet, Oslo
 MM T 431

40. THE WOMAN IS KILLED,
 1895-1896
 Pencil, India ink and wash on
 paper
 33.8 x 59.4 cm
 Munch-museet, Oslo
 MM T 1395

41. MADONNA IN THE
 CHURCHYARD, 1896
 India ink and wash, with touches
 of watercolor and crayon on
 paper
 56 x 44.8 cm
 Munch-museet, Oslo
 MM T 2364

42. THE SOURCE, 1909-1910
Crayon and watercolor on paper
56.2 x 78.1 cm
Munch-museet, Oslo
MM T 1733

43. THE DANCE OF LIFE, 1899
India ink and wash on paper
32.5 x 47.7 cm
Munch-museet, Oslo
MM T 2392

44. THE EMPTY CROSS, 1899-1901
India ink on paper
49.8 x 64.5 cm
Munch-museet, Oslo
MM T 375

45. THE CATHEDRAL IN THE
FOREST. THE SERMON,
1909-1911
Watercolor, crayon and pencil
on paper
70.3 x 44.4 cm
Munch-museet, Oslo
MM T 1703

46. CARICATURE, 1897
Pen and ink on postcard
9.3 x 14 cm
Private Collection

III. Prints

47. SELF-PORTRAIT WITH
SKELETON ARM, 1895
Lithograph
45.5 x 31.5 cm
Munch-museet, Oslo
Schiefler No. 31

48. WOMAN (WOMAN IN THREE
STAGES), 1895
Drypoint and aquatint, printed
in black-brown ink
29.9 x 34.2 cm (plate)
Museum of Modern Art,
New York
Acquired through the Lillie P.
Bliss Bequest
Schiefler No. 21

49. MADONNA, 1895
Lithograph
60.5 x 44.4 cm
Munch-museet, Oslo
Schiefler No. 33

50. THE SCREAM, 1895
Lithograph
44.2 x 15.4 cm
Collection of Nelson Blitz, Jr.
and Catherine Woodard
Schiefler No. 32

51. THE SICK CHILD, 1896
Lithograph
43.2 x 57.1 cm
Munch-museet, Oslo
Schiefler No. 59

52. LOVERS IN WAVES, 1896
Lithograph
30.7 x 41.2 cm
Munch-museet, Oslo
Schiefler No. 71

53. ANXIETY, 1896
Woodcut
45.7 x 37.5 cm
Munch-museet, Oslo
Schiefler No. 62

54. EVENING. MELANCHOLY I,
 1896
 Woodcut
 41 x 45.3 cm
 Munch-museet, Oslo
 Schiefler No. 82

55. EVENING. MELANCHOLY, 1901
 Woodcut
 38.8 x 46 cm
 Collection of Nelson Blitz, Jr.
 and Catherine Woodard
 Schiefler No. 144

56. EVENING. MELANCHOLY, 1896
 Woodcut
 38 x 45.4 cm
 Collection of Nelson Blitz, Jr.
 and Catherine Woodard
 Schiefler No. 82

57. ATTRACTION I, 1896
 Lithograph, printed in black ink
 47.7 x 36.5 cm
 Museum of Modern Art,
 New York
 The William B. Jaffe and Evelyn
 A.J. Hall Collection
 Schiefler No.65

58. MOONLIGHT I, 1896
 Woodcut
 40.2 x 47.6 cm
 Munch-museet, Oslo
 Schiefler No. 81

59. JEALOUSY II, 1896
 Lithograph
 47.5 x 57.2 cm
 Munch-museet, Oslo
 Schiefler No. 58

60. TOWARD THE WOOD, 1897
 Woodcut
 49.8 x 64.5 cm
 Munch-museet, Oslo
 Schiefler No. 100

61. TOWARD THE WOOD, 1897
 Color woodcut
 49.5 x 64.5 cm
 Collection of Nelson Blitz, Jr.
 and Catherine Woodard
 Schiefler No. 100

62. TOWARD THE WOOD, ca. 1899
 Color woodcut, unique
 49.5 x 64.5 cm
 Collection of Nelson Blitz, Jr.
 and Catherine Woodard

63. TOWARD THE WOOD, 1915
 Color woodcut
 51 x 64.5 cm
 Collection of Nelson Blitz, Jr.
 and Catherine Woodard
 Schiefler No. 444

64. DEATH AND LIFE, 1897
 Lithograph
 36.5 x 24.5 cm
 Munch-museet, Oslo
 Schiefler No. 95

65. FERTILITY, 1898
 Woodcut
 42 x 52 cm
 Munch-museet, Oslo
 Schiefler No. 110

66. WOMEN ON THE SHORE, 1898
Woodcut
45.3 x 51 cm
Collection of Nelson Blitz, Jr.
and Catherine Woodard
Schiefler No. 117

67. THE STUMP. MYSTERY ON THE
SHORE, 1899
Woodcut
37 x 56.9 cm
Munch-museet, Oslo
Schiefler No. 125

68. TWO HUMAN BEINGS. THE
LONELY ONES, 1899
Woodcut
39.5 x 55.7 cm
Munch-museet, Oslo
Schiefler No. 133

69. TWO HUMAN BEINGS. THE
LONELY ONES, 1899
Woodcut
39.3 x 54.6 cm
Collection of Nelson Blitz, Jr.
and Catherine Woodard
Schiefler No. 133

70. GIRL'S HEAD AGAINST THE
SHORE, 1899
Woodcut
46.7 x 41.4 cm
Munch-museet, Oslo
Schiefler No. 129

71. THE KISS IV, 1902
Woodcut
33 x 59.5 cm
Munch-museet, Oslo
Schiefler No. 102

72. THE LONELY ONE/YOUNG
GIRL ON THE SHORE
Color mezzotint
28.8 x 21.9 cm
Collection of Nelson Blitz, Jr.
and Catherine Woodard
Schiefler No. 42

73. EVENING ON KARL JOHAN
STREET
Hand-colored lithograph, unique
53.5 x 68.5 cm
Collection of Nelson Blitz, Jr.
and Catherine Woodard

74. GIRLS ON THE JETTY, 1920
Woodcut and color lithograph
49.6 x 43 cm
Private Collection
Schiefler No. 488B

Harald Sohlberg (1869-1935)

I. Paintings

75. CHRIST ON THE CROSS,
ca. 1892
Oil on canvas, mounted on
panel
33 x 26.5 cm
Nasjonalgalleriet, Oslo

76. THE GIRL AND THE DAISY,
ca. 1892/1893
Oil on board
13.5 x 20 cm
Private Collection

77. THE GIRL AND THE DAISY,
ca. 1892-1894
Oil on board
19.7 x 26.7 cm
Private Collection

78. VIEW OF CHRISTIANIA IN
WINTER, ca. 1892-1894
Oil on board
19.7 x 26.5 cm
Private Collection

79. FROM NORDRE LANGØ,
ca. 1893
Oil on canvas
47 x 39 cm
Private Collection

80. EVENING, 1893
Oil on canvas
25.5 x 33.5 cm
Private Collection

81. NIGHT GLOW, 1893
Oil on canvas
79.5 x 62 cm
Nasjonalgalleriet, Oslo

82. SUN GLEAM, 1894
Oil on canvas
73 x 59 cm
Private Collection

83. EUGENI, A STREET WOMAN,
1894
Oil on canvas mounted on
masonite
45 x 21 cm
Collection of Jorunn Sundar

84. VOGNMANDS-STREET, 1894
Oil on board
34.5 x 24.5 cm
Private Collection

85. STREET LAMP, 1894
Oil on masonite
16 x 19 cm
Collection of Ann Bernatek

86. SELF-PORTRAIT, 1895
Charcoal, pencil, and oil on
canvas
47 x 31.1 cm
Collection of Siri Sohlberg Næss

87. SELF-PORTRAIT, 1896
Oil on canvas
39 x 28.5 cm
Private Collection

88. THE MERMAID, 1896
Oil on canvas
51 x 89 cm
Private Collection

89. MERMAID, 1896
Oil on canvas
46.5 x 54.5 cm
Collection of Ragnhild Sohlberg

90. COUNTRY HOUSE, 1896
Oil on canvas
127 x 87 cm
Collection of Ann Bernatek

91. RIPE FIELDS, 1891-1898
Oil on canvas
73 x 116 cm
Private Collection

92. SUMMER NIGHT, 1899
Oil on canvas
114 x 135.5 cm
Nasjonalgalleriet, Oslo

93. CLOUDY WEATHER, ca. 1898
Oil on canvas
67 x 57 cm
Private Collection, Oslo

94. WINTER ON THE BALCONY
Oil on canvas
68.5 x 91 cm
Private Collection

95. WINTER NIGHT IN THE
MOUNTAINS, 1900
Oil on canvas
38.5 x 46.5 cm
Private Collection

96. WINTER NIGHT IN THE
MOUNTAINS, 1901
Oil on canvas
70 x 92 cm
Fjøsangersamlingene, Bergen

97. RONDANE BY SUNRISE, 1902
Oil on canvas
18 x 27 cm
Private Collection

98. ELEGY, 1903
oil on canvas
38 x 46 cm
Private Collection

99. NIGHT, 1904
Oil on canvas
113 x 134 cm
Trondhjems Kunstforening

100. FLOWER MEADOW IN THE
NORTH, 1905
Oil on canvas
96 x 111 cm
Nasjonalgalleriet, Oslo

101. DRIFTING SNOW, 1905
Oil on canvas
52 x 65 cm
Private Collection

102. FISHERMAN'S HOUSE, 1906
Oil on canvas
54 x 46 cm
Private Collection

103. FISHERMAN'S COTTAGE, 1907
Oil on canvas
109 x 94 cm
Collection of Edward Byron
Smith

104. MIDSUMMERNIGHT, NORDIC
THEME, 1907-1913
Oil on canvas
82 x 115.5 cm
Private Collection, Oslo

105. STUDY FOR ANDANTE, 1908
Oil on canvas
38 x 48 cm
Private Collection

106. ANDANTE, 1908
Oil on canvas
81 x 101.5 cm
Drammen Kunstforening

107. MOONLIGHT, 1909
Oil on canvas
35 x 47 cm
Private Collection

108. BY THE SEA, 1909
Oil on canvas
78 x 88 cm
Private Collection, Oslo

109. AUTUMN LANDSCAPE, 1910
Oil on canvas
82 x 70.6 cm
Rasmus Meyers Collection,
Bergen

110. LIGHT EVENING IN THE
SPRING, 1911
Oil on canvas
68 x 91 cm
Private Collection

111. COUNTRY ROAD, 1912
Oil on canvas
100 x 62 cm
Private Collection

112. EVENING, AKERSHUS, 1913
Oil on canvas
83 x 116 cm
City of Oslo Art Collections

II. DRAWINGS

113. FROM HEGGEFJORD, 1899
Pencil and watercolor on paper
16.9 x 27.3 cm
Private Collection

114. 115. 116. 117.
THE MERMAID
Pen and ink on paper
[four studies mounted together]
17 x 10 cm
Private Collection

118. THE GIRL AND THE DAISY
Pen and ink on paper
14.4 x 20 cm
Private Collection

119. THE LAST HEARTBEAT
Pen and ink on paper
32.5 x 14.5 cm
Private Collection

120. THE DEATH
Pen and ink, and pencil
on paper, bound in a book
49 x 70 cm
Private Collection

121. STARRY NIGHT ON THE FJORD
Drawing in pen and ink
35.5 x 22.5 cm
Private Collection

122. IN THE DEPTH OF MY
GARDEN, before 1897
Pen and ink, and pencil on
paper
34 x 21 cm
Private Collection

123. THE CLOUD, ca. 1893
Pen and ink, and pencil on
paper
23.3 x 18.3 cm
Private Collection

124. SIR EDVARD, ca. 1893
Pen and ink on paper
10 x 17 cm
Private Collection

125. ADAM, ca. 1893
Pen and ink on paper
10 x 17 cm
Private Collection

126. MOONLIGHT
Pen and ink on paper
18 x 26 cm
Private Collection

127. MOONLIGHT, ca. 1894
Pen and ink on paper
17.7 x 25.8 cm
Private Collection

128. TIME, LIFE, MANHOOD
Pen and ink on paper
18 x 15 cm
Private Collection

129. EXODUS
Pen and ink on paper
12.3 x 20.3 cm
Private Collection

130. SILENCE, ca. 1896
Sketchbook leaf
25.5 x 33.5 cm
Private Collection

131. THE MERMAID, 1897
Pencil on paper
46.5 x 54.5 cm
Private Collection

132. THE MERMAID, ca. 1897
Pencil, ink, and watercolor on
paper
47.5 x 30 cm
Private Collection

133. SELF-PORTRAIT
Pencil drawing
47 x 33.9 cm
Private Collection

134. THE COTTAGE, 1896
Pencil and watercolor on paper
58.4 x 42.5 cm
Collection of Harald Sohlberg
Stavnes

135. WINTER NIGHT IN THE
MOUNTAINS, 1900
Watercolor and charcoal on
paper
150 x 171 cm
City of Oslo Art Collections

136. WINTER NIGHT IN THE
MOUNTAINS, 1900
Charcoal, ink, and watercolor
on paper
68.5 x 89 cm
Courtesy of Galleri Bellmann,
Oslo

137. THE FISHERMAN'S COTTAGE,
1906
Pen and ink on paper
18.5 x 16 cm
Private Collection

138. SEA AND SKY, June 2, 1906
Pen and ink drawing
21.7 x 17 cm
Private Collection

139. EXODUS, 1907
Pencil and gouache on paper
80 x 99 cm
Private Collection

140. SEA SPRAY, 1908
Pen and ink, and watercolor on
paper
39 x 52.5 cm
Private Collection

141. PRIDE OF THE FAMILY: Jappe
Nilssen, Jens Thiis, Edvard
Munch, Ludvig Ravensberg,
and Christian Gierløff, 1908
Pen and ink on paper
25.5 x 32 cm
Private Collection

142. A ROYAL MEETING, 1910
Watercolor, and pen and ink on
paper
62.3 x 41.7 cm
Nasjonalgalleriet, Oslo

143. THE ASSAILANT, 1911
Pen and ink, and pencil on
paper
40 x 47 cm
Private Collection

144. VANITY IS PERISHABLE
Pen and ink on paper
25.5 x 25 cm
Private Collection

145. WINTER NIGHT IN THE
MOUNTAINS, 1911
Watercolor on paper
57.5 x 65 cm
Private Collection, Oslo

146. NIGHT, 1922
Pen and ink, and pencil on
paper
49.7 x 64.6 cm
Nasjonalgalleriet, Oslo

147. FROM AKERSHUS
Pen and ink on paper
28.8 x 29.2
Private Collection

III. Prints

148. THE GIRL AND THE DAISY,
1897
Etching
12.8 x 14.3 cm
Private Collection

149. MOONLIGHT, 1912
Etching
20.6 x 28 cm
Private Collection

150. THE FISHERMAN'S COTTAGE,
1912
Etching and aquatint
25.5 x 20.6 cm
Private Collection

151. MIDNIGHT, 1914
Etching
46.6 x 64 cm
Private Collection

152. STARRY NIGHT BY THE FJORD
Etching and aquatint
35.5 x 22.5 cm
Private Collection

153. SILENCE, 1931
 Etching
 17.2 x 24.1 cm
 Private Collection

154. THE MAN AND THE UNIVERSE
 Etching and aquatint
 25.1 x 17.2 cm
 Private Collection

155. FROM AKERSHUS
 Etching
 20.8 x 29.2 cm
 Private Collection

PLATES

EDVARD MUNCH
Paintings
Drawings
Prints

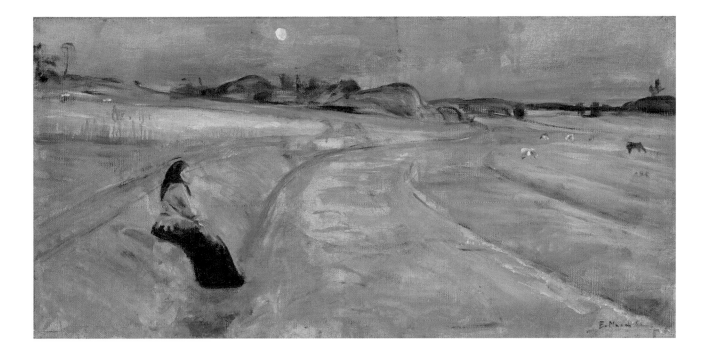

1. EVENING, 1888. 37 x 75 cm.

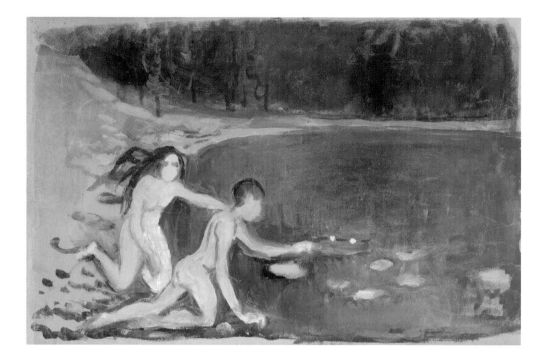

5. BY A POND WITH WATER LILIES, ca. 1892

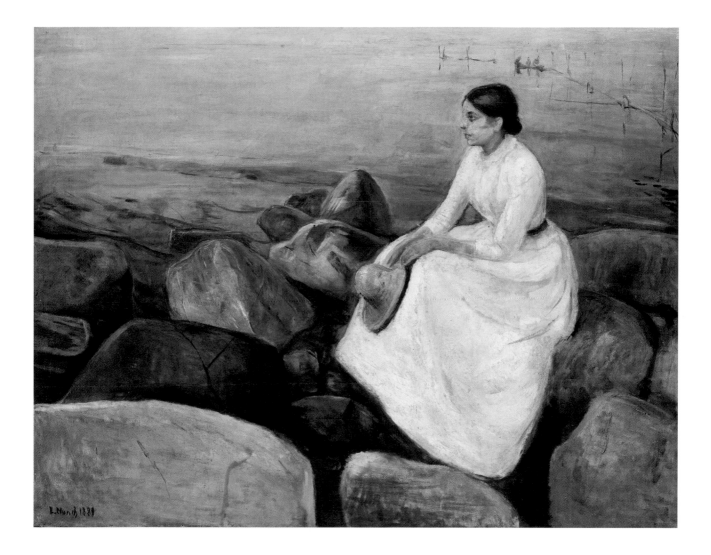

2. INGER AT THE SEASHORE, 1889. 126.5 x 162 cm

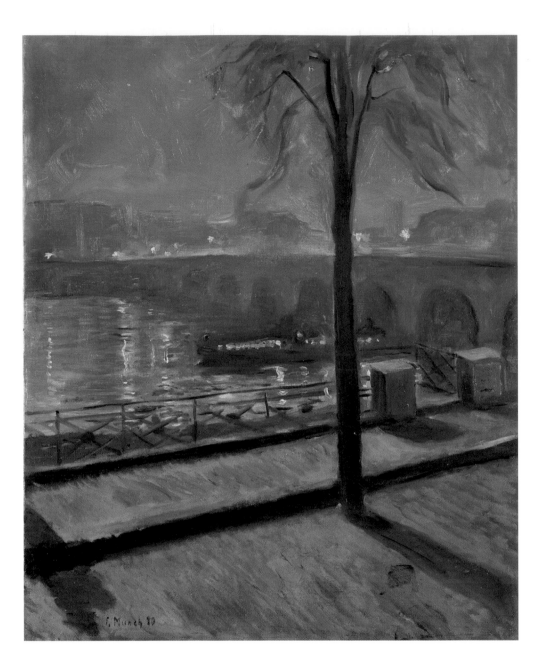

3. LA SEINE À ST. CLOUD, 1890. 61 x 50 cm

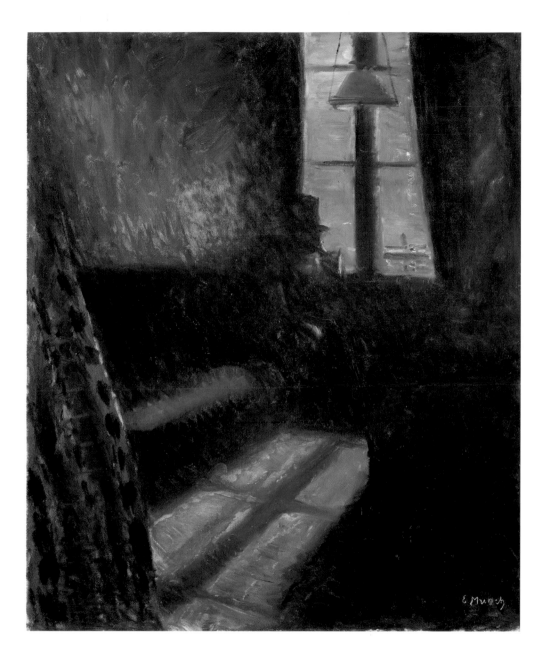

4. NIGHT IN ST. CLOUD, 1890. 64.5 x 54 cm

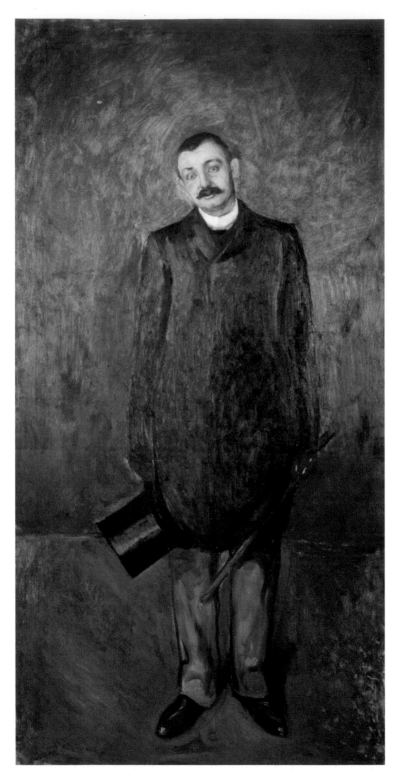

7. PORTRAIT OF LUDVIG MEYER ,1892
214.5 x 103.5 cm

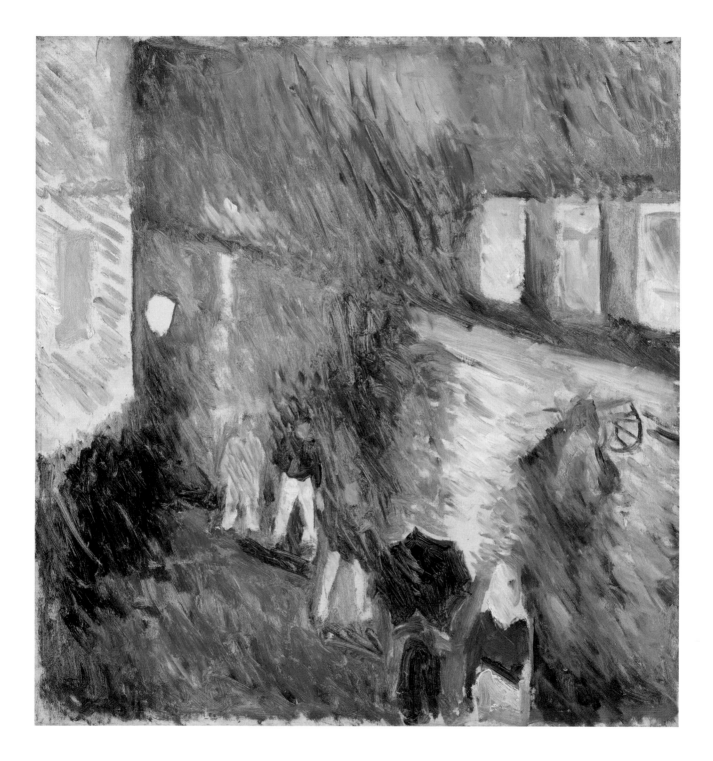

8. WINTER-MORNING (STREET, RAINY WEATHER IN CHRISTIANIA), 1892. 71.2 x 66.7 cm

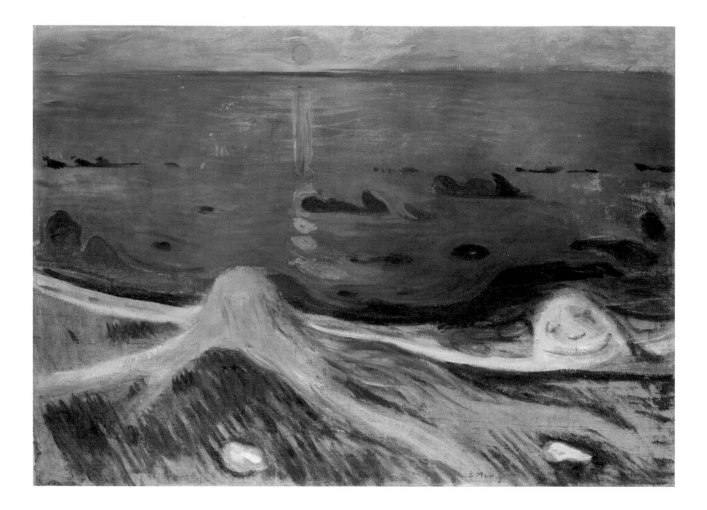

9. MYSTIC SHORE, 1892. 100 x 140 cm

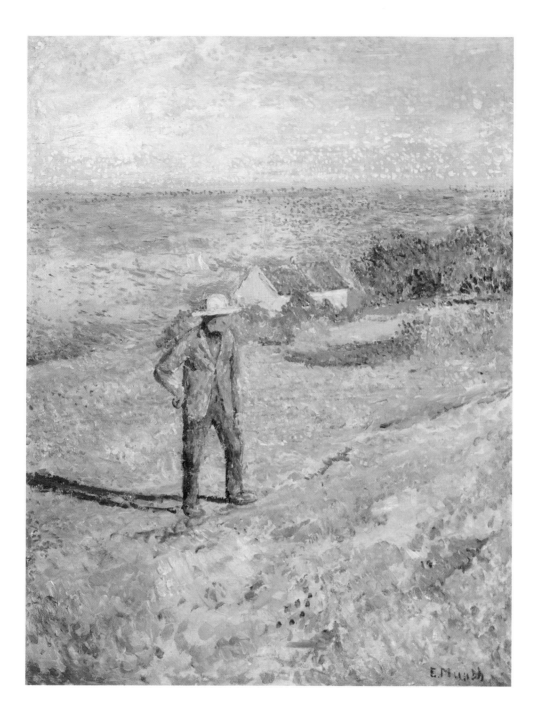

6. LANDSCAPE, ÅSGÅRDSTRAND, ca. 1892. 69 x 52 cm

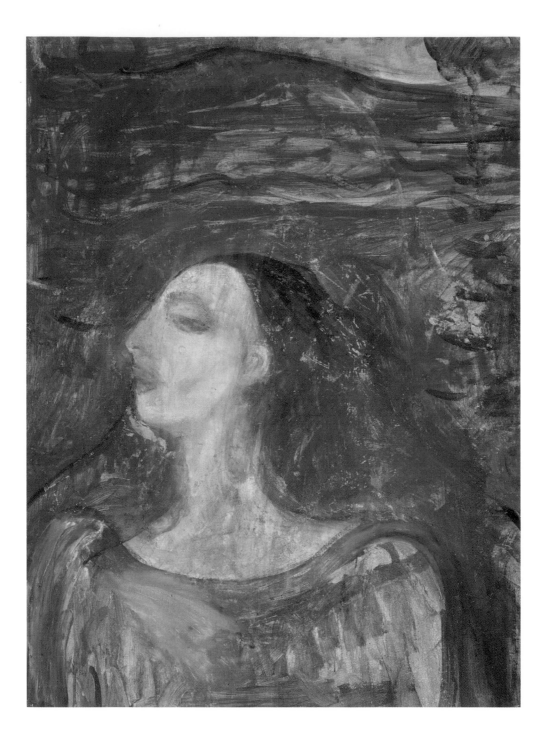

12. WOMAN'S HEAD AGAINST RED LANDSCAPE, 1894. 63 x 47.5 cm

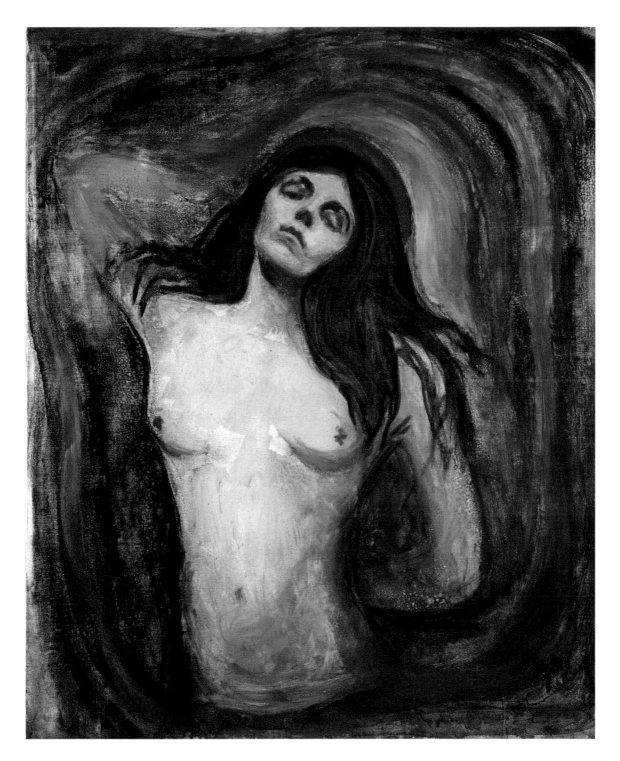

11. MADONNA, ca. 1894. 93 x 75 cm

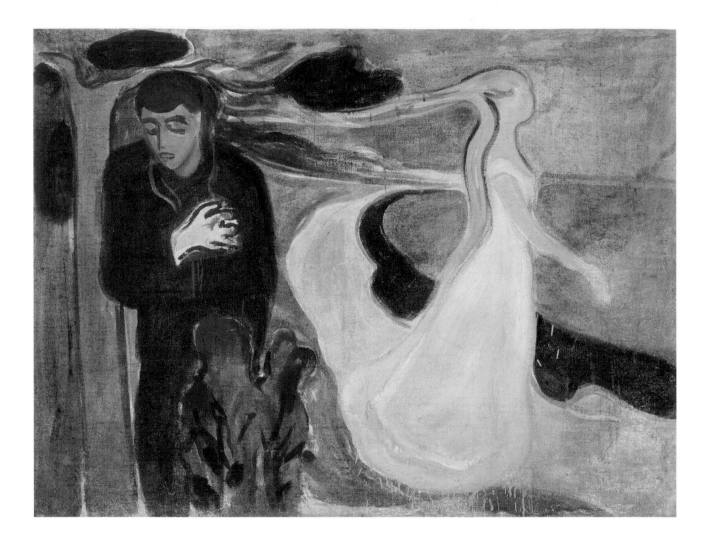

13. SEPARATION, 1896. 96.5 x 127 cm

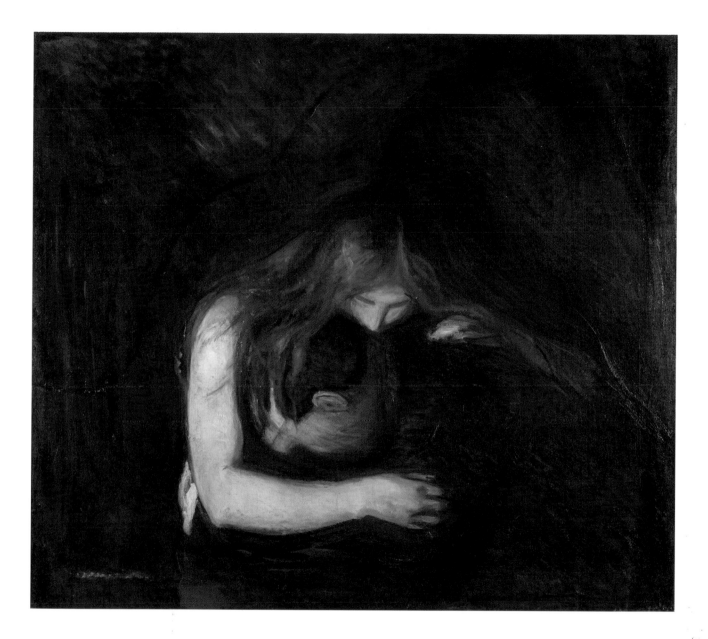

10. VAMPIRE, 1893. 100 x 110 cm

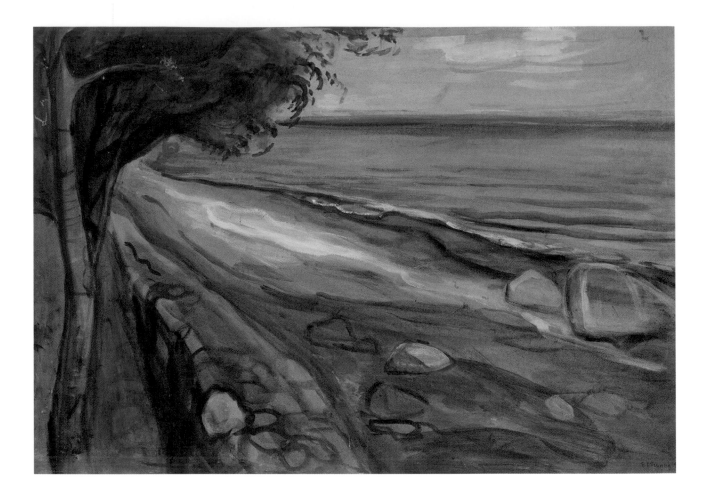

15. SEASHORE, 1898. 55.5 x 79 cm

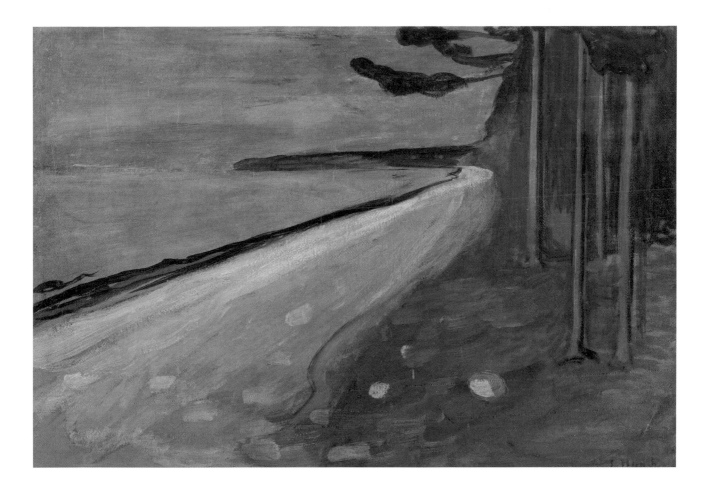

17. ÅSGÅRDSTRAND LANDSCAPE, 1895-1896. 57.5 x 83.5 cm

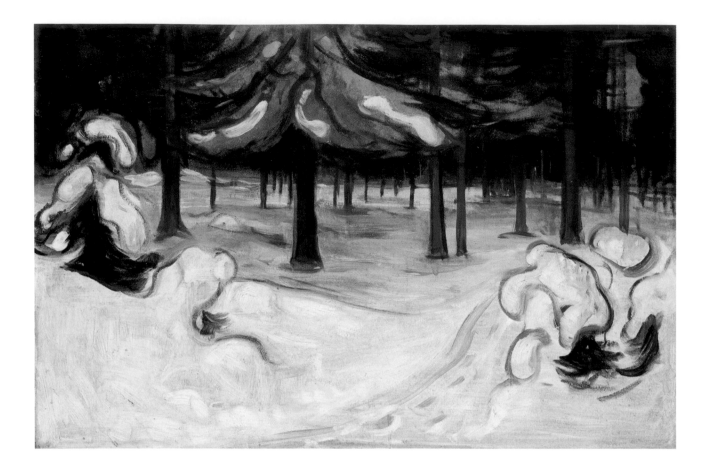

16. WINTER, 1899. 60.5 x 90 cm

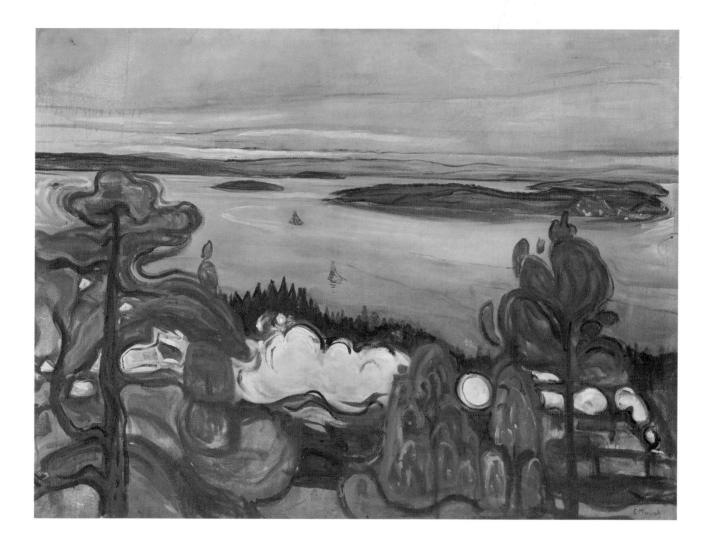

18. TRAIN SMOKE, 1900. 84.5 x 109 cm

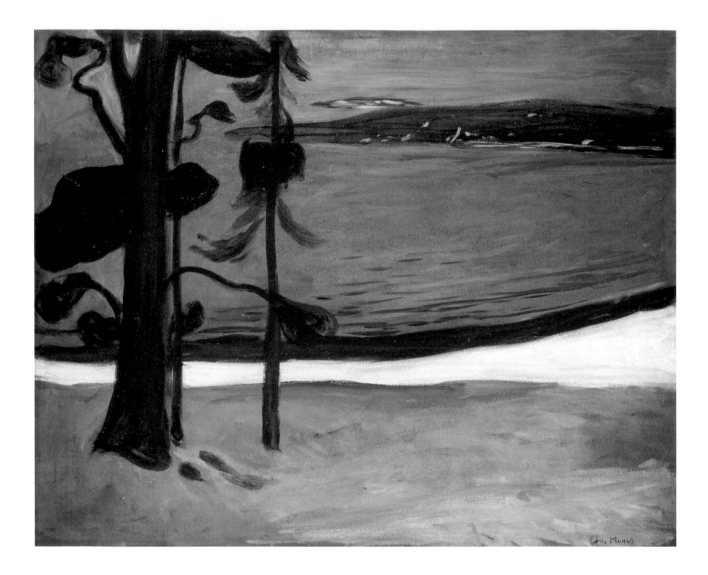

19. WINTER, NORDSTRAND, 1900. 64.5 x 80 cm

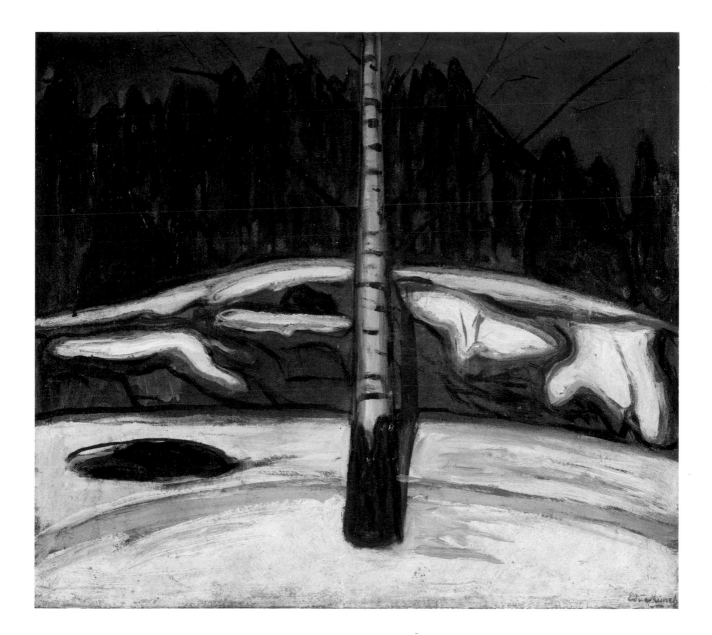

21. BIRCH IN THE SNOW, 1901. 60 x 67.5 cm

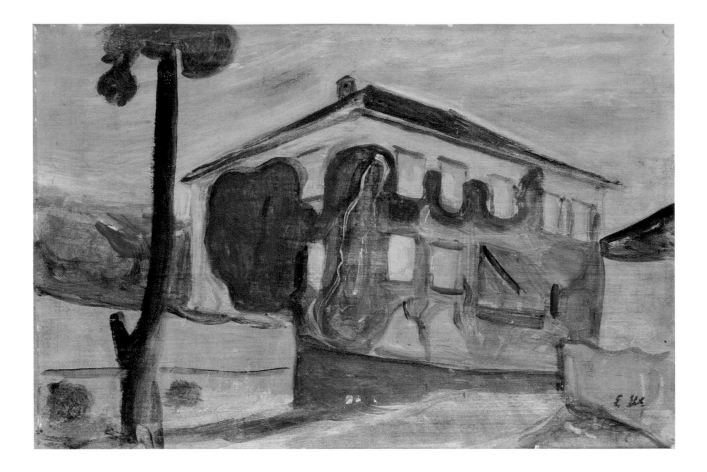

20. RED CREEPER, 1900. 32.5 x 48 cm

144

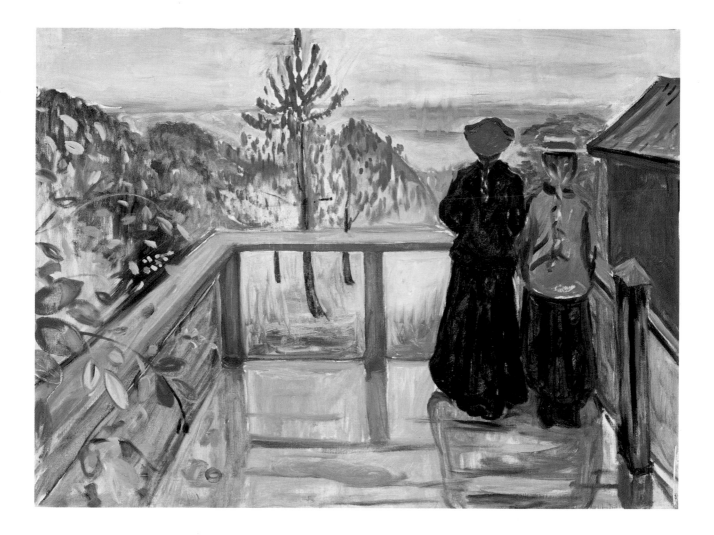

22. ON THE VERANDA, 1902. 86.5 x 115.5 cm

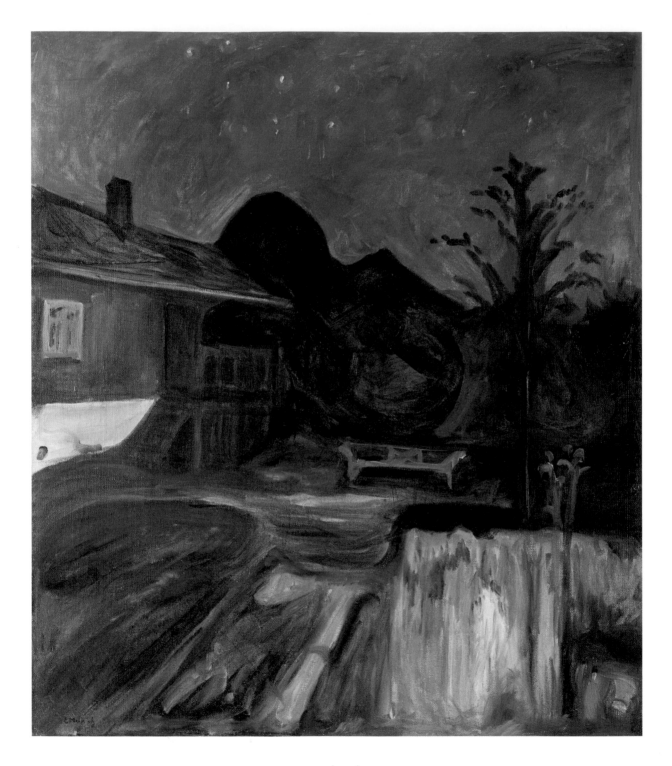

23. EVENING, MUNCH'S HOUSE IN ÅSGÅRDSTRAND, 1902. 115.9 x 100 cm

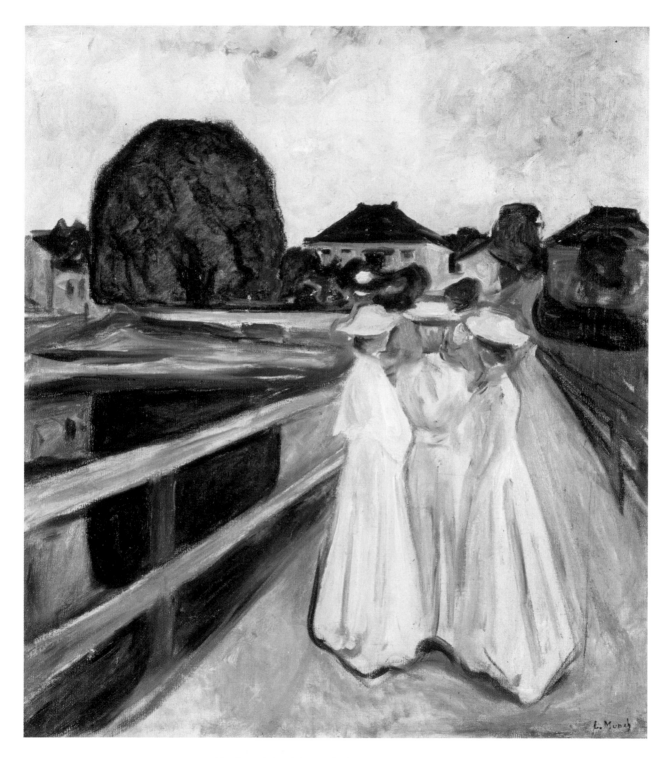

26. GIRLS ON THE JETTY, 1903. 92 x 80 cm

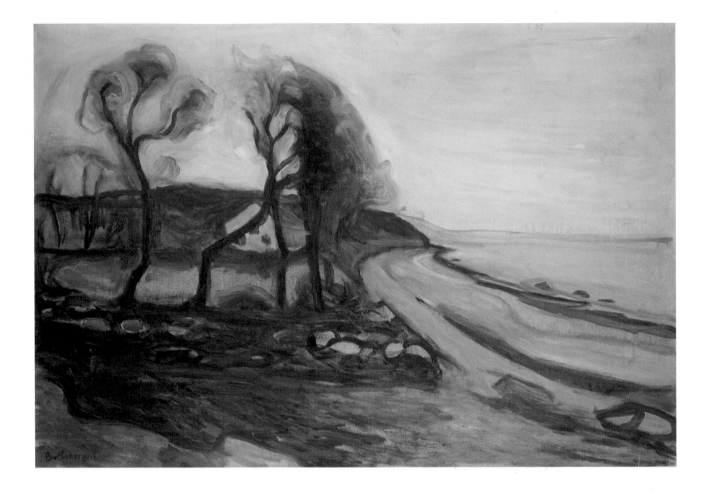

24. BY THE SHORE, ca. 1898-1904. 69.5 x 100.2 cm

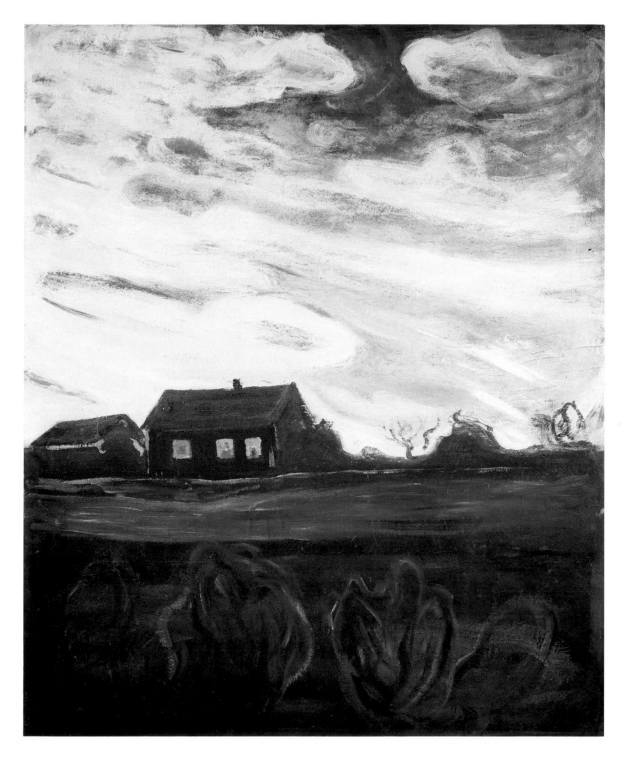

14. STORMY DAY (LANDSCAPE WITH RED HOUSE), before 1905. 79.5 x 64.5 cm

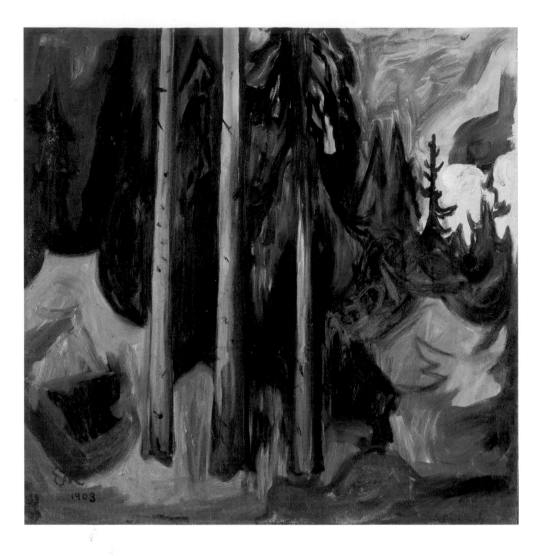

25. FOREST, 1903. 82.5 x 81.5 cm

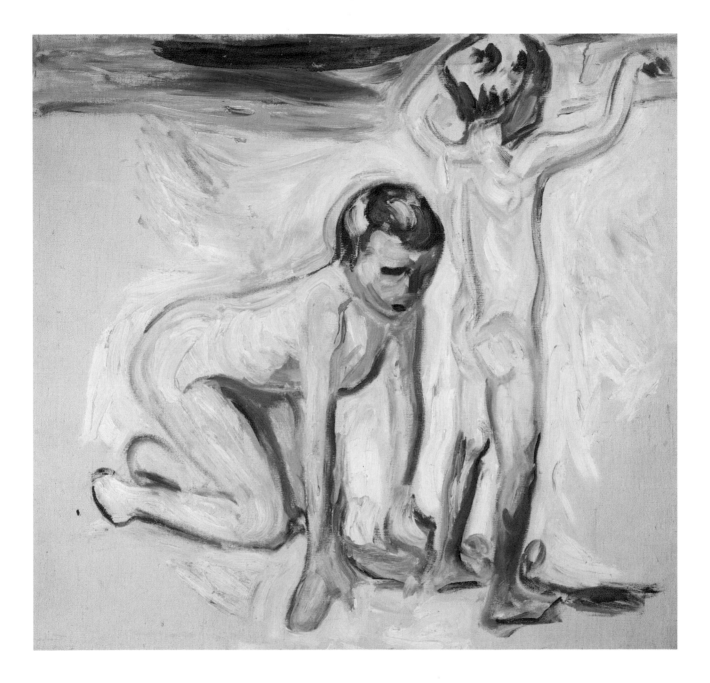

29. BOYS BATHING. 94 x 99.5 cm

30. PORTRAIT OF IDA
DOROTHEA ROEDE, 1909.
248 x 90 cm

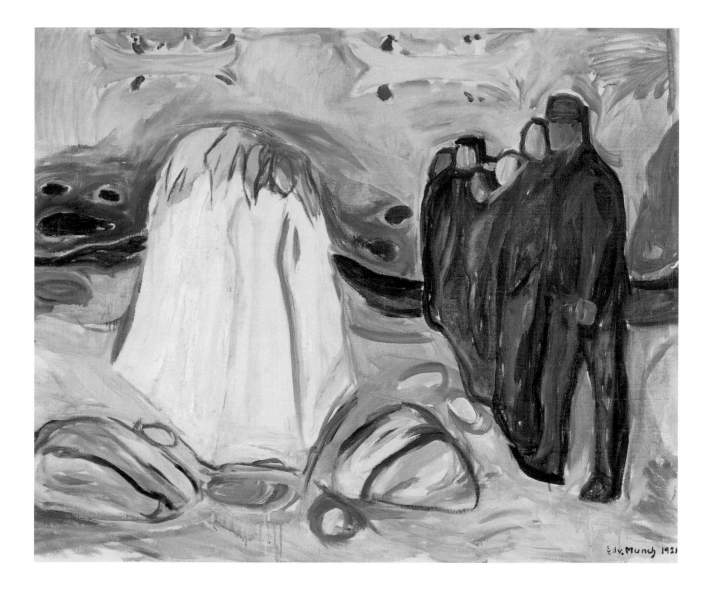

33. MEETING, 1921. 127 x 108 cm

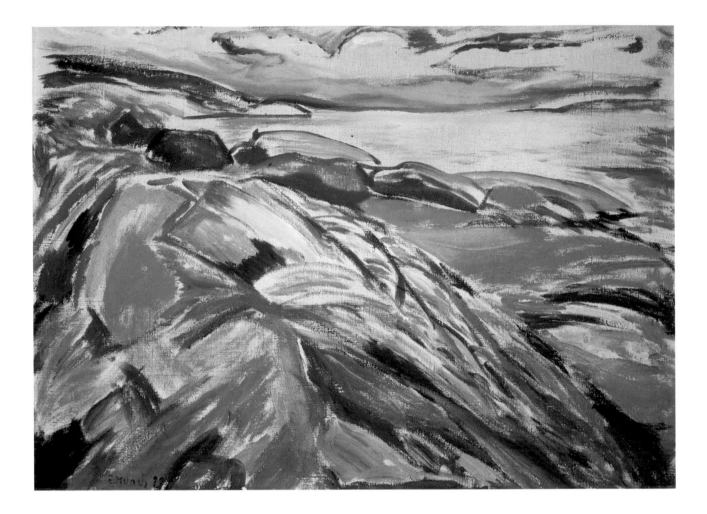

34. COASTAL LANDSCAPE, 1922. 74 x 92 cm

154

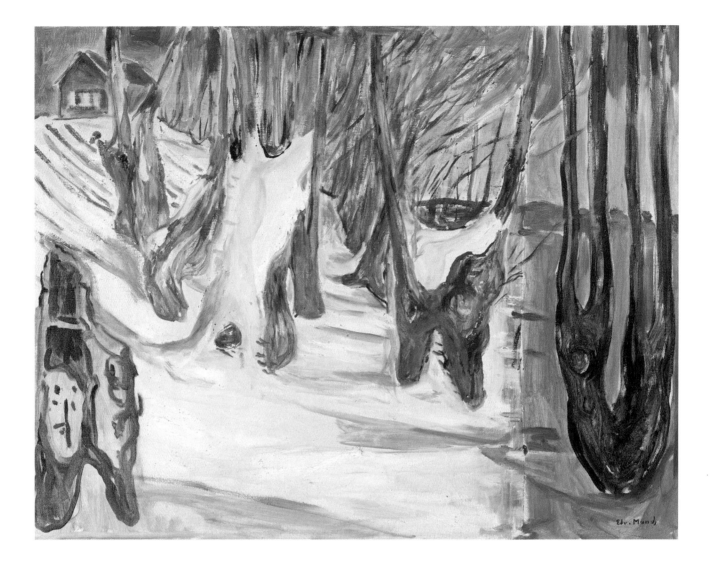

35. OLD TREES, ca. 1923-1925. 73 x 92 cm

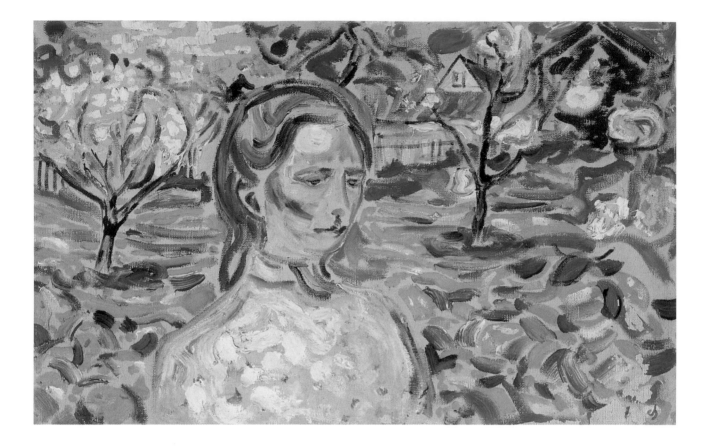

32. WOMAN IN AN ORCHARD. 52.5 x 85 cm

Drawings
Prints

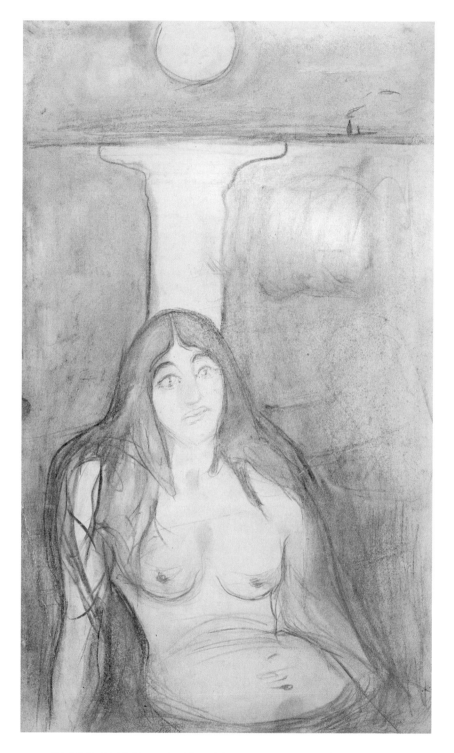

37. MERMAID IN FRONT OF THE MOON, 1892. 48 x 28.3 cm

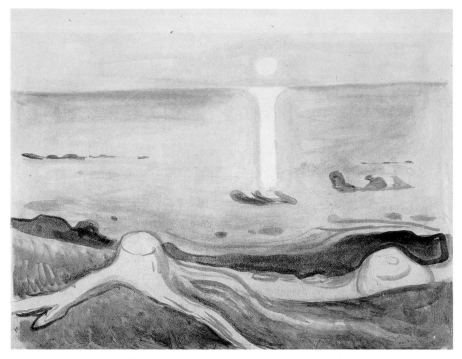

36. MYSTERY ON THE SHORE, 1892. 34.8 x 45.7 cm

38. THE VOICE (SUMMER NIGHT), 1893. 50 x 64.7 cm

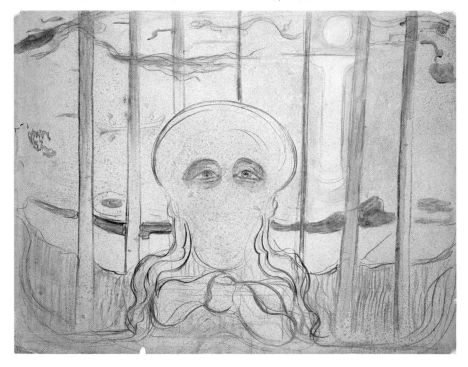

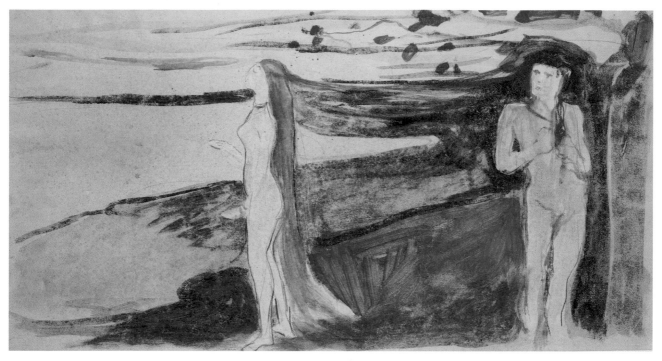

39. SEPARATION, 1896. 33.2 x 59.7 cm

40. THE WOMAN IS KILLED, 1895-1896. 33.8 x 59.4 cm

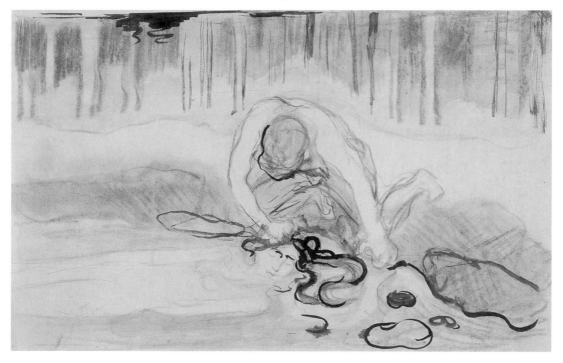

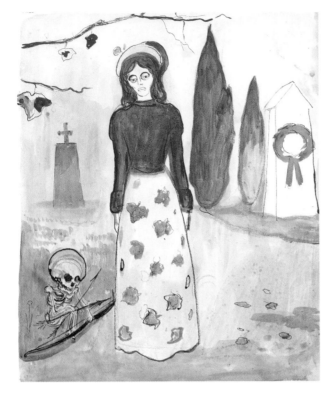

41. MADONNA IN THE CHURCHYARD, 1896.
56 x 44.8 cm

43. THE DANCE OF LIFE, 1899. 32.5 x 47.7 cm

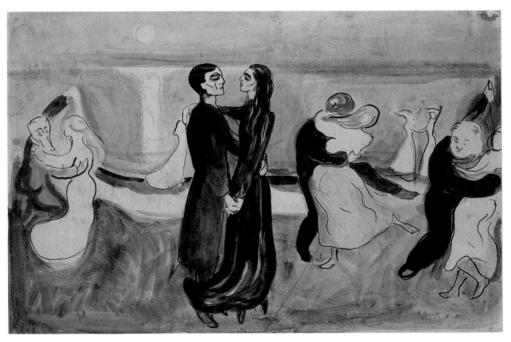

Verso of No. 44:
METABOLISM, 1899-1901.
49.8 x 64.5 cm

44. THE EMPTY CROSS, 1899-1901. 49.8 x 64.5 cm

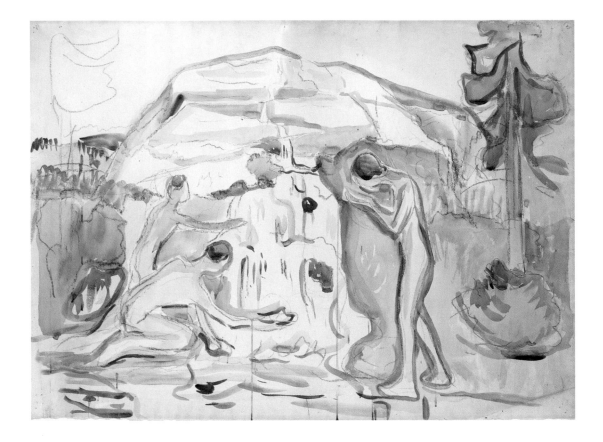

42. THE SOURCE, 1909-1910. 56.2 x 78.1 cm

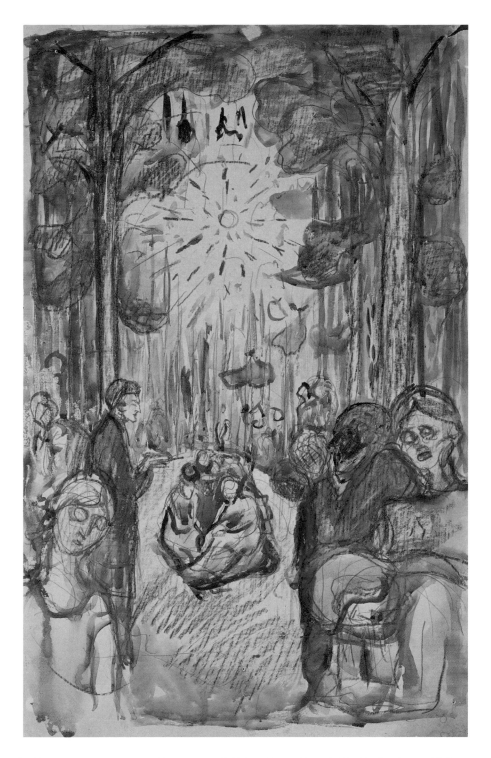

45. THE CATHEDRAL IN THE FOREST. THE SERMON, 1909-1911. 70.3 x 44.4 cm

46. CARICATURE, 1897. 9.3 x 14 cm

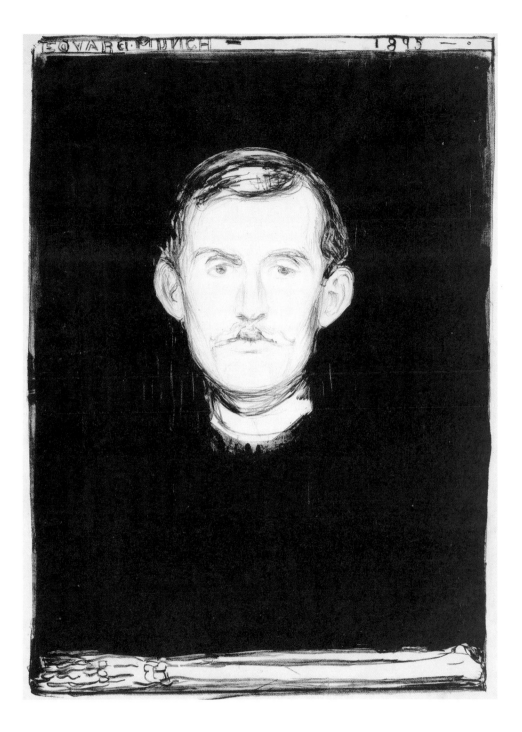

47. SELF-PORTRAIT WITH SKELETON ARM, 1895. 45.5 x 31.5 cm

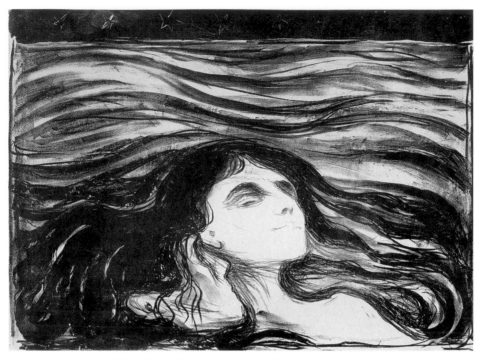

52. LOVERS IN WAVES, 1896. 30.7 x 41.2 cm

48. WOMAN (WOMAN IN THREE STAGES), 1895. 29.9 x 34.2 cm

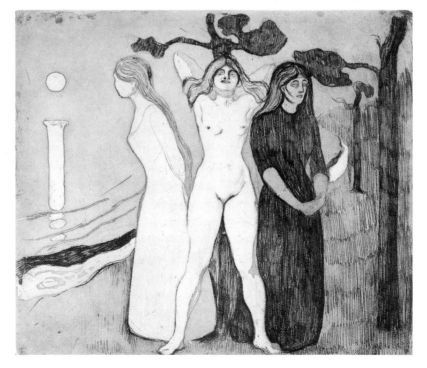

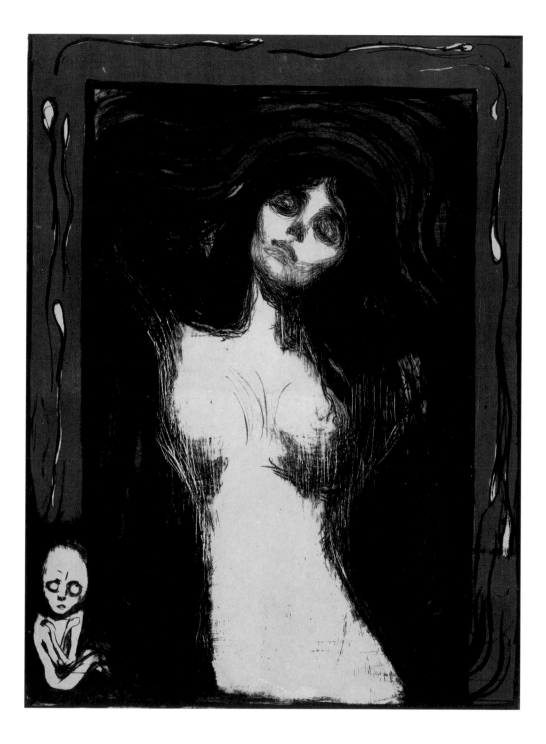

49. MADONNA, 1895. 60.5 x 44.4 cm

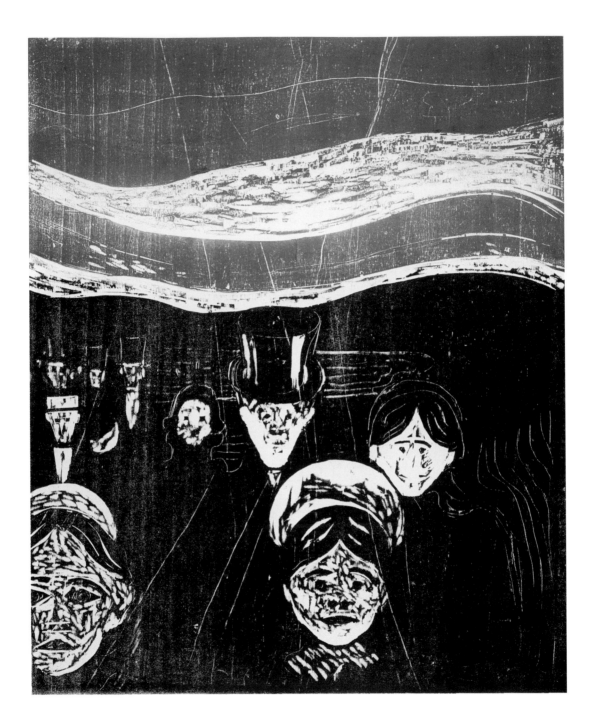

53. ANXIETY, 1896. 45.7 x 37.5 cm

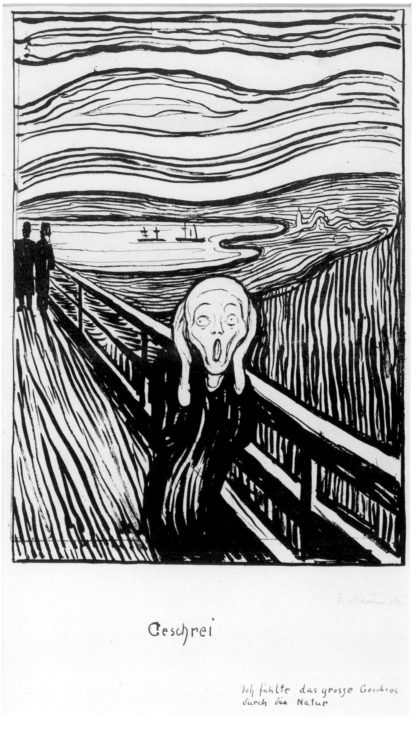

Geschrei

Ich fühlte das grosse Geschrei
durch die Natur

50. THE SCREAM, 1895. 44.2 x 15.4 cm

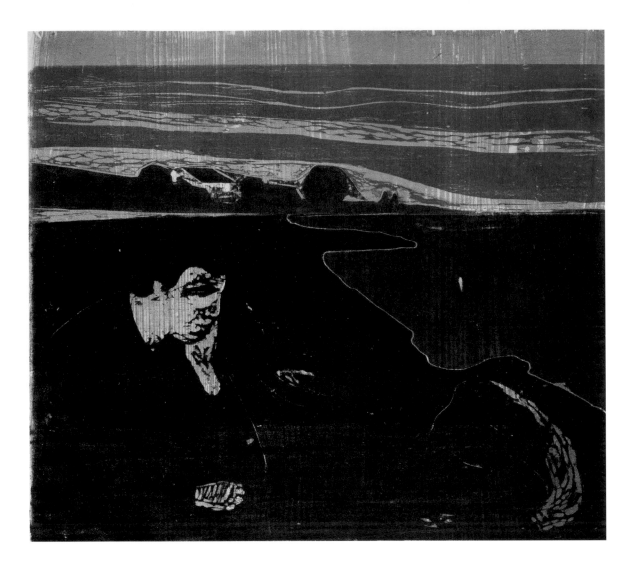

54. EVENING. MELANCHOLY I, 1896. 41 x 45.3 cm

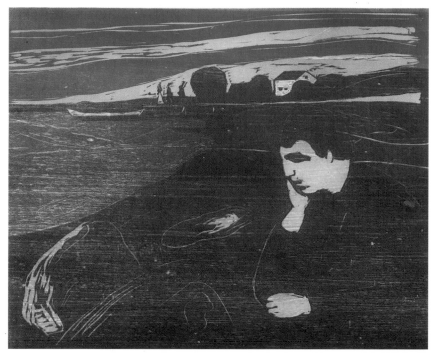

55. EVENING. MELANCHOLY, 1901. 38.8 x 46 cm

56. EVENING. MELANCHOLY, 1896. 38 x 45.4 cm

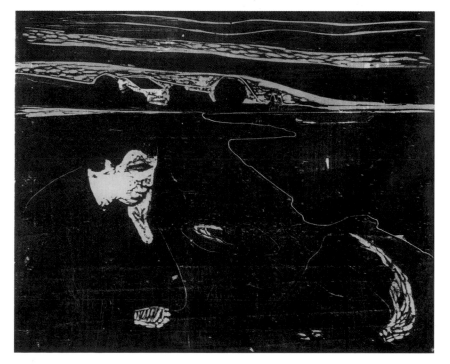

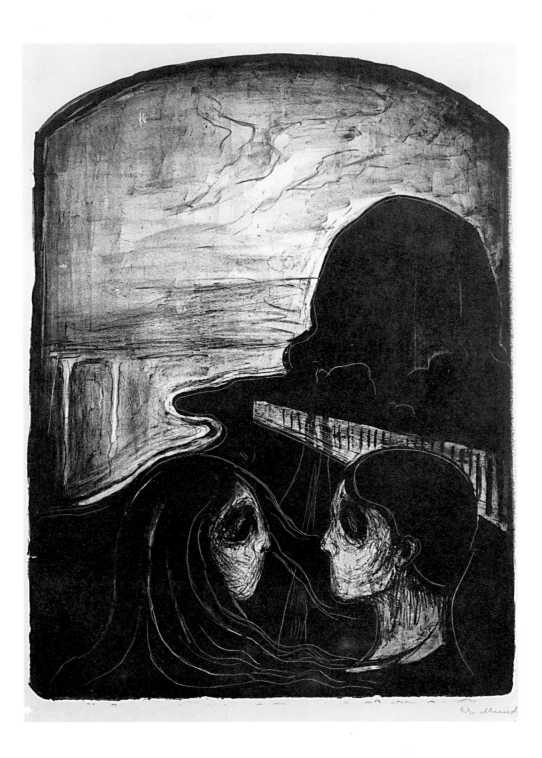

57. ATTRACTION I, 1896. 47.7 x 36.5 cm

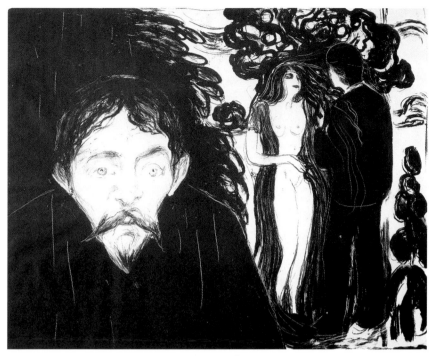

59. JEALOUSY II, 1896. 47.5 x 57.2 cm

58. MOONLIGHT I, 1896. 40.2 x 47.6 cm

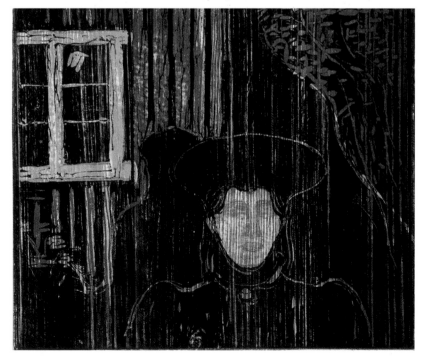

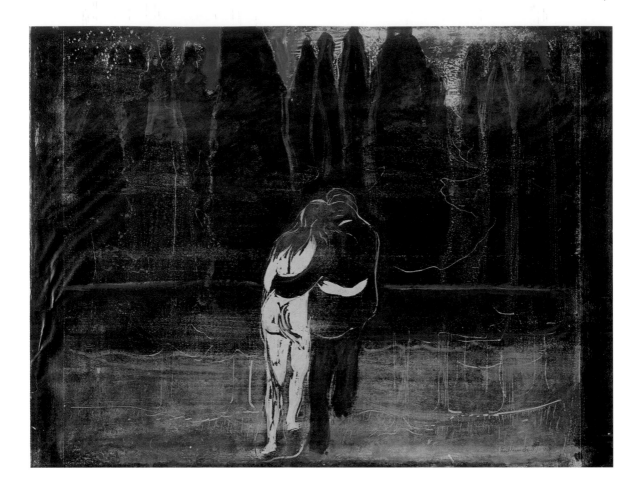

60. TOWARD THE WOOD, 1897. 49.8 x 64.5 cm

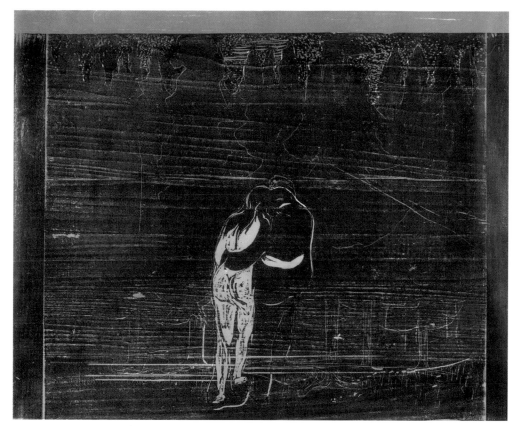

61. TOWARD THE WOOD, 1897. 49.5 x 64.5 cm

62. TOWARD THE WOOD, ca. 1899. 49.5 x 64.5 cm 63. TOWARD THE WOOD, 1915. 51 x 64.5 cm

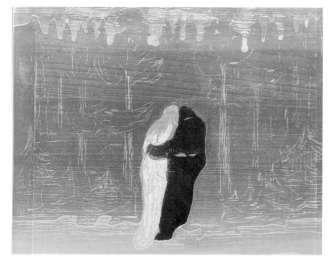

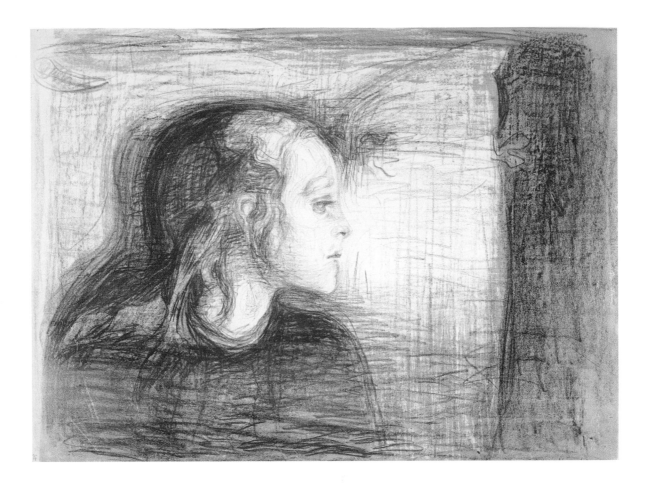

51. THE SICK CHILD, 1896. 43.2 x 57.1 cm

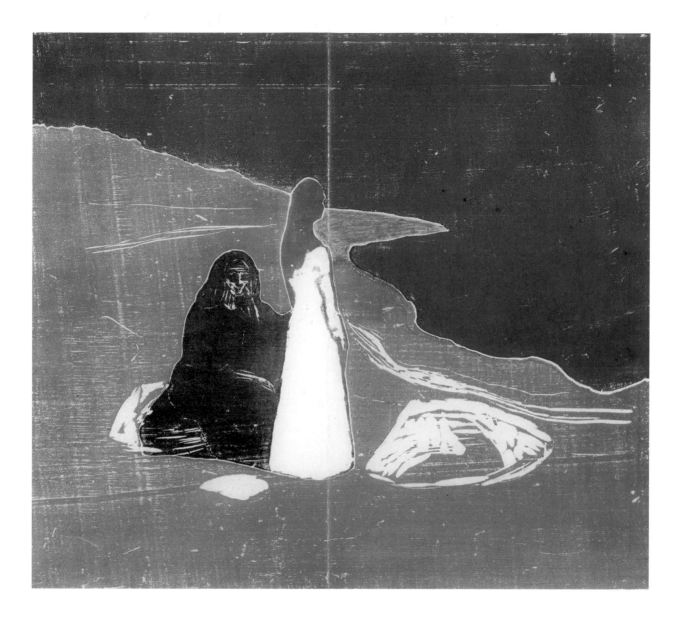

66. WOMEN ON THE SHORE, 1898. 45.3 x 51 cm

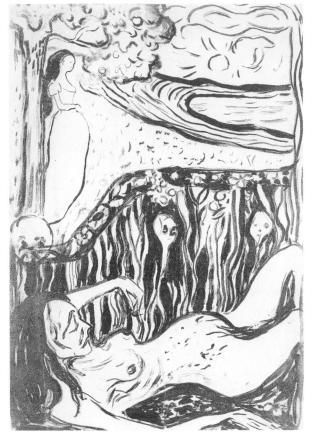

64. DEATH AND LIFE, 1897. 36.5 x 24.5 cm

65. FERTILITY, 1898. 42 x 52 cm

71. THE KISS IV, 1902. 33 x 59.5 cm

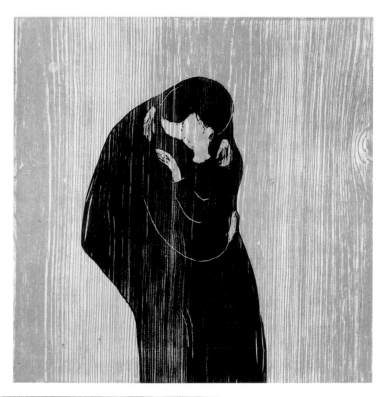

73. EVENING ON KARL JOHAN STREET.

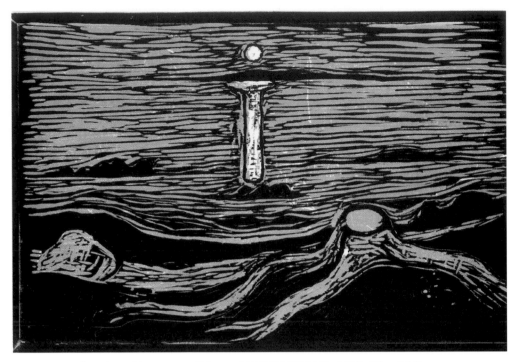

67. THE STUMP. MYSTERY ON THE SHORE, 1899. 37 x 56.9 cm

69. TWO HUMAN BEINGS. THE LONELY ONES, 1899. 39.3 x 54.6 cm

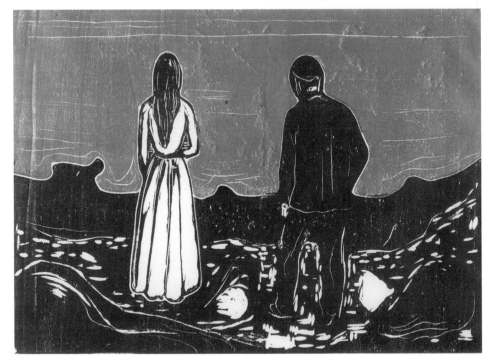

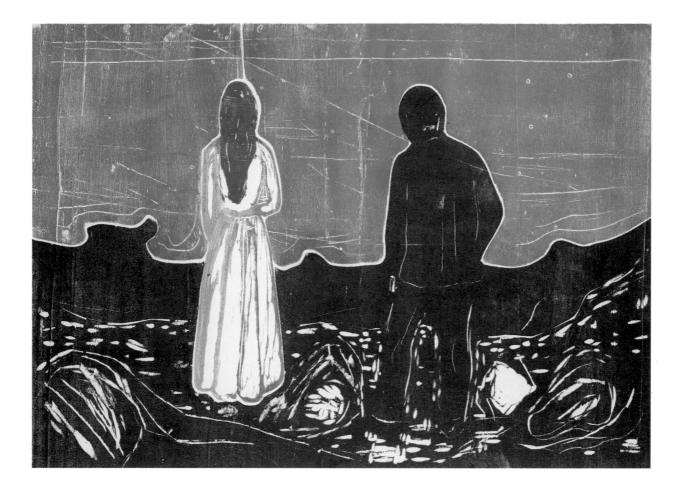

68. TWO HUMAN BEINGS. THE LONELY ONES, 1899. 39.5 x 55.7 cm

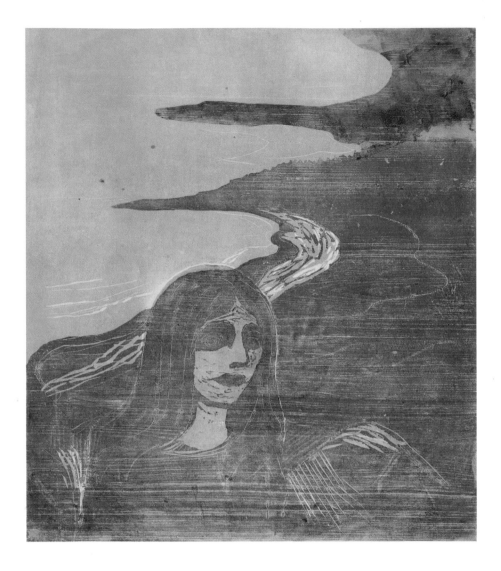

70. GIRL'S HEAD AGAINST THE SHORE, 1899. 46.7 x 41.4 cm

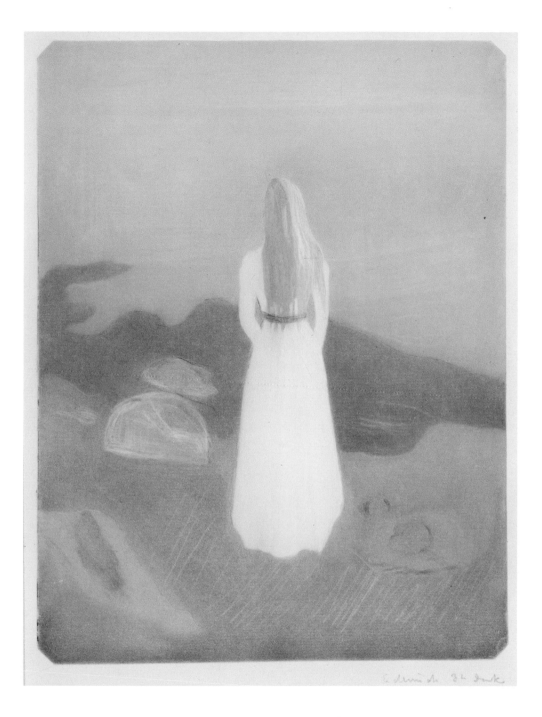

72. THE LONELY ONE/YOUNG GIRL ON THE SHORE. 28.8 x 21.9 cm

HARALD SOHLBERG
Paintings
Drawings
Prints

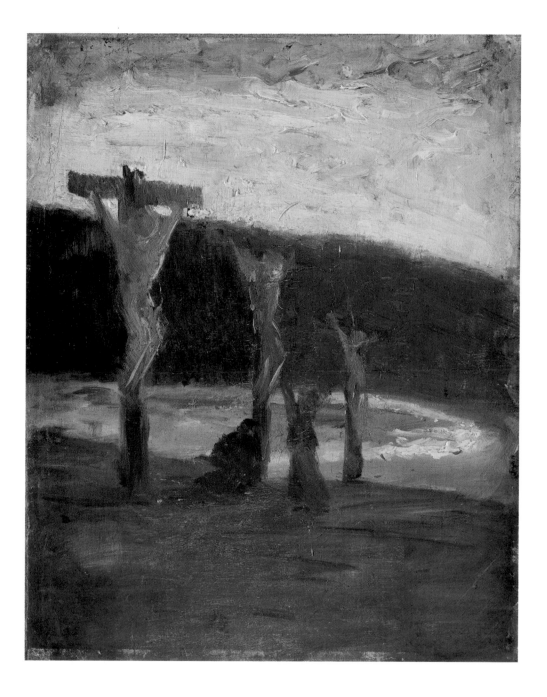

75. CHRIST ON THE CROSS, ca. 1892. 33 x 26.5 cm

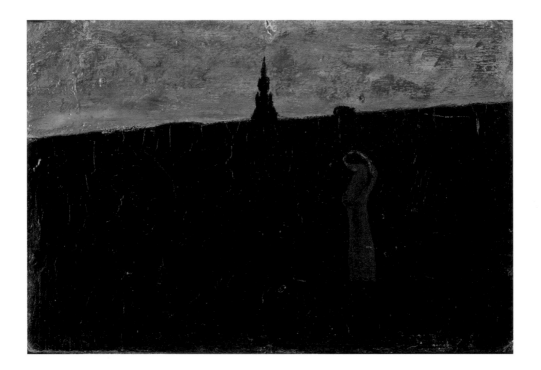

76. THE GIRL AND THE DAISY, ca. 1892/1893. 13.5 x 20 cm

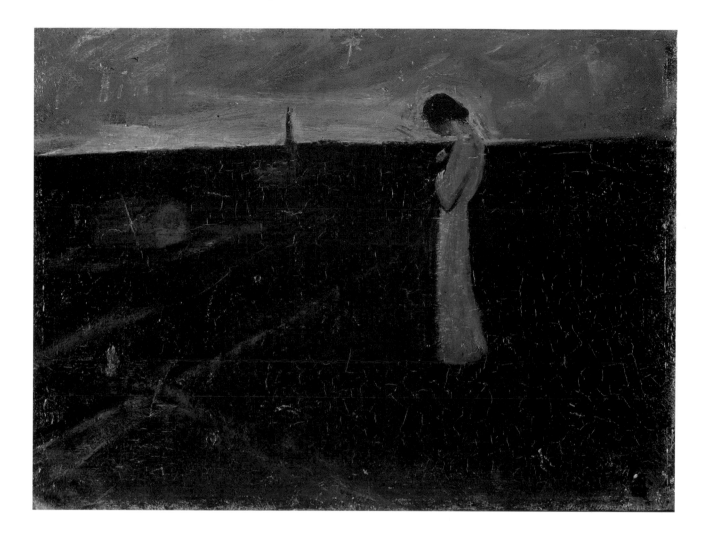

77. THE GIRL AND THE DAISY, ca. 1892-1894. 19.7 x 26.7 cm

78. VIEW OF CHRISTIANIA IN WINTER, ca. 1892-1894. 19.7 x 26.5 cm

79. FROM NORDRE LANGØ, ca. 1893. 47 x 39 cm

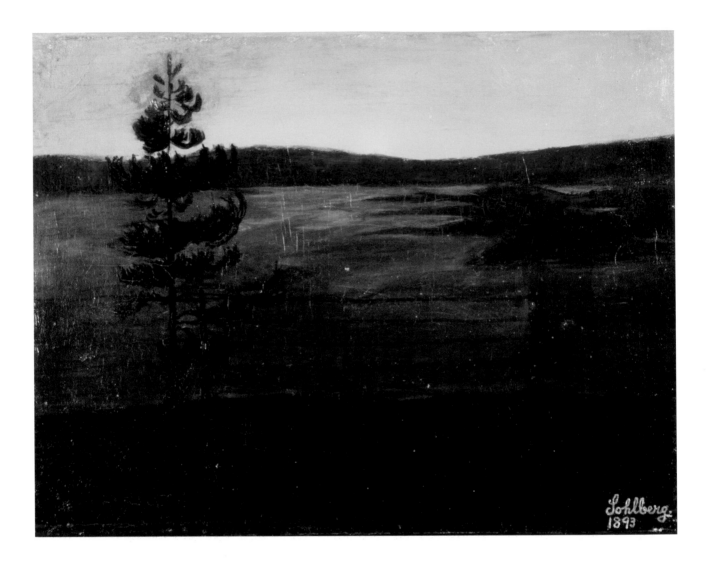

80. EVENING, 1893. 25.5 x 33.5 cm

194

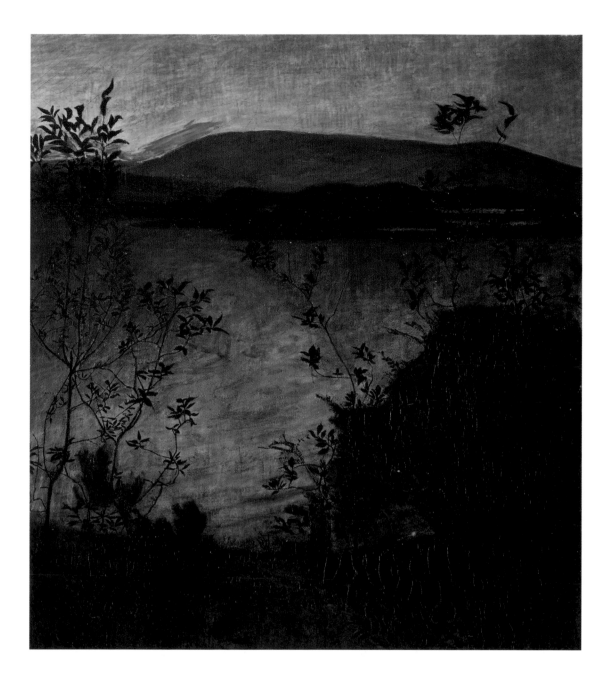

81. NIGHT GLOW, 1893. 79.5 x 62 cm

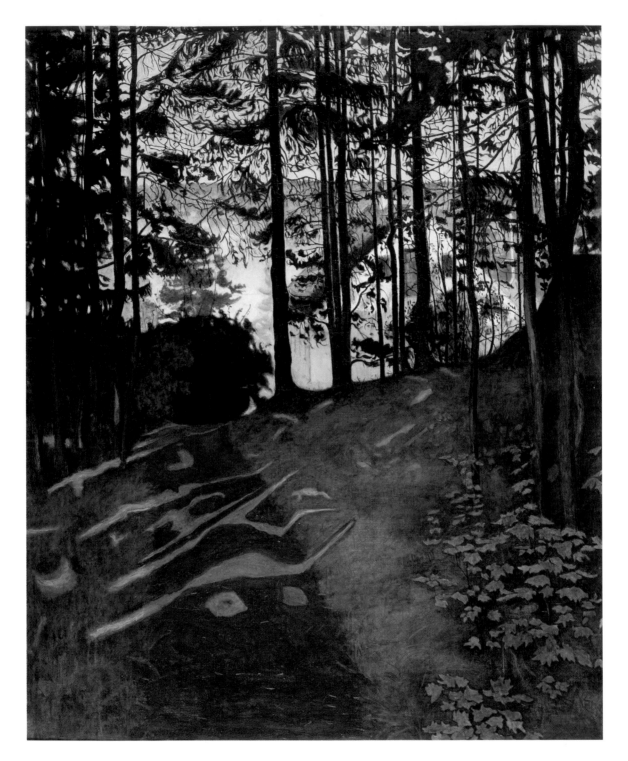

82. SUN GLEAM, 1894. 73 x 59 cm

83. EUGENI, A STREET WOMAN, 1894. 45 x 21 cm

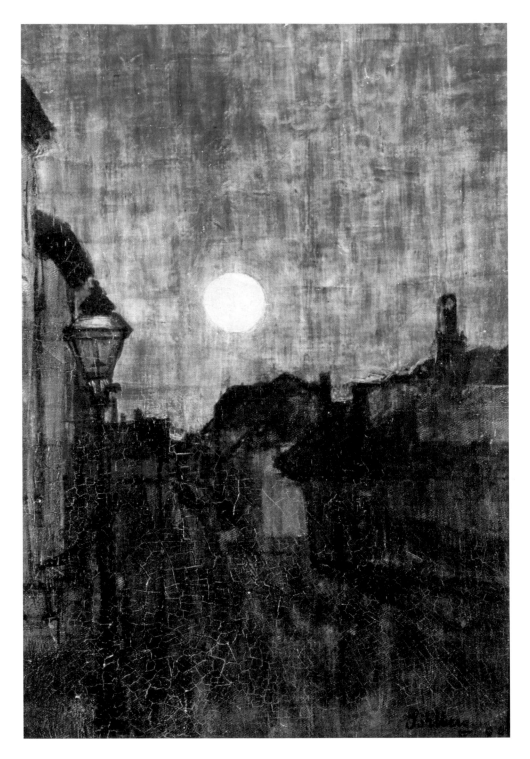

84. VOGNMANDS-STREET, 1894. 34.5 x 24.5 cm

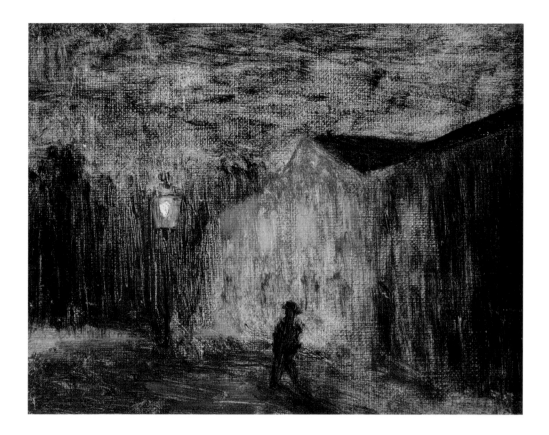

85. STREET LAMP, 1894. 16 x 19 cm

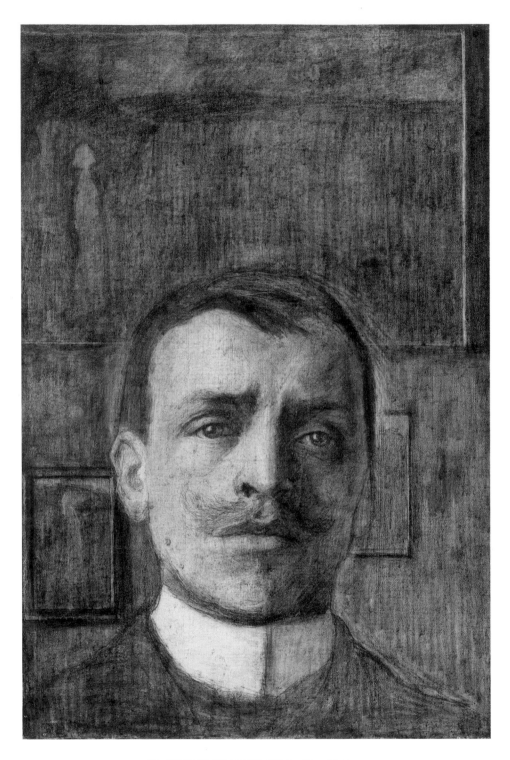

86. SELF-PORTRAIT, 1895. 47 x 31.1 cm

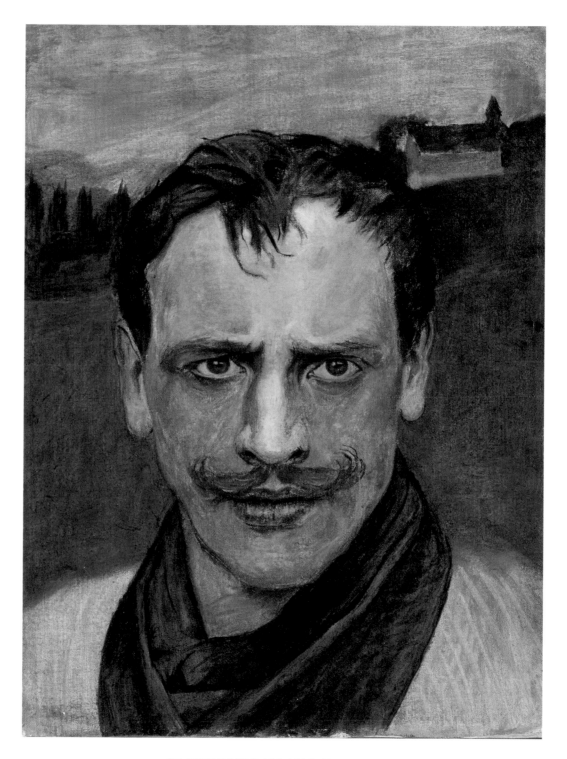

87. SELF-PORTRAIT, 1896. 39 x 28.5 cm

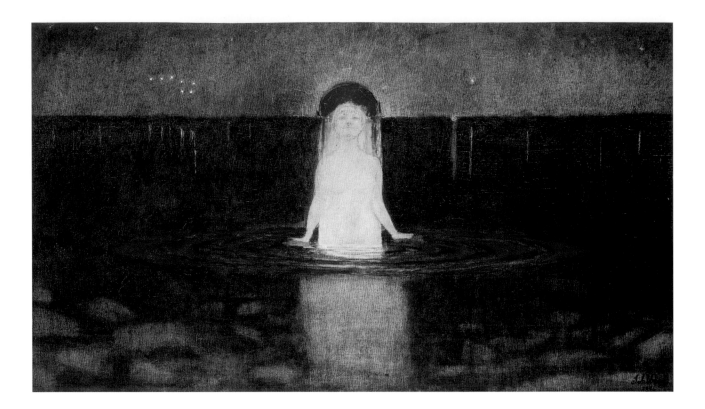

88. THE MERMAID, 1896. 51 x 89 cm

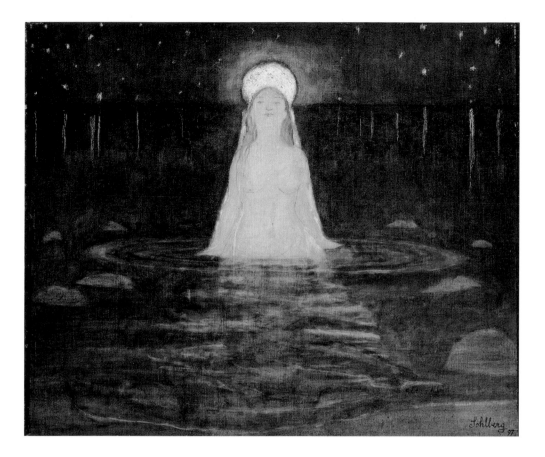

89. MERMAID, 1896. 46.5 x 54.5 cm

90. COUNTRY HOUSE, 1896. 127 x 87 cm

91. RIPE FIELDS, 1891-1898. 73 x 116 cm

92. SUMMER NIGHT, 1899. 114 x 135.5 cm

93. CLOUDY WEATHER, ca. 1898. 67 x 57 cm

94. WINTER ON THE BALCONY. 68.5 x 91 cm

95. WINTER NIGHT IN THE MOUNTAINS, 1900. 38.5 x 46.5 cm

97. RONDANE BY SUNRISE, 1902. 18 x 27 cm

96. WINTER NIGHT IN THE MOUNTAINS, 1901. 70 x 92 cm

98. ELEGY, 1903. 38 x 46 cm

99. NIGHT, 1904. 113 x 134 cm

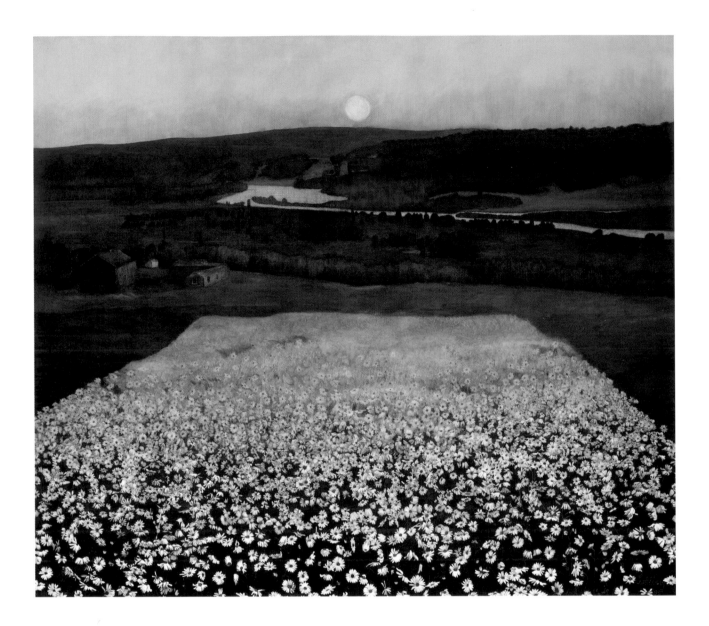

100. FLOWER MEADOW IN THE NORTH, 1905. 96 x 111 cm

101. DRIFTING SNOW, 1905. 52 x 65 cm

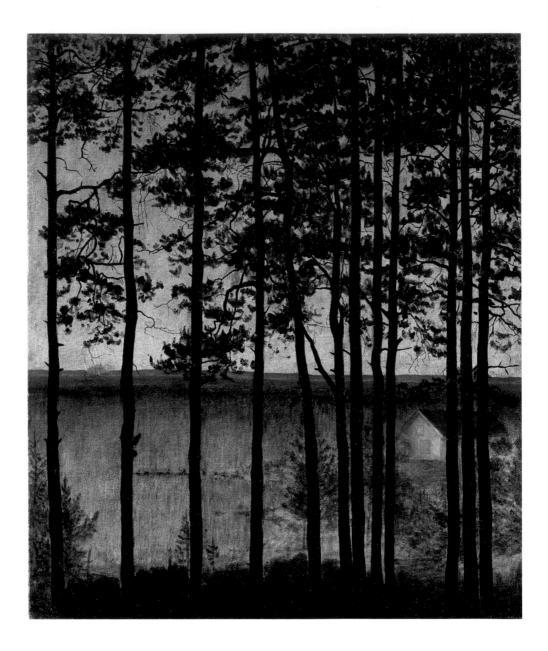

102. FISHERMAN'S HOUSE, 1906. 54 x 46 cm

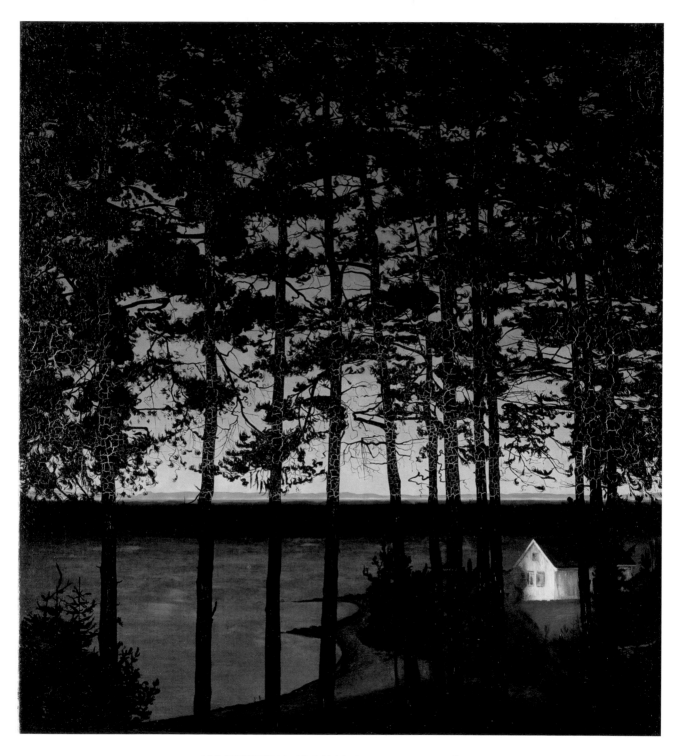

103. FISHERMAN'S COTTAGE, 1907. 109 x 94 cm

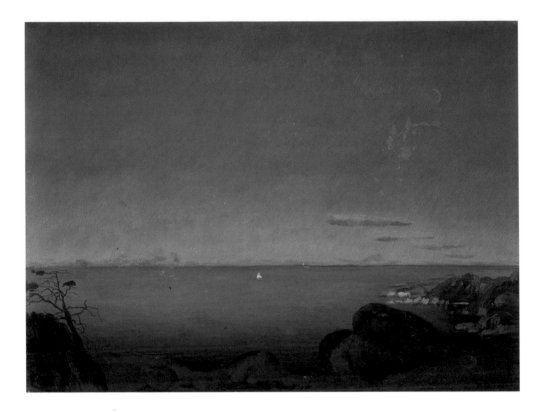

105. STUDY FOR ANDANTE, 1908. 38 x 48 cm

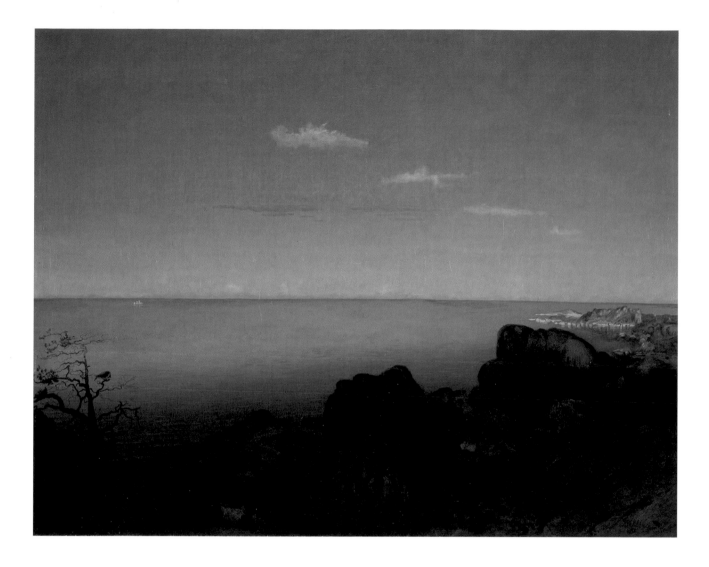

106. ANDANTE, 1908. 81 x 101.5 cm

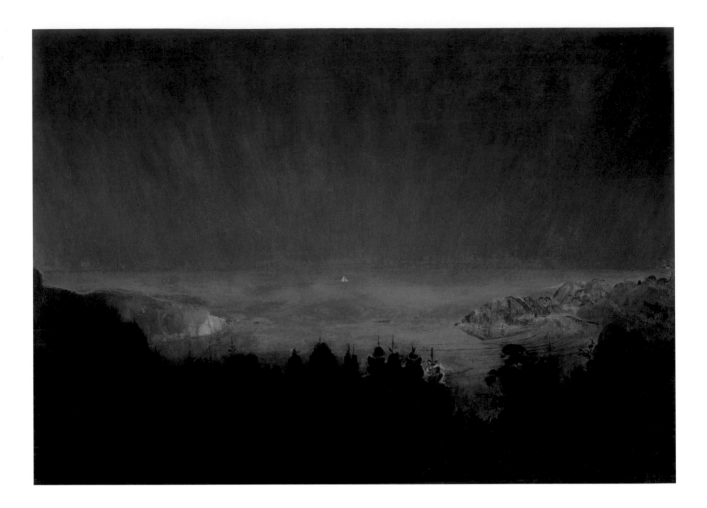

104. MIDSUMMERNIGHT, NORDIC THEME, 1907-1911. 82 x 115.5 cm

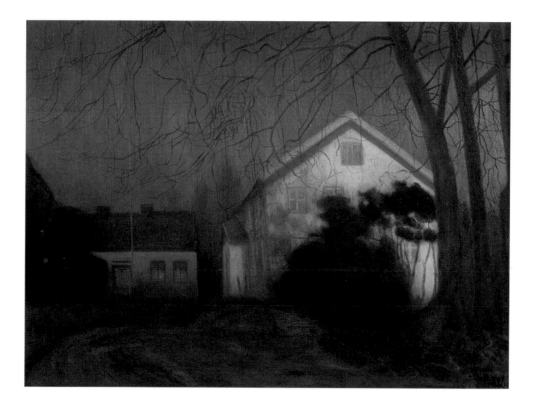

107. MOONLIGHT, 1909. 35 x 47 cm

108. BY THE SEA, 1909. 78 x 88 cm

109. AUTUMN LANDSCAPE, 1910. 82 x 70.6 cm

110. LIGHT EVENING IN THE SPRING, 1911. 68 x 91 cm

112. EVENING, AKERSHUS, 1913. 83 x 116 cm

111. COUNTRY ROAD, 1912. 100 x 62 cm

Drawings
Prints

114. 115. 116. 117.
The Mermaid
Pen and ink on paper
[four studies mounted together]
17 x 10 cm

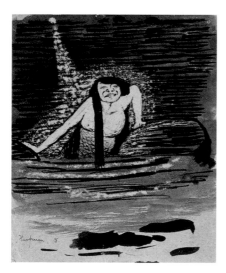

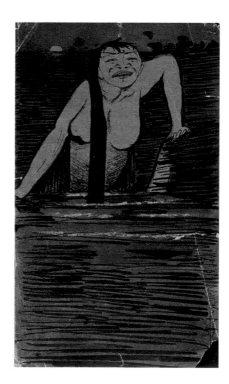

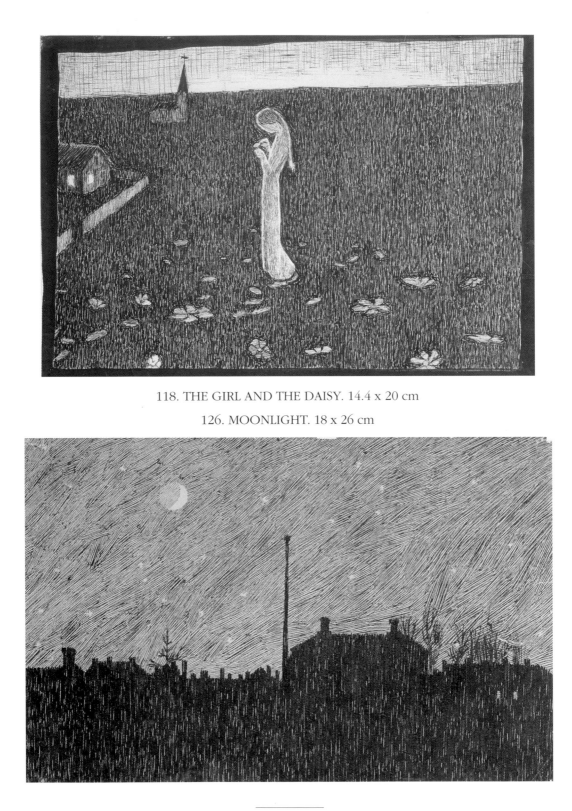

118. THE GIRL AND THE DAISY. 14.4 x 20 cm

126. MOONLIGHT. 18 x 26 cm

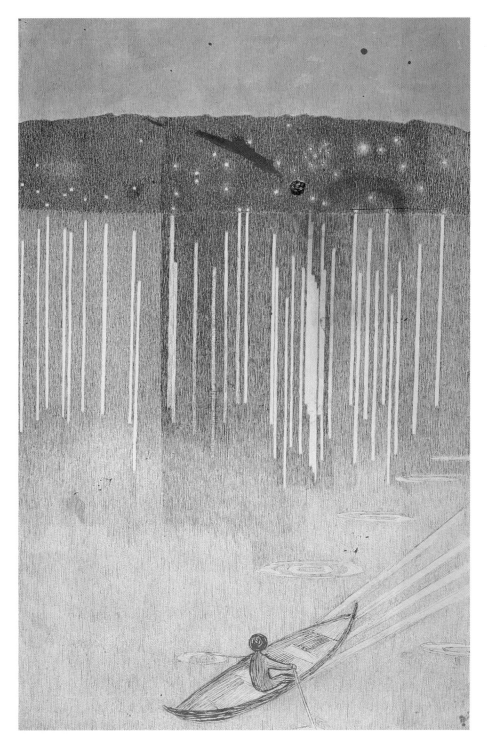

121. STARRY NIGHT ON THE FJORD. 35.5 x 22.5 cm

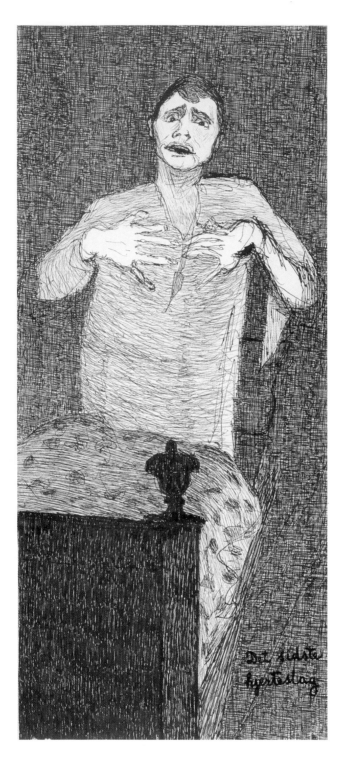

119. THE LAST HEARTBEAT. 32.5 x 14.5 cm

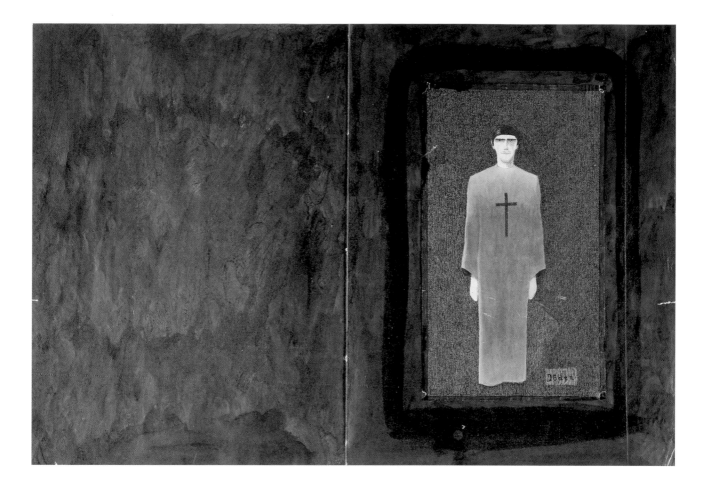

120. THE DEATH. 49 x 70 cm

123. THE CLOUD, ca. 1893. 23.3 x 18.3 cm

127. MOONLIGHT, ca. 1894. 17.7 x 25.8 cm

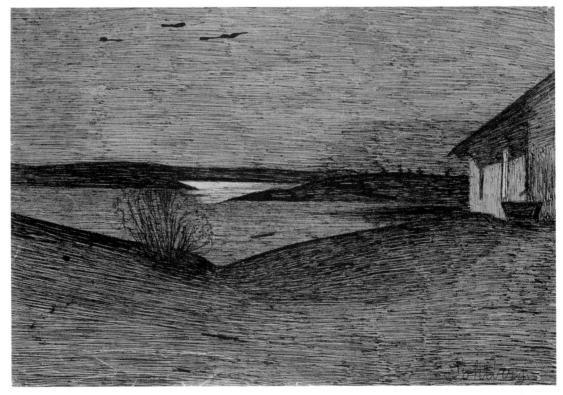

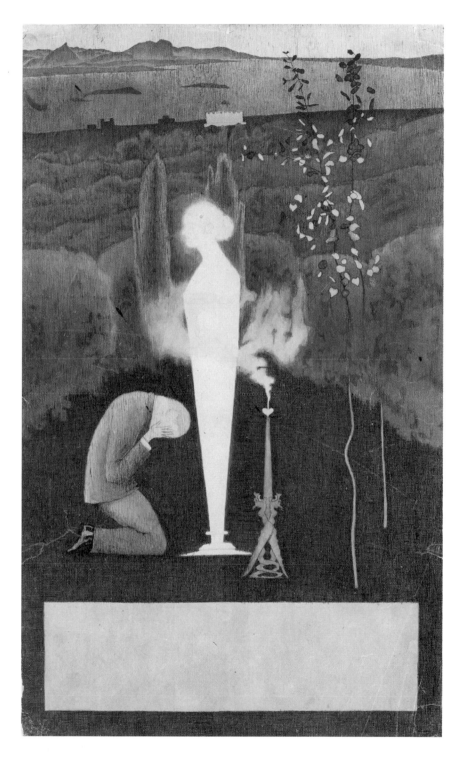

122. IN THE DEPTH OF MY GARDEN, before 1897. 34 x 21 cm

128. TIME, LIFE, MANHOOD. 18 x 15 cm

124. SIR EDVARD, ca. 1893. 10 x 17 cm 125. ADAM, ca. 1893. 10 x 17 cm

236

132. THE MERMAID, ca. 1897. 47.5 x 30 cm

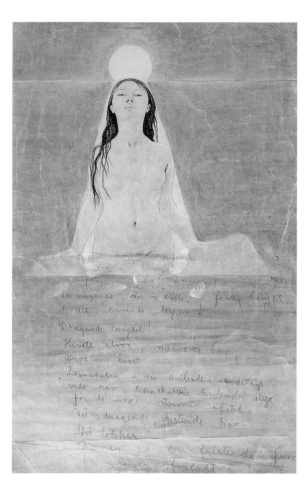

131. THE MERMAID, 1897. 46.5 x 54.5 cm

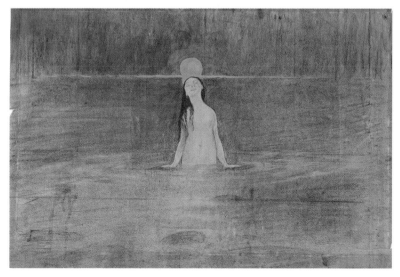

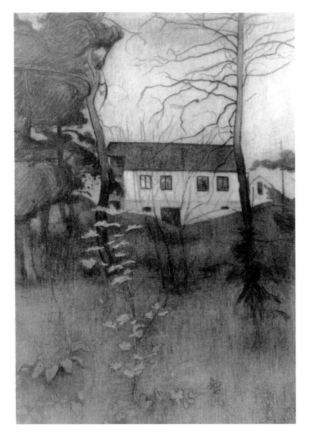

134. THE COTTAGE, 1896. 58.4 x 42.5 cm

130. SILENCE, ca. 1896. 25.5 x 33.5 cm

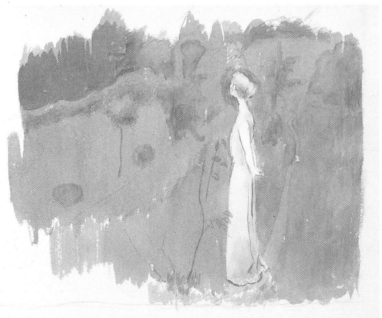

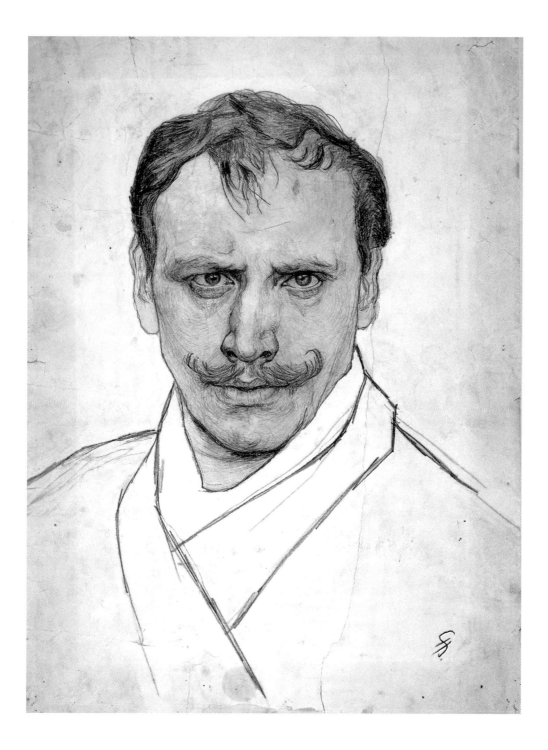

133. SELF-PORTRAIT. 47 x 33.9 cm

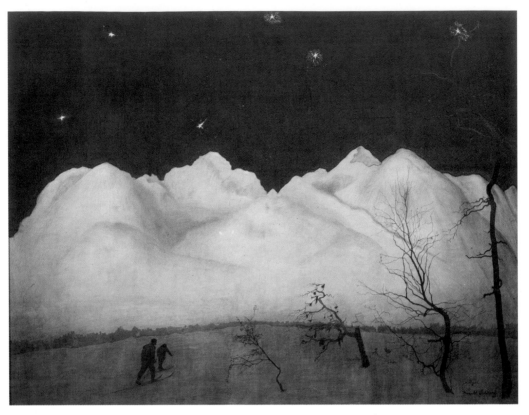

136. WINTER NIGHT IN THE MOUNTAINS, 1900. 68.5 x 89 cm

145. WINTER NIGHT IN THE MOUNTAINS, 1911.
57.5 x 65 cm

135. WINTER NIGHT IN THE MOUNTAINS, 1900.
150 x 171 cm

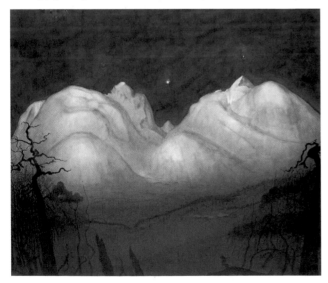

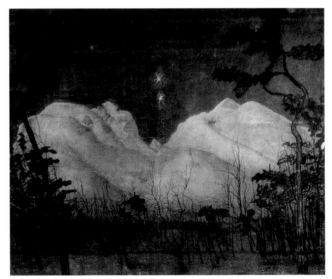

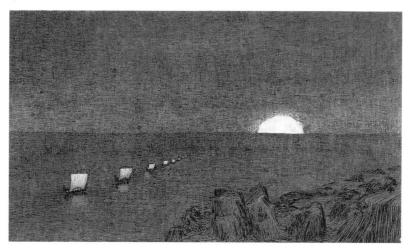

129. EXODUS. 12.3 x 20.3 cm

139. EXODUS, 1907. 80 x 99 cm

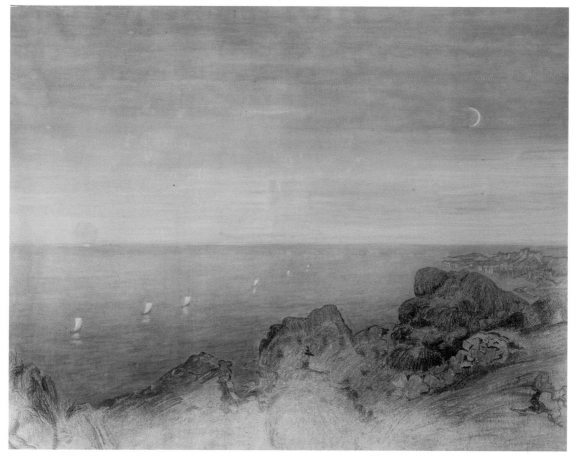

137. THE FISHERMAN'S
 COTTAGE, 1906.
 18.5 x 16 cm

138. SEA AND SKY,
 June 2, 1906.
 21.7 x 17 cm

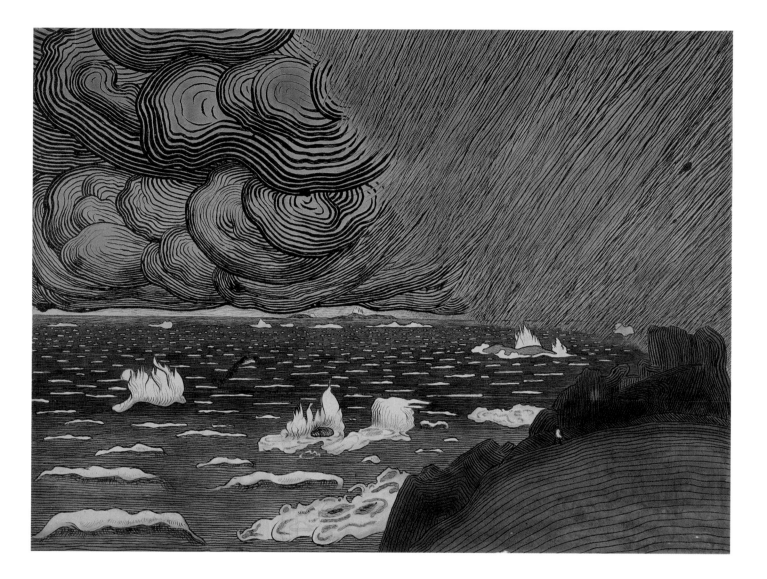

140. SEA SPRAY, 1908. 39 x 52.5 cm

141. PRIDE OF THE FAMILY: Jappe Nilssen, Jens Thiis, Edvard Munch, Ludvig Ravensberg and Christian Gierløff, 1908. 25.5 x 32 cm

144. VANITY IS PERISHABLE. 25.5 x 25 cm

143. THE ASSAILANT, 1911. 40 x 47 cm

142. A ROYAL MEETING, 1910. 62.3 x 41.7 cm

147. FROM AKERSHUS. 28.8 x 29.2

146. NIGHT, 1922. 49.7 x 64.6 cm

148. THE GIRL AND THE DAISY, 1897. 12.8 x 14.3 cm

149. MOONLIGHT, 1912. 20.6 x 28 cm

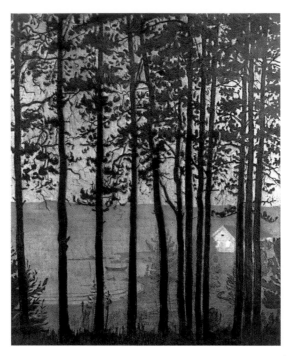

150. THE FISHERMAN'S COTTAGE, 1912. 25.5 x 20.6 cm

151. MIDNIGHT, 1914. 46.6 x 64 cm

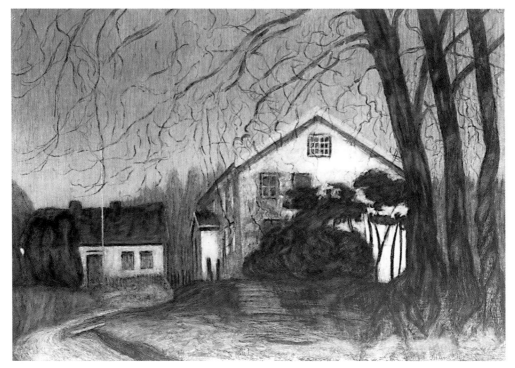

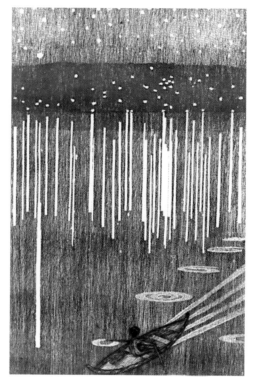

152. STARRY NIGHT BY THE FJORD. 35.5 x 22.5 cm

153. SILENCE, 1931. 17.2 x 24.1 cm

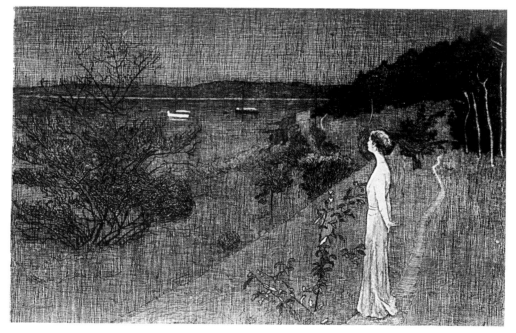

154. THE MAN AND THE UNIVERSE. 25.1 x 17.2 cm

155. FROM AKERSHUS. 20.8 x 29.2 cm

Bibliography

All short–title citations are by author (or editor) and date, including exhibitions catalogues. The Norwegian letters Å, æ, and Ø are alphabetized as one would expect to find them in English (i.e., letter for letter ignoring accents).

Aars 1914
Harald Aars. "Harald Sohlberg." *Kunst og Kultur* 4 (1914).

Askeland 1966
Jan Askeland. "Angstmotivet i Edvard Munchs Kunst," [The Fear Motif in Edvard Munch's Art] *Kunsten Idag* 8 (1966), no. 4, pp. 4–47, English text, pp. 52–57.

Aubert 1894–1895
Andreas Aubert. "Den første vaarutstilling." *Nyt Tidsskrift,* ny række (1894–1895), pp. 434–443, 525–533, and Vol. 2, 6, pp. 525–533.

Aubert 1904
Andreas Aubert. *Det nye Norges malerkunst.* Kristiania, 1904.

Aubert 1917
Andreas Aubert. *Norsk kultur og norsk kunst.* Kristiania: Steenske forlag, 1917.

Bang 1946
Erna Holmboe Bang. *Edvard Munch og jappe Nilssen: Etterlatte brev og kritikker.* Oslo: Dreyer, 1946.

Bang 1963
Erna Holmboe Bang. *Edvard Munch kriseår: belyst i brever.* Oslo: Glydendal norsk forlag, 1963.

Belting 1992
Hans Belting. *Die Deutschen und ihre Kunst: ein schwieriges Erbe.* Munich: Verlag C.H. Beck, 1992.

Benesch 1960
Otto Benesch. *Edvard Munch.* Trans. Joan Spencer. London: Phaidon Press, 1960.

Benesch 1963
Otto Benesch. "Edvard Munch's tro. Oslo Kommunes Kunstsamlinger." *Årbok 1963* (Oslo), pp. 9–23.

Berg 1981
Knut Berg. *Norges kunsthistorie*. vol. 5. Oslo: Gyldendal norsk forlag, 1981.

Berg 1993
Knut Berg. "Om dateringen av et Munch–maleri." *Kunst og Kultur* 76 (1993), no. 4, pp. 213–223.

Berman 1993
Patricia G. Berman. "Edvard Munch's Self–portrait with Cigarette: Smoking and the Bohemian Persona," *Art Bulletin* 4 (December 1993), pp. 626–646.

Berman 1993
Patricia G. Berman. "Body and Body Politic in Edvard Munch's Bathing Men," pp. 71-83 in *The Body Imagined*. Ed. Kathleen Adler and Maria Pointon. Cambridge: Cambridge University Press, 1993.

Bjerke 1985
Øivind Storm Bjerke. *Harald Sohlberg*. Exh. cat. Trondheim: Trondjems Kunstforening, 1985.

Bjerke 1986
Øivind Storm Bjerke. "Harald Sohlberg, Grafikk," pp. 49–68. In *Harald Sohlberg, katalog for utstilling i Galleri K*. Exh. cat. Oslo: Galleri K, 1986.

Bjerke 1987
Øivind Storm Bjerke. "Høstutstillingen 1882-1940." pp. 13-48. In *Statens 100. Kunstutstilling*. Exh. cat. Oslo. Statens Kunstutstilling 1987.

Bjerke 1988
Øivind Storm Bjerke. "Harald Sohlbergs fotografier," pp. 79– 100. *Skandinavisk kunst og fotografi*. Munch–museets skrifter 4, Oslo: Kommunes Kunstsamlinger, 1988.

Bjerke 1991
Øivind Storm Bjerke. *Harald Sohlberg: ensomhetens maler*. Oslo: Gyldendal norsk forlag, 1991.

Bjerke 1994
Øivind Storm Bjerke. "Symbol og fantasi møtes i maleriet," pp. 93–112. *Tradisjon og fornyelse: Norge rundt århundreskiftet*. Tone Skedsmo, ed. Exh. cat. Oslo: Nasjonalgalleriet, Oslo 1994.

Blomberg 1951
Erik Blomberg. "Geniet och Målaren" ["Genius and Painter"]. *Kunsten Idag* 20 (1951), no. 4, pp. 4–31; English trans. Christopher Norman, pp. 56–58.

Bock 1973
Henning Bock and Gunter Busch, eds. *Edvard Munch: Probleme – Forschungen – Thesen*. Munich, 1973.

Boyle–Turner 1989
Caroline Boyle–Turner. *Jan Verkade, ein holländischer Schüler Gauguins*. Exh. cat. Amsterdam: Rijksmuseum Vincent van Gogh, 1989 (also shown at Quimper, Musée de Beaux–Arts, and Albstadt, Städtlische Galerie). German ed., Zwolle: Waanders Verlag, 1989.

Brenna 1972
Arne Brenna. "Hans Jægers fengselsfrise." *St. Hallvard.* (1972), pp. 238–266.

Brenna 1976
Arne Brenna. "Hans Jæger og Edvard Munch." *Nordisk Tidskrift* 52 (1976), Part I: pp. 89–115; Part II: pp. 188–215.

Brenna 1978
Arne Brenna. "Edvard Munch Arbeiderbilder 1909–1915." *Kunst og Kultur* 61 (1978), no. 4, pp. 197–220.

Castleman 1973
Riva Castleman. *The Prints of Edvard Munch.* Exh. cat. New York: Museum of Modern Art, 1973.

Colditz 1888
Herman Colditz. *Kjærka. Et Atelier–interiør.* Copenhagen, 1888.

Dedekam 1908
Hans Dedekam. "Edvard Munch." pp. 288–310. *Kunst og Kultur.* Studier og Afhandlinger tilegnet Lorentz Dietrichson. Christiania: Alb. Cammermeyers Forlag, 1908.

Deknatel 1950
Frederick B. Deknatel. *Edvard Munch.* Bibiliography by Hannah B. Muller. Exh. cat. Boston, Institute of Contemporary Art, and New York, Museum of Modern Art. New York, Chanticleer Press, 1950.

De Man 1969/1983
Paul de Man. "The Rhetoric of Temporality"[1969]. In *Blindness and Insight: Essays in the Rhetoric of Contemporary Criticism.* Minneapolis: University of Minnesota Press, 1983.

Dietrichson 1885
Lorentz Dietrichson. *Fra Kunstens Verden.* Copenhagen: Gyldendalske Boghandels Forlag, 1885.

Digby 1955
George Wingfield Digby. *Meaning and Symbol in Three Modern Artists: Edvard Munch, Henry Moore, Paul Nash.* London: Faber & Faber, 1955.

Dittmann 1982
Reidar Dittmann. *Eros and Psyche. Strindberg and Munch in the 1890s.* Ann Arbor, Michigan: UMI Research Press, 1982.

Dorra 1976
Henri Dorra. "Munch, Gauguin and Norwegian Painters in Paris." *Gazette des Beaux Arts* 88 (November 1976), pp. 175– 180.

Dorra 1994
Henri Dorra. *Symbolist Art Theories: A Critical Anthology.* Berkeley: University of California Press, 1994.

Eggum 1976
Arne Eggum. "Edvard Munch and America," pp. 80–84. In *Edvard Munch, the Major Graphics*. Washington, D. C.: Smithsonian Institution Traveling Exhibition Service, 1976.

Eggum and Woll 1977
Arne Eggum and Gerd Woll. *Edvard Munch*. Exh. cat., Stockholm: Liljevalchs Konsthall and Kulturhuset, 1977.

Eggum 1978
Arne Eggum. "Munch's Self–portraits"; "The Major Paintings"; "The Theme of Death," pp. 11–33, 33–75, 143–183. In Rosenblum 1978.

Eggum 1979
Arne Eggum. *Edvard Munch. Malerier fra Eventyrskoven*. Exh. cat. Copenhagen: Kastrupgårdsamlingen 16. 1979.

Eggum 1980a
Arne Eggum. "James Ensor and Edvard Munch: Mask and Reality," pp. 21–30. In *James Ensor, Edvard Munch, Emil Nolde*. Exh. cat. Regina, Saskatchewan: Norman McKenzie Art Gallery, University of Regina, 1980.

Eggum 1980b
Arne Eggum. *Edvard Munch: Paintings from the Munch Museum, Oslo*. Trans. Rachel Cutting. Exh. cat. Newcastle–upon–Tyne: Polytechnic Art Gallery, 1980. (Also shown in Liverpool, Walker Art Gallery).

Eggum 1980c
Arne Eggum. "Edvard Munch tidlige barneportretter." *Kunst og Kultur* 63 (1980), no. 4, pp. 241–256.

Eggum 1982a
Arne Eggum. "Litteraturen om Edvard Munch gjennom nitti år." *Kunst og Kultur* 65 (1982), no. 4, pp. 270–279.

Eggum 1982b
Arne Eggum. *Edvard Munch: Expressionist Paintings 1900–1940: A Loan Exhibition...* Exh. cat. Madison, Wisconsin: Elvehjem Museum of Art, University of Wisconsin–Madison, 1982 (also shown at St. Paul, Minnesota Museum of Art, 1982; Newport Beach, California, Newport Harbor Art Museum, 1983; Seattle Art Museum, 1983).

Eggum 1983
Arne Eggum. *Edvard Munch: Malerier – Skisser og Studier*. Oslo: J.M. Stenersens forlag, 1983.

Eggum 1984
Arne Eggum. *Edvard Munch: Paintings, Sketches and Studies*. Trans. Ragnar Christophersen. New York: Clarkson N. Potter, 1984.

Eggum 1987
Arne Eggum, ed. *Briefwechsel Edvard Munch/Gustav Schiefler...* Vols. 1–2. Hamburg: Verlag Verein für Hamburgische Geschichte, 1987–1990.

Eggum 1987/1989
Arne Eggum. *Munch og fotografi:* Gyldendal norsk forlag, 1987. English ed. *Munch and Photography.* Trans. Birgit Holm. New Haven: Yale University Press, 1989.

Eggum 1988
Arne Eggum. *Edvard Munch og hans modeller 1912–1943.* Exh. cat. Oslo: Munch–museet, 1988.

Eggum 1990
Arne Eggum. *Edvard Munch. Livsfrisen fra maleri til grafikk,* Oslo: J.M. Stenersens Forlag, 1990.

Eggum 1994
Arne Eggum. *Edvard Munch. Portretter.* Exh. cat. Oslo: Munch–museet, 1994. Oslo: Labyrinth Press, 1994.

Eggum and Pedersen 1979
Arne Eggum and Marit Lande Pedersen. *Frederick Delius og Edvard Munch.* Exh. cat. Oslo: Munch–museet, 1979.

Eggum and Woll 1981
Arne Eggum and Gerd Woll. *Edvard Munch. Alpha and Omega.* Exh. cat. Oslo: Munch–museet, 1981.

Epstein 1983
Sarah Epstein. *The Prints of Edvard Munch, Mirror of His Life: An Exhibition of Prints from the Collection of Sarah G. and Lionel C. Epstein.* Exh. cat. Oberlin, Ohio: Allen Memorial Art Museum, Oberlin College, 1983.

Gadamer 1960/1975
Hans Georg Gadamer. *Wahrheit und Methode.* Tübingen: Mohr, 1960. English ed. *Truth and Method.* Garrett Barden and John Cumming eds. New York: Seabury Press, 1975.

Gauguin 1933/1946
Pola Gauguin. *Edvard Munch.* Oslo: Glydendal, 1933. New ed., 1946.

Gauguin 1946a
Pola Gauguin. *Grafikeren Edvard Munch. Litografier.* Trondheim: Brun, 1946.

Gauguin 1946b
Pola Gauguin. *Grafikeren Edvard Munch, Tresnitt og raderinger.* Trondheim: Brun, 1946.

Gerlach 1955
Hans Egon Gerlach. *Edvard Munch: sein Leben und sein Werk.* Hamburg: Christian Wegner, 1955.

Gide 1949
André Gide. *Anthologie de la poésie française.* Paris: Libraire Gallimard, 1949.

Gierløff 1953
Christian Gierløff. *Edvard Munch selv.* Oslo: Gyldendal norsk forlag, 1953. German ed., Berlin, 1953.

Glaser 1917
Curt Glaser. *Edvard Munch*. Berlin: B. Cassirer, 1917.

Gløersen 1956
Inger Alver Gløersen. *Den Munch jeg møtte*. Oslo: Gyldendal norsk forlag, 1956. English ed.: Copenhagen: Edition Bløndahl, 1994.

Gløersen 1970
Inger Alver Gløersen. *Lykkehuset: Edvard Munch og Åsgårdstrand*. (English summary, pp. 61–64). Oslo: Gyldendal norsk forlag, 1970.

Goldstein 1892
Emanauel Goldstein. *Kameratkunst* (Copenhagen), February 8, 1892.

Goldwater 1979
Robert Goldwater. *Symbolism*. New York: Harper & Row, 1979.

Gran 1950
Henning Gran. "Omkring et semester hos Zahrtmann." *Kunst og Kultur* 16 (1950), no. 2, pp. 69–92.

Gran 1951
Henning Gran. "Munch Gjennom Werenskiolds Briller." [Munch Seen Through the Eyes Of Werenskiold]. *Kunsten Idag* 17 (1951), no. 1, pp. 4–21; English trans. Christopher Norman, pp. 54–57.

Gran 1963
Henning Gran. "Edvard Munchs møte med norsk kritikk 1895." *Kunst og Kultur* 46 (1963), no. 4, pp. 205–226.

Greenberg 1986
Clement Greenberg. *The Collected Essays and Criticism*. Chicago: University of Chicago Press, 1986.

Greve 1963
Eli Greve. *Edvard Munch: Liv og verk i lys av tresnittene*. Oslo: J. W. Cappelens Forlag, 1963.

Guenther 1976
Peter W. Guenther. *Edvard Munch*. Exh. cat. Houston: Sarah Campbell Blaffer Gallery of the University of Houston, 1976 (also exhibited at New Orleans Museum of Art and San Antonio, Witte Memorial Museum, 1976).

Hansen and Schneede 1994
Dorothee Hansen and Uwe M. Schneede. *Munch und Deutschland*. Exh. cat. Hamburg: Hamburger Kunsthalle, 1994. Stuttgart: Verlag Gerd Hatje, 1994.

Hauser 1951/1962
Arnold Hauser. *A Social History of Art*. 2 vols. London, Routledge & Paul, 1951. Rev. ed. 4 vols., London, Routledge & Paul, 1962.

Heller 1968
Reinhold Heller. "Strømpefabrikanten, Van de Velde og Edvard Munch." *Kunst og Kultur* 51 (1968), no. 2, pp. 89–104.

Heller 1969
Reinhold Heller. "Affæren Munch, Berlin 1892–1893." *Kunst og Kultur* 52 (1969), no. 3, pp. 175–191.

Heller 1969/1984
Reinhold Heller. *Edvard Munch's Life Frieze. Its Beginnings and Origins.* (Ph.D. diss., University of Indiana, Bloomington, 1969), Ann Arbor, Michigan: University Microfilms, 1984.

Heller 1970
Reinhold Heller. "The Iconography of Edvard Munch's Sphinx." *Artforum* 9 (October 1970), pp. 72–80.

Heller 1973a
Reinhold Heller. "Edvard Munch's Vision and the Symbolist Swan." *Art Quarterly* 36 (Autumn 1973), pp. 209–249.

Heller 1973b
Reinhold Heller. *Edvard Munch: The Scream.* New York: Viking Press, 1973.

Heller 1978a
Reinhold Heller. "Love as a Series of Paintings and a Matter of Life and Death," pp. 87–111. In Rosenblum 1978.

Heller 1978b
Reinhold Heller. Edvard Munch's "Night": The Aesthetics of Decadence and the Content of Biography." *Arts Magazine* 53 (October 1978), pp. 80–105.

Heller 1984
Reinhold Heller. *Munch: His Life and Work.* Chicago: University of Chicago Press, 1984.

Heller 1993
Reinhold Heller. "Anton von Werner, der Fall Munch und die Moderne im Berlin der 1890er Jahre," pp. 101–109. In *Anton von Werner, Geschichte in Bildern.* Ed. Dominik Bartmann. Exh. cat. Berlin: Deutsches historisches Museum, 1993. Berlin: Hirmer, 1993.

Hodin 1948
Josef Paul Hodin. *Edvard Munch, der Genius des Nordens.* Stockholm: Neuer Verlag, 1948.

Hodin 1972
Josef Paul Hodin. *Edvard Munch.* London: Thames & Hudson 1972.

Hofstätter 1963
Hans Hofstätter. *Geschichte der europäischen Jugendstilmalerei: ein Entwurf.* Cologne: M. DuMont Schauberg, 1963.

Hofstätter 1965
Hans Hofstätter. *Symbolismus und die Kunst der Jahrhundertwende: Voraussetzungen, Erscheinungsformen, Bedeutungen.* Cologne: M. DuMont Schauberg, 1965.

Høifødt 1989
Frank Høifødt. "Smertens blomst— et supplement." *Kunst og Kultur* 72 (1989), no. 4, pp. 219–231.

Høifødt 1990
Frank Høifødt. "Livets dans." *Kunst og Kultur* 73 (1990), no. 3, pp. 166–181.

Hougen 1977
Pål Hougen. "Edvard Munch og Henrik Ibsen," pp. 216–234. *Contemporary Approaches to Ibsen.* Oslo: Universitetsforlaget, 1977.

Hougen 1978
Pål Hougen. *Edvard Munch and Henrik Ibsen.* Exh. cat. Northfield, Minnesota: St. Olafs College, 1978.

Ingebretsen 1937
Eli Ingebretsen. "Harald Sohlberg." *Kunst og Kultur* 21 (1937), no. 2, pp. 57–60.

Jameson 1991
Frederic Jameson. *Postmodernism, or, the Cultural Logic of Late Capitalism.* Raleigh: Duke University Press, 1991.

Jæger 1886/1889
Hans Jæger. *Impressionisten,* no. 1 (1886), and no. 8 (1889).

Kermode 1975
T.S. Eliot. In Frank Kermode, ed. *Selected Prose.* London: Faber & Faber, 1975.

Koerner 1990
Joseph Leo Koerner. "Symbol and Allegory." *Caspar David Friedrich and the Subject of Landscape.* London: Reaktion Books, 1990.

Kokoschka 1952
Oskar Kokoschka. "Edvard Munchs ekspressionisme." *Kunst og Kultur* 35 (1952).

Krag 1893
Vilhelm Krag. "Hans Sidste Breve" [His Final Letters]. *Samtiden* (1893), pp. 129–135.

Krag 1930
Vilhelm Krag. *Digte.* Oslo: Aschehoug & Co., 1930.

Krohg 1989
Christian Krohg. *Kampen for tilværelsen.* Oslo: Gyldendal norsk forlag, 1989.

Kuspit 1993
Donald Kuspit. *Signs of Psyche in Modern and Postmodern Art.* Cambridge: Cambridge University Press, 1993.

Langaard 1932
Johan H. Langaard. *Edvard Munch: Maleren.* Nasjonalgalleriets Veileder IV. Oslo: Nasjonalgalleriet, 1932.

Langaard 1937
Johan H. Langaard. "Harald Sohlberg." *American–Scandinavian Review* (March 1937).

Langaard 1948
Johan H. Langaard. "Edvard Munchs formler, et lite forsøk på en formanalyse." *Samtiden* (1948), p. 50.

Langaard 1949
Johan H. Langaard. "Edvard munchs formler." *Samtiden* (1949), pp. 50–56.

Langaard 1952
Johan H. Langaard. "Munch i Amerika." *Kunst og Kultur* 35 (1952), no. 2, pp. 55–64.

Langaard 1960a
Ingrid Langaard. *Edvard Munch. Modningsår: en studie i tidlig ekspresjonisme og symbolisme.* Oslo: Gyldendal, 1960.

Langaard 1961
Johan H. Langaard and Reidar Revold. *Edvard Munch fra år til år: en håndbok* [*A Year by Year Record of Edvard Munch's Life: A Handbook*]. Oslo: H. Aschehoug and Co., 1961 (Norwegian and English).

Langaard 1963
Johan H. Langaard, ed. *Edvard Munch 100 år.* Oslo: Oslo Kommunes Kunstsamlinger Årbok 1963, 1963.

Langaard 1967
Johan H. Langaard. *Edvard Munch i familien Sigval Bergesen D.Y's eie.*, Oslo: 1967

Langaard and Revold 1957/1958
Johan H. Langaard and Reidar Revold. "The Drawings of Edvard Munch." *Kunsten Idag* 42 (1957), no. 4, pp. 4–55, and 43 (1958), no. 1, pp. 4–55; English trans. (1957), pp. 56–57 and (1958), pp. 56–57.

Langaard and Revold 1960
Johan H. Langaard and Reidar Revold. *Edvard Munch. The University Murals: Graphic Art, and Paintings.* Oslo: Forlaget Norsk Kunstreproduksjon, 1960.

Langaard and Revold 1964
Johan H. Langaard and Reidar Revold. *Edvard Munch. Mesterverker i Munch–museet.* Oslo: Norsk Kunstreproduksjon (Stenersen), 1963. English ed. *Edvard Munch: Masterpieces from the Artist's Collection in the Munch Museum in Oslo.* Trans. Michael Bullock. New York: McGraw–Hill, 1964.

Langaard and Væring 1947
Johan H. Langaard, intro., and Ragnvald Væring, comp. *Edvard Munchs selvportretter.* Oslo: Gyldendal norsk forlag, 1947.

Lange 1903
Julius Lange. "Studiet i marken. Skilderiet. Erindringens kunst." In *Nordisk Tidskrift* (1889). Reprinted in *Utvalgte Skrifter.* (Copenhagen) 3 (1900–1903), pp. 159–168.

Lange 1977
Marit Ingeborg Lange. "Fra den hellige lund til Fleskum: Kitty L. Kielland og den nordiske sommernatt." *Kunst og Kultur* 60 (1977), no. 2, pp. 69–92.

Lange 1990
Marit Lange, "Sannhet og sunnhet, Dahl, Aubert og den norske tradisjon." *Kunst og Kultur* 73 (1990), pp. 85–101.

Lande 1992
Marit Lande. *For aldrig meer at skilles..., Fra Edvard Munchs barndom og ungdom i Christiania.* Oslo: Universitetsforlaget, 1992.

Langslet 1994
Lars Roar Langslet. *Henrik Ibsen, Edvard Munch: To genier møtes. Two geniuses meet.* (English trans. pp. 114–163). Oslo: J. W. Cappelens Forlag a.s., 1994.

Lathe 1979
Carla Lathe. *Edvard Munch and His Literary Associates: An Exhibition of Prints, Books and Documents.* Exh. cat. Norwich: University of East Anglia, 1979 (also shown at the Hatton Gallery, University of Newcastle-upon-Tyne, and Crawford Centre for the Arts, University of St. Andrews.)

Lippincott 1988
Louise Lippincott. *Edvard Munch, Starry Night.* Getty Museum Studies on Art. Malibu, California: J. Paul Getty Museum, 1988.

Loge 1991
Øystein Loge. *Deformasjon: nedbrytingen av det klassiske naturbildet i norsk landskapskunst.* [Deformation: Disintegrating the Classical Concept of Nature in Norwegian Landscape Painting]. Exh. cat. Bergen Billedgalleri and Oslo: Dreyers Forlag, 1991.

Mæhle 1970
Ole Mæhle. *Jens Thiis.* Oslo: Gyldendal norsk forlag, 1970.

Malmanger 1985
Magne Malmanger. *Norsk kunstdebatt ved modernismens terskel.* Oslo: Universitetsforlaget, 1985.

Malmanger 1986
Magne Malmanger. "Harald Sohlberg, maleri," pp. 4–46. In Exh. cat. *Harald Sohlberg, katalog for utstilling i Galleri K.* Exh. cat. Oslo: Galleri K., 1986.

Malmanger 1987
Magne Malmanger. "'Impressionismen' og 'Impressionisten,'" pp. 31–49. In Thue and Wikborg 1987.

Malmanger 1991
Magne Malmanger. "Det Romantiske landskaps retorikk." *Grunnlagsproblemer i estetisk forskning.* Vol. 2. Oslo: Norges Allmennvitenskapelige Forskningsråd, 1991.

Märtz 1994
Roland Märtz. "Das Urbild eines nordischen Künstlers," pp. 131–138. In *Germanemythos, Nationalsozialismus und Edvard Munch, Munch und Deutschland.* Exh. cat. Hamburg: Hamburger Kunsthalle, 1994.

Masheck 1993
Joseph Masheck. *Modernities: Art–Matters in the Present.* University Park, Pennsylvania: Pennsylvania State University Press, 1993.

McEvilley 1993
Thomas McEvilley. *The Exile's Return: Toward a Redefinition of Painting for the Post–Modern Era.* Cambridge and New York: Cambridge University Press, 1993.

Messel 1982
Nils Messel. "Fra realistisk virkelighetsskildring til dekorativ form." *Kunst og Kultur* 63 (1982), no. 3, pp. 152– 171.

Messel 1989
Nils Messel. "Fra Munch's have til Matisse' atelier." *Kunst og Kultur* 72 (1989), no. 3, pp. 122–136.

Messel 1994
Nils Messel. "Edvard Munch and His Critics in the 1880s." *Kunst og Kultur* 77 (1994), no. 4, pp. 213–227.

Messel 1994
Nils Messel. "Andreas Aubert om kunst, natur og nasjonalitet," pp. 49–67. In Tone Skedsmo, ed. *Tradisjon og fornyelse.* Oslo: Nasjonalgalleriet, 1994.

Messer 1973
Thomas M. Messer. *Edvard Munch.* New York: Harry N. Abrams, 1973.

Mohr 1960
Otto Louis Mohr. *Edvard Munchs Auladekorasjoner.* With an English summary. Oslo: Gyldendal norsk forlag, 1960.

Muller and Revold 1963
Hannah B. Muller and Reidar Revold. *Munch–bibliografi.* In *Årbøker,* 1951, 1952–1959, 1960, 1963. Oslo: Oslo Kommunes Kunstsamlinger Årbok, 1951.

Munch 1946
Edvard Munch. *Edvard Munch: Mennesket og kunstneren.* Essays by Karl Stenerud, Axel L. Romdahl, Pola Gauguin, Christian Gierløff, N. Rygg, Erik Pedersen, Birgit Prestøe, Chrix Dahl, Johan H. Langaard. Oslo: Gyldendal norsk forlag, 1946.

Munch 1946a
Edvard Munch. *Edvard Munch, som vi kjente ham.* Essays by K. E. Schreiner, Johs Roede, Ingeborg Motzfeldt Løchen, Titus Vibe Müller, Birgit Prestøe, David Bergendahl, Christian Gierløff, L. O. Ravensberg. Oslo: Dreyers Forlag, 1946.

Munch 1949b
Edvard Munchs Brev: Familien. Inger Munch, ed. Munch–museets Skrifter I, Oslo Kommunes Kunstsamlinger. Oslo: Johan Grundt Tanums Forlag, 1949.

Munch 1954
Edvard Munch. *Edvard Munchs brev fra Dr. Max Linde.* Oslo: Dreyers Forlag, 1954.

Nag 1993
Martin Nag. "Dostojevskij og Edvard Munch." *Kunst og Kultur* 76 (1993), no. 1, pp. 41–55.

Nasgaard 1984
Roald Nasgaard. *The Mystic North: Symbolist Landscape Painting in Northern Europe and North America, 1890–1940.* Exh. cat. Toronto: Art Gallery of Ontario, 1984 (also shown at Cincinnati Art Museum).

Nergaard 1967
Trygve Nergaard. "Edvard Munchs visjon. Et bidrag til Livsfrisens historie." *Kunst og Kultur* 50 (1967), no. 2, pp. 69–92.

Nergaard 1974
Trygve Nergaard. "Kunsten som det evig kvinnelige, en vampyrgåte." *Kunst og Kultur* 57 (1974), no. 3/4, pp. 251–262.

Nergaard 1975
Trygve Nergaard. "Emanuel Goldstein og Edvard Munch." *Louisiana Revy* (October 1975), pp. 16–18.

Nergaard 1978
Trygve Nergaard. "Despair," pp. 113–141. In Rosenblum 1978.

Norberg–Schulz 1978/1992
Christian Norberg–Schulz. *Mellom jord og himmel: en bok om steder og hus*. Oslo: Universitets forlag, 1978. Rev. ed., 1992.

Nordenfalk 1947
Carl Nordenfalk. "Apropos Munch utställninger." *Konstperspektiv* 3 (1947), no. 1, pp. 3–7.

Obstfelder 1896
Sigbjørn Obstfelder. "Edvard Munch. Et forsøg." *Samtiden* (1896), pp. 17–22.

Obstfelder 1950
Sigbjørn Obstfelder. *Samlede verker*. Vol. 3. Oslo: Gyldendal Norsk Forlag, 1950.

Østby 1934
Leif Østby. *"Fra naturalisme til nyromantikk."* Oslo: Gyldendal norsk forlag, 1934.

Østby 1936
Leif Østby. *Harald Sohlberg*. Oslo: Gyldendal norsk forlag, 1936.

Østby 1963
Leif Østby. "Edvard Munch slik samtiden så ham." *Kunst og Kultur* 46 (1963), no. 4, pp. 243–256.

Østby 1966
Leif Østby. "Et Edvard Munch motiv." *Kunst og Kultur* 49 (1966), no. 3, pp. 151–158.

Owens 1992
Craig Owens. "The Allegorical Impulse: Toward a Theory of Postmodernism," pp. 52–87. In *Beyond Recognition: Representation, Power, and Culture*. Scott Bryson, et al., eds. Berkeley: University of California Press, 1992. (First appeared in *October* [Fall 1979])

Pater 1980
Walter Pater. *The Renaissance: Studies in Art and Poetry: The 1893 Text*. Donald L. Hill, ed. Berkeley: University of California Press, 1980.

Prelinger 1983
Elizabeth Prelinger. *Edvard Munch, Master Printmaker: An Examination of the Artist's Works and Techniques Based on the Philip and Lynn Straus Collection*. New York: W. W. Norton & Company, 1983 (with the Busch–Reisinger Museum, Harvard University, Cambridge, Massachusetts).

Przybyszewski 1894
Stanislaw Przybyszewski, ed. *Das Werk des Edvard Munch: Vier Beiträge von Stanislaw Przybyszewski, Dr. Franz Servaes, Willy Pastor, Julius Meier–Graefe*. Berlin: S. Fischer Verlag, 1894.

Rapetti 1991
Rodolphe Rapetti. *Munch et la France*. Exh. cat. Paris, Musée d'Orsay, 1991.

Read 1963
Herbert Read. "Edvard Munch," pp. 56–61. *Årbok* 1963, Oslo kommunes Kunstsamlinger.

Romdahl 1975
Axel L. Romdahl. "Edvard Munchs stil: Ett utkast till en undersökning." *Kunst og Kultur* 30 (1946), pp. 79–102.

Rossholm 1972
Margaretha Rossholm. "Bilden som mikrokosmos eller bilden som själsspegel: enstudie i fransk och germansk symbolism." *Konsthistorisk Tidskrift* 41 (December 1972), pp. 95–112.

Rosenblum 1975/1983
Robert Rosenblum. *Modern Painting and the Northern Romantic Tradition: Friedrich to Rothko*. New York: Icon Editions, Harper & Row, 1975. Rev. ed. 1983.

Rosenblum 1978
Robert Rosenblum, intro. *Edvard Munch: Symbols & Images*. Exh. cat. Washington, D. C.: National Gallery of Art, 1978.

Sarvig 1964
Ole Sarvig. *Edvard Munchs grafik*. Copenhagen: J. H. Schultz, 1948. Rev. ed. Copenhagen: Gyldendal, 1964.

Sarvig 1980
Ole Sarvig. *The Graphic Works of Edvard Munch*. Trans. Helen Sarvig. Copenhagen, Forlaget Hamlet, 1980.

Schiefler 1907
Gustav Schiefler. *Verzeichnis des graphischen Werks Edvard Munchs bis 1906*. Berlin: B. Cassierer, 1907.

Schiefler 1928
Gustav Schiefler. *Verzeichnis des graphichen Werks Edvard Munch*. Vol. 1, Berlin: 1907; Vol. 2, Leipzig: 1928.

Schjeldahl 1979
Peter Schjeldahl. "Munch: the Missing Master." *Art in America* 67 (May 1979), pp. 80–95.

Schapiro 1994
Meyer Schapiro. "On Some Problems in the Semiotics of Visual Art: Field and Vehicle in Image-Signs, in Theory and Philosophy of Art." In *Style, Artist, and Society*. New York: George Braziller, 1994.

Sherman 1976
Ida Landau Sherman. "Edvard Munchs 'Pubertet' og Félicien Rops." *Kunst og Kultur* 59 (1976), no. 4, pp. 243–258.

Selz 1974
Jean Selz. *Edvard Munch*. Trans. Eileen B. Hennessy. New York: Crown Publishers, 1974.

Skedsmo 1982
Tone Skedsmo. "Hos kunstnere, polarforskere og mesener." *Kunst og Kultur* 65 (1982), no. 3, pp. 131–151.

Skedsmo 1985
Tone Skedsmo. "Tautrekning om Det syke barn." *Kunst og Kultur* 68 (1985), pp. 184–195.

Skedsmo 1987
Tone Skedsmo. *Olaf Schous gaver til Nasjonalgalleriet. Exh. cat.* Oslo: Nasjonalgalleriet, 1987.

Skedsmo 1989
Tone Skedsmo. *Edvard Munch i Nasjonalgalleriet.* Exh. cat. Oslo: Nasjonalgalleriet, 1989.

Skredsvig 1943
Christian Skredsvig. *Dage og nætter blandt Kunstnere.* Oslo 1943.

Smith 1983
John Boulton Smith. *Frederick Delius and Edvard Munch. Their Friendship and Their Correspondence.* Rickmansworth, Hertfordshire: Triad Press, 1983.

Søderstrum 1989
Gøran Søderstrøm, ed. *August Strindberg Underlandet.* Exh. cat. Malmö: Malmö Konsthall, 1989.

Stabell 1967
Waldemar Stabell. "Edvard Munch og Eva Mudocci," *Kunst og Kultur* 50 (1967), no. 4, pp. 209–236.

Stang 1972
Nicolay Stang. *Edvard Munch*. Ragna Stang, ed. English ed., trans. Carol J. Knudsen. Oslo: Tanum Forlag, 1972.

Stang 1977
Ragna Stang. *Edvard Munch: The Man and the Artist.* Trans. Geoffrey Culverwell. New York: Abbeville Press, 1977.

Stang 1978
Ragna Stang. "The Aging Munch: New Creative Poser," pp. 77–85. In Rosenblum 1978.

Stang 1982
Ragna Stang. *Edvard Munch. Mennesket og Kunstneren.* Oslo: H. Aschehoug & Co., 1982.

Stenersen 1946/1969
Rolf E. Stenersen. *Edvard Munch. Närbild av ett geni.* Stockholm: Wahlström & Widstrand, 1944. Enlarged Norwegian ed., Oslo: Gyldendal norsk forlag, 1946. English ed. *Edvard Munch: Close–up of a Genius.* Trans. and ed. Reidar Dittmann. Oslo: Gyldendal norsk forlag, 1969.

Stenseng 1963
Arne Stenseng. *Harald Sohlberg: en kunstner utenfor allfarvei.* Oslo: Gyldendal norsk forlag, 1963.

Stevens 1966
William Stevens. "Munch in America ... echoes of 1912 ..." *Art News* 64 (January 1966), pp. 41–43.

Svenæus 1953
Gösta Svenæus. *Idé och innehåll i Edvard Munchs konst. En analys av aulamålningarna.* Oslo: Gyldendal norsk forlag, 1953.

Svenæus 1967
Gösta Svenæus. "Strindberg och Munch i Inferno," *Kunst og Kultur* 50 (1967), pp. 1–30.

Svenæus 1969
Gösta Svenæus. "Munch och Strindberg. Quickborn–Episoden 1898," *Kunst og Kultur* 52 (1969), no. 1, pp. 13–36.

Svenæus 1973
Gösta Svenæus. *Edvard Munch. Im männlichen Gehirn.* 2 vols. Vetenskaps–Societeten i Lund [Publications of the New Society of Letters at Lund], nos. 66–67. Lund: Gleerup, 1973.

Thaulow 1992
Frits Thaulow. *I kamp og fest.* 1908. New ed. Oslo: 1992.

Thiis 1907
Jens Thiis. *Norske malere og billedhuggere.* Vol. 2. Bergen: John Griegs forlag, 1907.

Thiis 1913
Jens Thiis. "Edvard Munch, I. Om indholdet i hans kunst; II Om utviklingslinjen i hans kunst," *Kunst og Kultur* (1913), pp. 81–101.

Thiis 1920
Jens Thiis. *Samlede avhandlinger om Nordisk Kunst.* Kristiania and Copenhagen, Nordisk Forlag, 1920.

Thiis 1927
Jens Thiis. *Norsk kunsthistorie.* Oslo: 1927.

Thiis 1933
Jens Thiis. *Edvard Munch og hans samtid. Slekten, livet, kunsten og geniet.* Oslo: Gyldendal norsk forlag, 1933. German ed. *Edvard Munch.* Trans. Joachim Dieter Bloch. Berlin: Rembrandt Verlag, 1934.

Thue 1973
Oscar Thue. "Edvard Munch og Christian Krohg." *Kunst og Kultur* 56 (1973), no. 4, pp. 237–256.

Thue and Wikborg 1987
Oscar Thue and Ingeborg Wikborg, eds. *Christian Krohg*. Exh. cat. Oslo: Nasjonalgalleriet, 1987.

Timm 1969
Werner Timm. *The Graphic Art of Edvard Munch*. Greenwich, Connecticut: New York Graphic Society, 1969.

Torjusen 1971
Bente Torjusen. "Edvard Munchs utstilling i Praha 1905" ["Edvard Munch's Exhibition in Prague, 1905]" *Kunsten Idag* 97 (August 1971), pp. 5–51; English text, pp. 52–55.

Torjusen 1978
Bente Torjusen. "The Mirror," pp. 185–227. In Rosenblum 1978.

Torjusen 1989
Bente Torjusen. *Words and Images of Edvard Munch*. London: Thames & Hudson, 1989.

Varnedoe 1979
Kirk Varnedoe. "Christian Krohg and Edvard Munch." *Arts Magazine* 53 (April 1979), pp. 88–95.

Varnedoe 1982
Kirk Varnedoe, ed. *Northern Light: Realism and Symbolism in Scandinavian Painting, 1880–1910*. Exh. cat. Washington, D. C.: Corcoran Gallery of Art, 1982 (also shown in New York, Brooklyn Museum, Minneapolis Institute of Arts, and Gøteborgs Konstmuseum).

Varnedoe and Lee 1976
Kirk Varnedoe and Thomas P. Lee. *Gustave Caillebotte: A Retrospective Exhibition*. Exh. cat. Houston: Museum of Fine Arts, 1976 (also shown in New York, Brooklyn Museum).

Weisberg 1992
Gabriel P. Weisberg. *Beyond Impressionism: The Naturalist Impulse*. New York: Harry N. Abrams, 1992.

Weisner 1980
Ulrich Weisner, ed. *Edvard Munch. Liebe – Angst – Tode: Themen und Variationen....* Exh. cat. Bielefeld: Kunsthalle Bielefeld, 1980 (also shown in Krefeld, Kaiser Wilhelm Museum, and Kaiserlautern, Pfalzgalerie).

Werenskiold 1972
Marit Werenskiold. *De norske Matisse–elevene. Læretid og gjennombrudd, 1908–1914*. Oslo: Gyldendal, 1972.

Werenskiold 1974
Marit Werenskiold. "Die Brucke und Edvard Munch," pp. 140–152. *Zeitschrift des deutschen Verein für Kunstwissenschaft* 28 (Berlin), nos. 1–4, 1974.

Willoch 1950
Sigurd Willoch. *Edvard Munchs Raderinger.* Munch–museets Skrifter 2. Oslo: Johan Grundt Tanum Forlag, 1950.

Willoch 1965
Sigurd Willoch, ed. *Edvard Munch.* Exh. cat. New York: Solomon R. Guggenheim Museum, 1965.

Woll 1978
Gerd Woll. *Now the Time of the Workers Has Come.* Stockholm, 1977.

Woll 1978
Gerd Woll. "The Tree of Knowledge of Good and Evil," pp. 229– 248. In Rosenblum 1978.

Woll 1980
Gerd Woll. *Angst findet man bei ihm überal.* Bielefeld, 1980.

Woll 1993
Gerd Woll and Per Bj. Boym, eds. *Edvard Munch. Monumental projects, 1909–1930.* Trans. Stephen Dobson. Exh. cat. Lillehammer: Lillehammer Art Museum, 1993.

Woll 1995
Gerd Woll. *Edvard Munch 1895 første år som grafiker/Edvard Munch's First Year as a Graphic Artist.* Trans. Ruth Waaler. Exh. cat. Oslo: Munch-museet, 1995.

This book is printed in Norway by
TANGEN Grafiske Senter AS, Drammen

Photograph Credit
Glenn Castellano
Jaques Lathion, Nasjonalgalleriet
Per Petterson, Fotograf O. Væring
Øystein Thorvaldsen, Henie-Onstad Kunstsenter